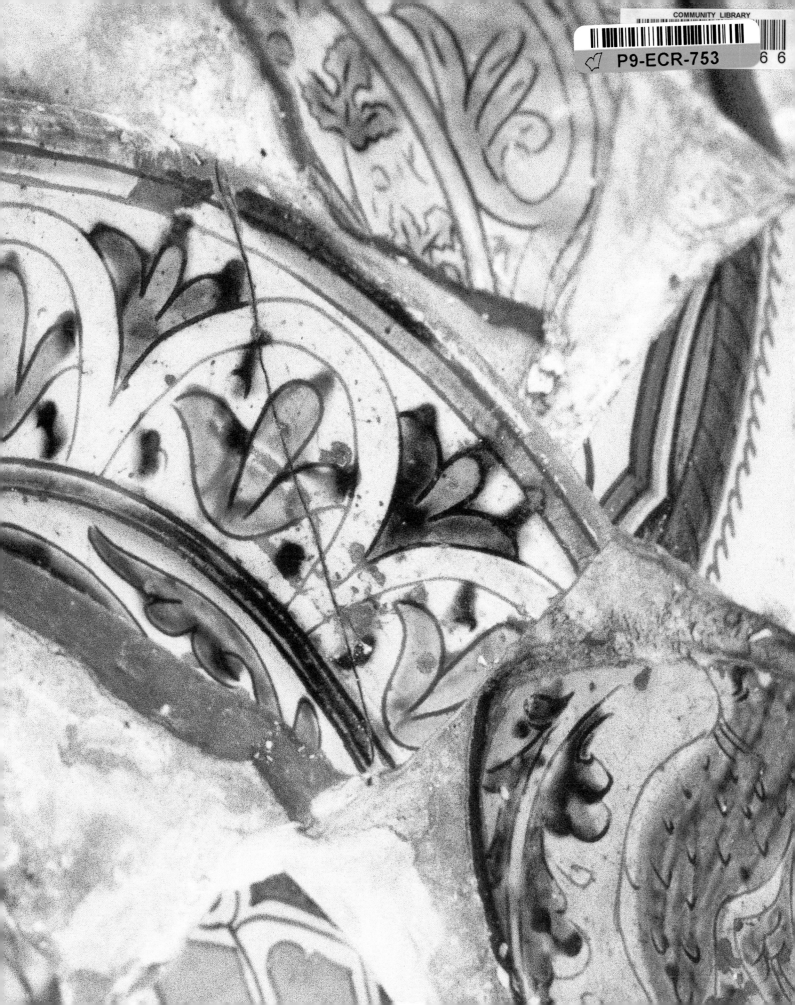

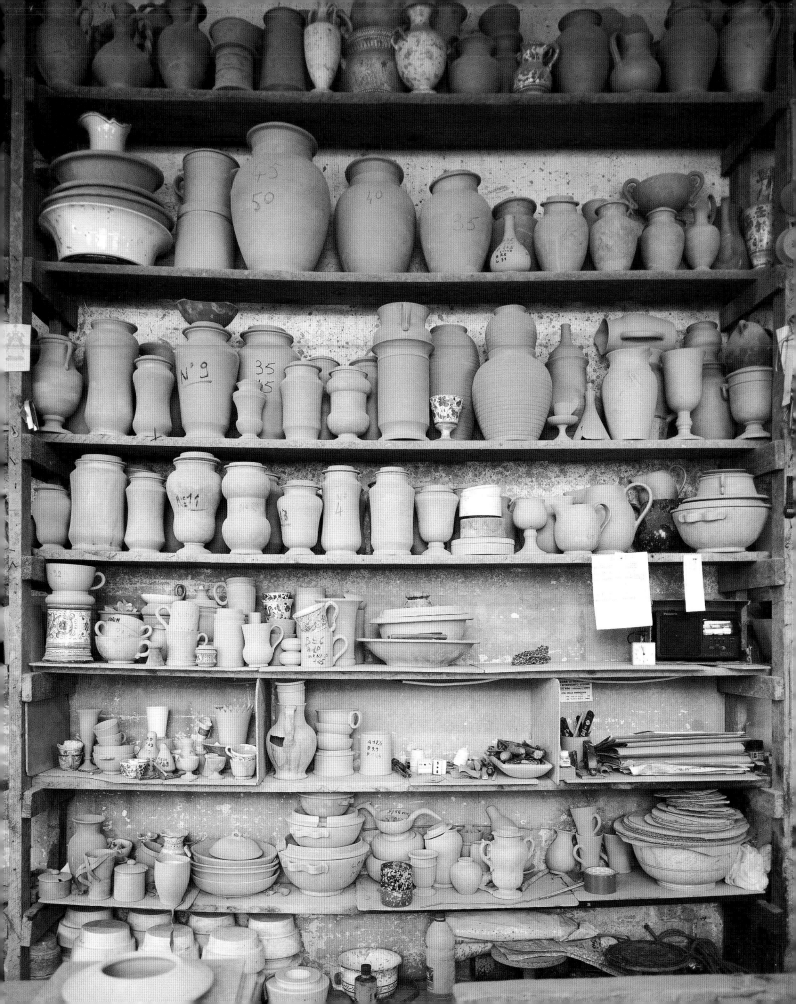

Deruta

A Tradition of Italian Ceramics

Text by Elizabeth Helman Minchilli

Photographs by Susie Cushner and David Hamilton

IN COLLABORATION WITH MELANIE DOHERTY

CHRONICLE BOOKS

SAN FRANCISCO

Library of Congress Cataloging-in-Publication Data:

Minchilli, Elizabeth Helman.

Deruta : a tradition of Italian ceramics / Text by Elizabeth Helman Minchilli;

photographs by Susie Cushner and David Hamilton.

p. cm.

In collaboration with Melanie Doherty.

Includes index.

ISBN 0-8118-1794-6

1. Majolica, Italian—Italy—Deruta.

I. Cushner, Susie. II. Hamilton, David, 1933- . III. Title.

NK4315.H45 1998

738.3'0945'651—dc21 97-44652 CIP

Book and cover design by Melanie Doherty Design

Distributed in Canada by Raincoast Books

8680 Cambie Street, Vancouver, BC V6P 6M9

10 9 8 7 6 5 4 3 2 1

Chronicle Books, 85 Second Street, San Francisco, CA 94105

Web Site: www.chroniclebooks.com

To Domenico,
with love.
—EH

To Susie and Jerry,
sources of great
inspiration.
—MD

End sheets: Rare
ceramic fragments
from the collection of
Ubaldo Grazia.

Page 1: Form models
with notations for
replication.

Page 2: The form wall
at Grazia Deruta.

Right: A craftsman
trimming an unfired
saucer.

Following page: An
architectural decoration
at the train station
announces Deruta's
ceramic industry.

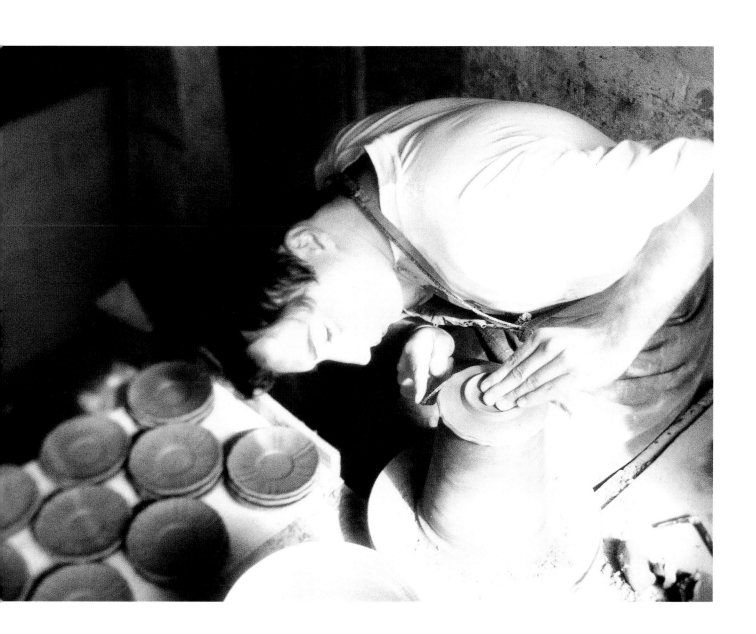

MAIOLICHE
S.A. COMBATTENTI
DITTA G. GRAZIA
DERVTA

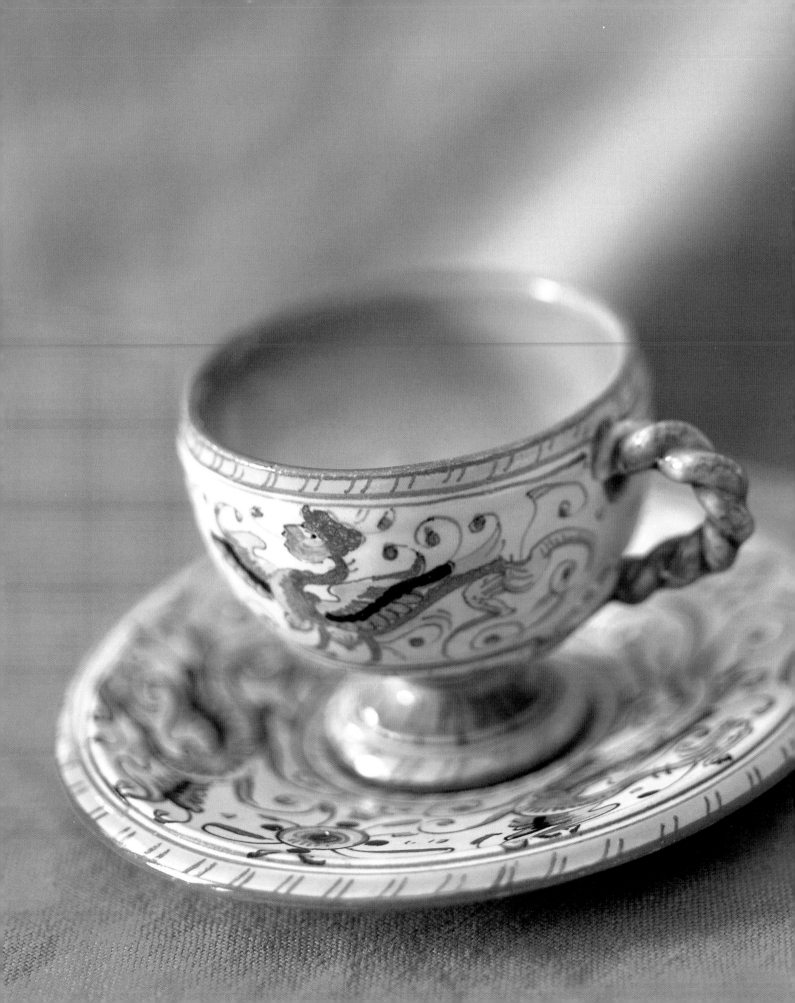

Preface

Those familiar with Italian ceramics will have already heard of Deruta. Along with other small towns throughout Italy, like Vietri and Grottaglia, Deruta is one of the biggest producers of the glazed Italian ceramic ware known as majolica. Then why choose Deruta as the star of a book on Italian ceramics, and not the others? Deruta, unlike other centers of this age-old craft, has been producing majolica of high quality for over six centuries without interruption, and continues to do so today. Through an exploration of Deruta and its craft we will see a portrait of a town and its unique artistic production. It is this continuous and ever developing history that informs the majolica from Deruta and distinguishes it from other cities. It is this sense of history that is acquired when we bring a piece of Deruta ceramics into our homes today.

Left: The Renaissance pattern *Raffaellesco* is applied to the lyrical form of a late nineteenth-century espresso cup.

Right: The red-tiled rooftops of the old part of Deruta give way to the Tiber valley below.

The same plates, bowls, jars, and pitchers that were produced in Deruta in the sixteenth century are still being formed and painted by the descendants of the families that produced these objects hundreds of years ago. Something about the beauty of the glazes and the patterns applied to these classic forms remains timeless. The standard shapes of centuries ago continue to be useful, whether holding wine or pasta on dining tables or a simple arrangement of sunflowers atop a mantelpiece. These forms work as well today as they did for distant European ancestors.

Deruta is in the "green heart" of Italy, in the center of Umbria, located just to the south of Tuscany. The walled town sits atop a hill, overlooking the Tiber valley. The name Deruta probably derives originally from the Latin *diruta*, or destroyed. The long and varied history of the town will explain why it could so often be described as a "destroyed" city. Eventually the town came to be known simply as Ruta, a shortened form of Deruta as well as the name of a medicinal plant common in the Mediterranean. This rounded-leaf plant became the symbol of the town and shows up often in its heraldry, even when the town's name settles and becomes, finally, Deruta.

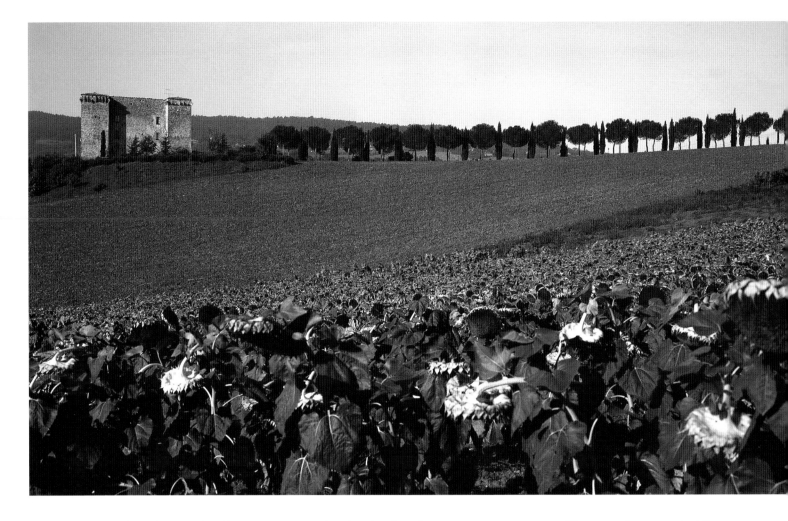

Deruta's pre-medieval history is uncertain, though archaeological remains attest to some sort of Roman settlement on the hill. Capitals and other architectural elements survive from ancient buildings, though, strangely, little exists from the preceding Etruscan period. The history of Deruta as a majolica-producing town doesn't begin until the fourteenth century.

Deruta: A Tradition of Italian Ceramics is divided into three sections. The first chapter explores the birth of the craft in the fourteenth century to the present day. Deruta had its high points as well as its hard times, which affected the ceramic trade and altered patterns of production. Two of the periods discussed at length are the sixteenth century, when Deruta was truly a world-class majolica center, and our present century, when Deruta revived the techniques that led to its original renown. We also look at lesser-known periods of production, bearing in mind that the kilns of Deruta, once lit, have never died out. From the seventeenth to the twentieth centuries, the town continued to produce ceramics that both reflected the various styles of these periods and were unique to Deruta.

The second chapter of the book takes tradition as its theme, since this is one of the fundamental influences behind any aspect of the craft. One of the most attractive factors of contemporary Deruta pottery is a sense of history. There are more than three hundred ceramic firms in Deruta today, making it one of the biggest ceramic producers in Italy. But if quantity may ring of impersonalized industrialization of a craft, the briefest of trips to Deruta dispels this view. This little town is a place where the human touch is always in evidence. The handcrafted element conveys itself in the shapes, textures, and colors of the finished works. Every stage, from the manipulation of the raw clay to the brilliant, colorfully glazed, finished product, is explored through word and image. Although

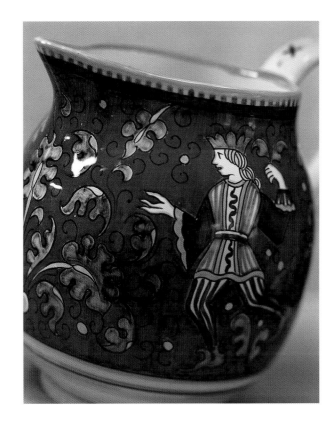

Left: The Umbrian countryside appears much as it did in the sixteenth century. Cultivated fields are dotted with imposing fortresses and humble farmhouses.

Right: Figura Antica, a modern pattern by Grazia Deruta, borrows from antique motives to produce a design steeped in history.

certain steps have changed over the centuries (with the introduction of electricity), the basic process remains very much as it was five hundred years ago.

The final section of the book visits several studios producing ceramics today. Although production is high, the craft still remains, by and large, a personal one, and one of the joys of visiting Deruta is the possibility of meeting the people who craft each piece individually. Most firms are run by at least two generations of the same family, each with their own stories to tell. Every pattern, whether it was designed yesterday or in 1582, plays an essential role in the development of this craft. Classic patterns such as *Raffaellesco, Gallo Verde,* and *Arabesco* are painstakingly painted by craftspeople who have studied with a master, the techniques and patterns carefully handed down from one generation to the next. Renaissance pieces continue to be emulated, but there is also constant innovation and research into new designs. Exports to America, Canada, Australia, and Japan have paved the way for a dialogue that has led many designers to visit Deruta's studios, resulting in new and exciting patterns that employ ancient techniques.

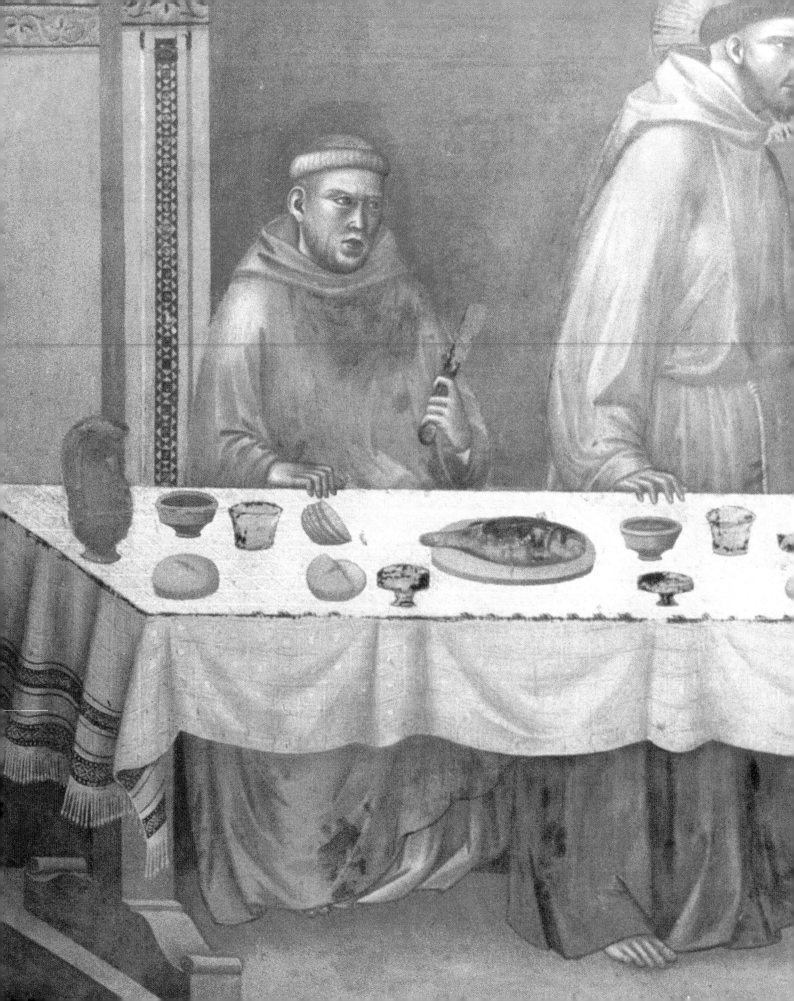

I.

The History of Deruta

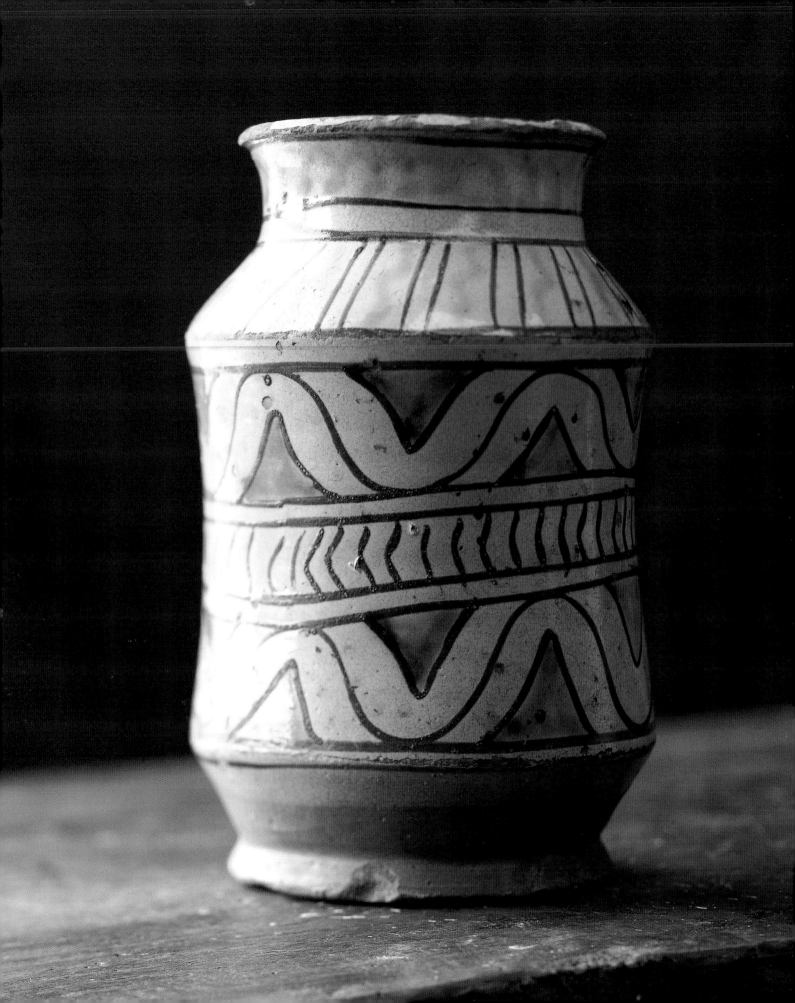

The Beginnings

Much of the earliest work in glazed ceramics survives only as bits and pieces. Yet these cultural artifacts, shiny fragments of broken forms, glow with a liveliness and brilliance that is denied their more important relatives in the major arts. Paintings and frescoes, crafted in the vulnerable media of tempera and oil, suffer more at the hands of time. Colors fade, and supports crumble. Yet even the smallest shard of majolica shines like it did the day it was painted.

Still, an artifact, no matter how well preserved, can tell us only so much about the people and culture that made it. For a view into the life of Deruta during the Middle Ages, written records tell the story, not painted remnants. Scratchy, sometimes almost illegible notations capture the everyday events — lists of births and deaths, marriages and wills — that were preserved for posterity in dusty archives of large vellum-bound albums.

Deruta is first mentioned as a community in 990 A.D., when the Emperor Otto II awarded the land in this area to several German barons. In recognition of their devotion, he conferred upon these barons the title *nobiles de Deruta*, or noblemen of Deruta. Although these noblemen may have never visited this town, they were entitled to levy taxes. This implies that Deruta, even then, was profitable enough to contribute to the coffers of "non-resident" barons.

In the thirteenth century, Deruta made its first attempts at governmental organization. In 1221, the town had grown large enough to win the right to nominate and elect its own mayor and was one of the few villages in the area to gain a certain level of administrative and political independence at such an early date.

One of the most notable, if not happy, events of the thirteenth century was the death of Pope Urban IV, who passed away in Deruta in 1264, while on his way from Todi to Perugia. Deruta, located on the main trade route linking northern and southern Italy, was usually just another way station for passing kings, cardinals, and, yes, popes. The pope's death is the first time world history makes itself felt in this otherwise unremarkable hill town. If nothing else, Urban IV's death illustrates the importance of the town's location along the Via Tiberina, a road following the course of the Tiber river.

A map illustrates Deruta's position, both geographically and politically. Never a large city in its own right, Deruta would forever be tied, for better or worse, to the political fortunes of its larger neighbor, Perugia. Since Deruta was allied with Perugia, but smaller and less fortified, it suffered greatly both at the hands of Perugia's enemies and from the passage of its ally's own troops.

Preceding page:
A detail from Giotto's *Banquet in the House of the Knight of Celano,* in the Church of San Francesco in Assisi, illustrates the use of ceramics as tableware in the fourteenth century.

Left: This common apothecary jar, which displays the vivid green and black glazes typical of the fourteenth century, was used to store medicinal herbs or spices. The jars were usually closed with a piece of waxed parchment or leather, secured around the lip with a cord.

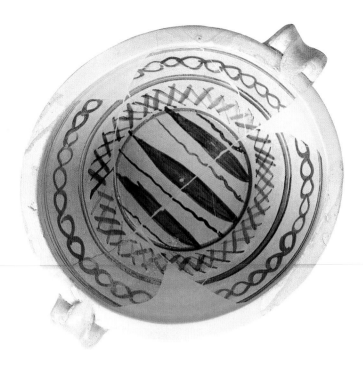

Left: In patterns typical of the early stages of Deruta ceramics, green chains and cross-hatching follow the round form of a two-handled bowl, and abstract lozenges cover the bottom. The copper green is captured crisp and clear against the white background and every stroke of the painter's brush is clearly visible.

Right: Ignazio Danti's large scale fresco adorns the Hall of the Maps in the Vatican Palace in Rome. This brilliantly colored and detailed painting is one of more than forty that show the Catholic Church's holdings in the sixteenth century. The map shows Deruta's strategic position along the Tiber valley.

Deruta's relationship with Perugia dictated its fate in the 1300s. In 1310 Captain Gentile Orsini, a Perugian commander, billeted his troops in Deruta during his battle with neighboring Todi. Although the visiting soldiers were on the same side as their host, the effects of housing a gang of warriors were harsh. Later in the fourteenth century, Perugia took measures to reinforce the small town by erecting new walls and fortresses. Deruta was again invaded, this time by the army of the Catholic Church, which was seeking to subdue Perugia and bring its lands within its vast holdings. In 1370, to teach the rebellious cities of Umbria a lesson, the Church chose to make Deruta an example and devastated the town yet again. Deruta being described as "destroyed" begins to make sense.

A violent uprising against Perugia was brought about by the murder of three Derutan ambassadors. This rebellion was immediately squashed by Perugia and by 1391 the larger town finally decided that stronger measures needed to be taken. To protect Deruta as well as guarantee its loyalty in turbulent times, new watchtowers and fortified walls were built, along with an enormous fortress at the north end of the main square. The gates of the Church of St. Angelo were reinforced, and a large fortified tower was erected where the town hall still stands today.

In the first years of the fifteenth century, Deruta was at the heart of a series of battles for control of Umbria. From 1408 to 1416, Deruta suffered from the continual struggles between Braccio Fortebracci, an independent warlord, and Perugia for control of that city. In 1408, Fortebraccio declared to his troops that the

area of Deruta known as Il Borgo would "be consumed and devoured by flames!" The Derutan troop's valor in defending itself and its ally Perugia was to no avail, and both towns crumbled to the *condottieri*'s will.

Unfortunately, little remains of the earliest buildings in Deruta. Both war and time have taken their toll over the centuries. A fortuitous testament from this period exists in the form of a fresco (recently transferred to the local museum) painted for the Church of San Francesco. The main subjects of this painting are Deruta's patron saints, Rocco and Romano. This graceful work, attributed to Perugino, is of particular interest because it includes

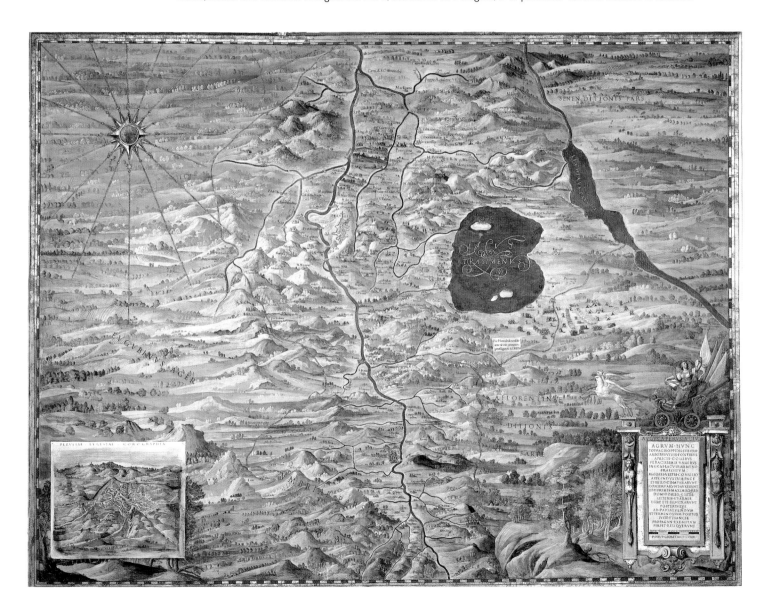

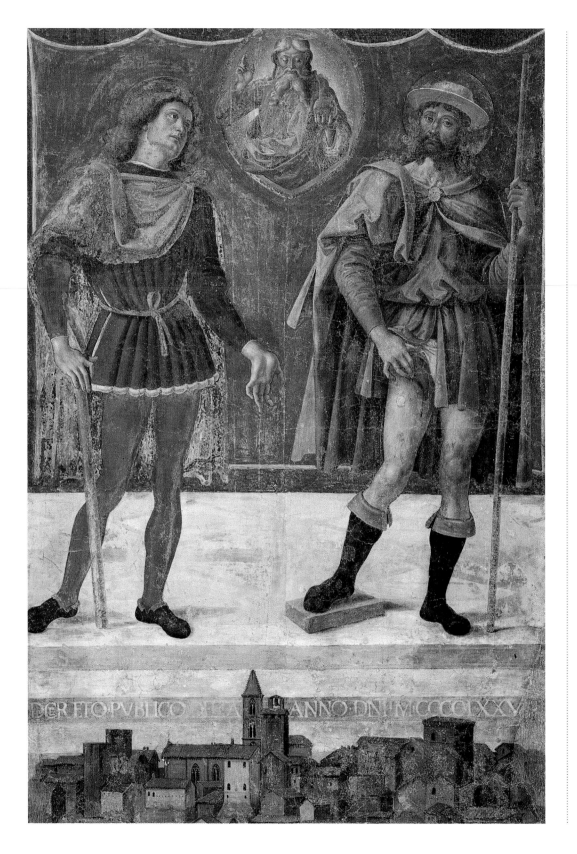

Left: In the middle of the fifteenth century, the plague devastated Deruta, and the inhabitants prayed for divine protection to San Rocco and San Romano. In thanks for their deliverance, the townspeople commissioned this altarpiece depicting the two saints, and God the Father between them, to be placed in the Church of San Francesco.

Right: This small jug's decoration clearly explains its use. While most Derutan pieces from this period emphasize abstract and vegetal designs, some show crudely drawn human forms.

an accurate and detailed rendering of the skyline of Deruta as it was in 1479, the year the fresco was painted. The forts are located at either end of the main piazza, and the pointed tower of the town hall and the peaked roof of the Church of Santa Maria dei Consoli, break the rhythms of the skyline. In the center, the west flank of the Church of San Francesco appears as the biggest building in town. The church, which was consecrated in 1388, has survived many restorations over the centuries and is still the town's main place of worship and one of its major monuments. Although some of the important frescoes and works of art have been transferred to the museum for safekeeping and public display, the church retains its typically Gothic architectural elements and proportions, as well as fragments of the original fourteenth-century cloister.

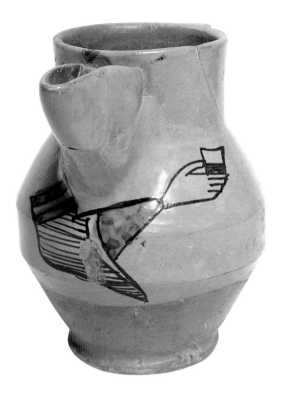

The event that was to shape Deruta's destiny had nothing to do with politics. Like other towns throughout central Italy, Deruta had been producing ceramics for its own use for quite some time: it had a kiln that churned out simple but useful forms. These rustic pots and bowls were either undecorated, in unglazed, baked terra-cotta; or treated with a simple, transparent lead-based glaze. By the mid-fourteenth century, an important change in the glazing technique began to take hold. Tin glazing, later known as majolica, encouraged the decoration of these rough shapes to become more important, equaling or surpassing the forms of the objects themselves.

The technique of tin glazing is ancient, developed by the Assyrians some three thousand years ago. From the eighth to the eleventh centuries, Persian and Egyptian examples of tin-glazed ware were imported to Spain, resulting in the indigenous development of Spanish-Moresque ware. But it was not until the thirteenth century that examples of Spanish tin-glazed ware began to be imported by Majorcan traders into Italy, sparking a new interest in this type of glazing. The word used today to refer to this type of ware, *majolica*, is in fact derived from the name Majorca, the Spanish island from which these techniques were thought to have originated.

Tin glazing is distinguished from lead-based glazes because it provides a white, opaque background on which more-detailed and increasingly precise designs could be developed. Lead-based glazes were transparent, which left a muddy,

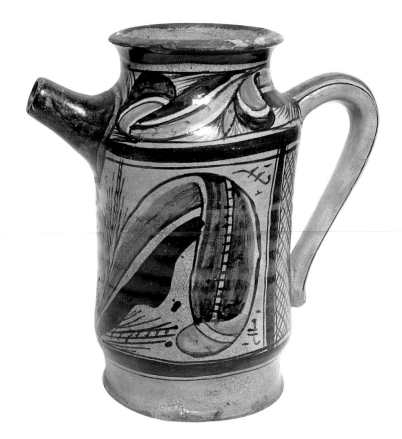

brownish base on which to trace designs. Lead-based glazes are also unstable at low temperatures, fusing easily and causing designs to bleed. Tin glazing, in addition to being opaque, was also more stable.

Once formed either on the wheel or in molds, the objects were fired in a kiln to reach the stage known as *biscotto,* or bisque ware. The piece was then dipped into a bath of glaze known as the *bianco,* or white coating, a mixture of lead and tin oxides and a silicate of potash. Once this white porous coating was dry, the piece was ready to receive its decoration. Brush in hand, the painter applied quick, sure strokes of pigment following his chosen design. A second firing simultaneously melted the white base to the object while it fused the pigments of the decoration.

The earliest pieces of tin-glazed ware we have from Deruta belong to the period known as *Archaic,* which spans the mid-thirteenth century through the first decades of the fifteenth century. The Archaic period of central Italian ceramics is best represented in Italian museum collections, because, unlike later majolica, especially from the sixteenth century on, these earlier pieces were mostly produced to be *used.* They were not placed on a shelf or hung on a wall to be admired and, more importantly, preserved. Pieces from the Archaic period were often chipped, broken, or thrown away. They were usually discarded not far from where they were originally produced, and recent excavations make attributions to specific sites possible.

In the fourteenth century, the range of shapes was quite limited. The potters produced objects that had a definite, practical use, usually as tableware. Jugs, bowls, and cups — objects meant to hold liquids — were routinely formed of clay, baked, and glazed. Plates and platters, however, tended to be made of other materials,

Left: In the second half of the fifteenth century, the majolica palette expanded: deep blues and oranges joined the green and brown already in use.

Right: One typical fifteenth-century pattern in Deruta is a slightly curved triangular motif with bipartite tips. Another distinctive decorative technique was to scratch the various motifs into a purplish-brown base of glaze, which would reveal white underneath.

such as wood and metal. An illustration of a fifteenth-century table setting appears in Giotto's fresco *Banquet at the House of the Knight of Celano*, in the Church of San Francesco in nearby Assisi. A dinner is underway, and two green-glazed pitchers, two brown-glazed bowls, and several cups and goblets of either wood or ceramic are scattered across the table. A large fish is presented on a wooden platter. The meal consisted of bread and fish, which were dipped in the sauces in the cups or bowls. Utensils were not yet common and some of the cups surely contained water to wash sticky fingers. However simple this dinner setting may seem, tin glazing still represented the high end of the market for tableware in the fourteenth century. The basic ingredient, tin, was imported from Devon and Cornwall, and pieces displaying this type of decoration were still too expensive for common use.

The range of colors available in the Archaic period was quite restricted. Copper was used to create a bright green glaze, while manganese was used to make a purplish-brown tint. The designs of the Archaic period are simple, stylized, and almost abstract and can be seen as a general reflection of the Gothic aesthetics prevalent throughout the peninsula. Vegetal and geometric patterns prevail. There is none of the complexity (monsters and beasts) seen in the same period in nearby Orvieto. The patterns include lance-shaped and rounded leaves, as well as interlacing and small crosses, generally on a poor, slightly gray base. Since pieces from this period tend to be similar throughout central Italy, it is not always easy to distinguish objects made in one small town from those made in another. The Deruta museum's extensive collection of *locally* found objects guarantees their provenance and makes it possible to distinguish these works from those of other sites.

A pitcher (see page 25) from this period displays many of these typical design elements. The painter of this jug takes his lead from the slightly complicated forms of the articulated pitcher. Manganese brown is applied in thin, quick

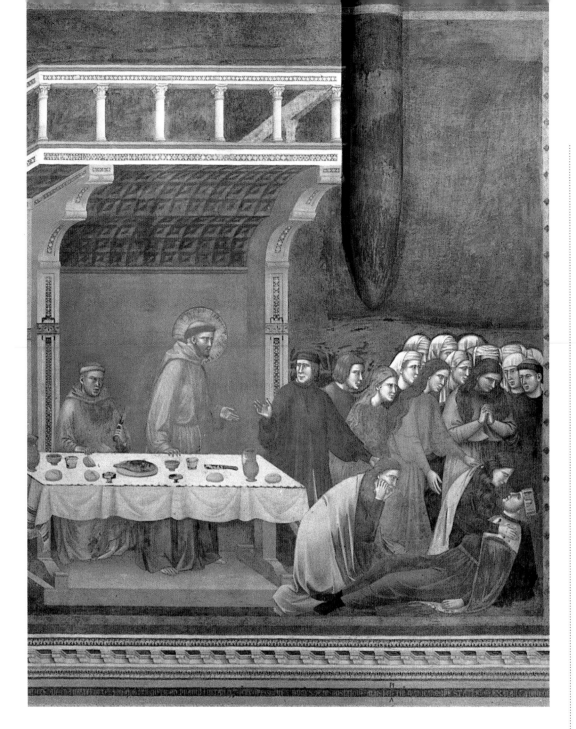

Left: In Giotto's *Banquet at the House of the Knight of Celano*, a fresco in the Church of San Francesco in Assisi, ceramic pitchers and bowls dot the table, while the main course is served on a large wooden platter. Some bowls held sauces in which the fish and bread were dipped, and other bowls held water for cleaning sauce-covered fingers, since eating utensils were not yet common.

Right: Assisi is only fifteen miles from Deruta and was one of its biggest clients. Pilgrims visiting the birthplace of San Francesco were in constant need of bowls and cups for eating as well as souvenirs bearing the saint's image.

strokes to emphasize the spout and to delineate the various zones that will hold the decoration. The swollen belly and squat neck are separated to form distinct areas. A repetitive series of loops runs around the neck, while the main body receives a more complicated treatment. The stylized leaves are brushed on in copper green, and then outlined in a thin band of brown, which also forms the stems. The design shows forethought as well as sensitivity to the relationship of the applied decoration to the original form. While the design is fluidly applied and appears spontaneous, the painter had to be meticulous, since any mistake could ruin the

piece. The green and brown glazes were immediately absorbed into the porous white base, granting a permanence to every brush stroke, intended or not.

Although many towns made their own ceramics, this craft began to take on a central role in Deruta's economy, and in 1336 three auditors and attorneys were elected to oversee the guild's affairs. By the end of the thirteenth century, Deruta was producing enough ceramics to pay its taxes to Perugia in vases instead of cash. By the mid-fourteenth century, Deruta had assumed its role as the regional producer of ceramics, exceeding even nearby Orvieto. Production far surpassed what could be sold locally. Deruta had progressed beyond the typical small-town kiln to become a major exporter.

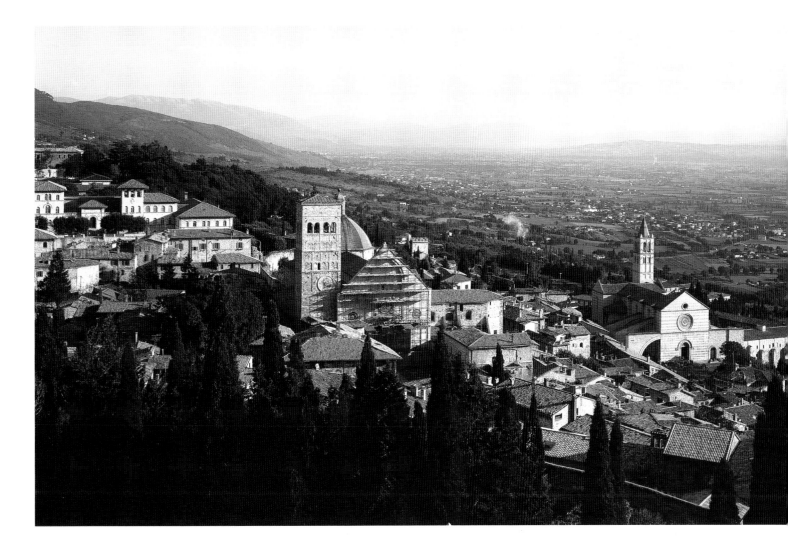

In 1358, Deruta exported over one thousand pieces to neighboring Assisi, which was already a thriving attraction for pilgrims. San Francesco's (St. Francis') hometown was in constant need of tableware to feed the visitors, as well as souvenir bowls bearing the saint's image to carry home. Cecce Alexandri, a ceramic merchant in Assisi, sold a large quantity of Derutan ceramics to Assisi's Church of San Francesco. Since Alexandri also dealt in locally produced ware, it appears that at certain times, for example religious festivals, he had to go to Deruta to meet the demand.

Several other factors about its location encouraged Deruta to become a major producer of ceramics in the fifteenth century, one of which was the availability of suitable earth from which to form clay. The hills around Deruta have been mined for centuries. They are particularly rich in a pure strain of clay which also washes up along the shores of the Tiber river. Deruta was surrounded by abundant firewood to fuel the ever-hungry kilns. An advantage of having a concentration of kilns near, but not actually in a large city was that the constant hazard of fire was minimized, since the population was less dense; similar concentrations of kilns in a walled city like Florence or Perugia would have been unacceptably dangerous. But even though the ceramic industry began to shift to smaller towns like Deruta, funding still came from their larger neighbors. In fact, it is clear that without major investment from neighboring Perugia, Deruta would never have expanded as it did. Because it appeared in such important and well-visited

Left: Nearby Perugia played a fundamental role in the economic development of the smaller Deruta, which came under the governmental aegis of its larger neighbor and depended upon it for protection in times of war. The expansion of Deruta's ceramic industry could not have occurred without the financial investment of Perugia's wholesalers, who gave monetary loans in exchange for merchandise.

Right: Two jugs, used to hold wine or water during meals, show the straightforward practicality typical of the period.

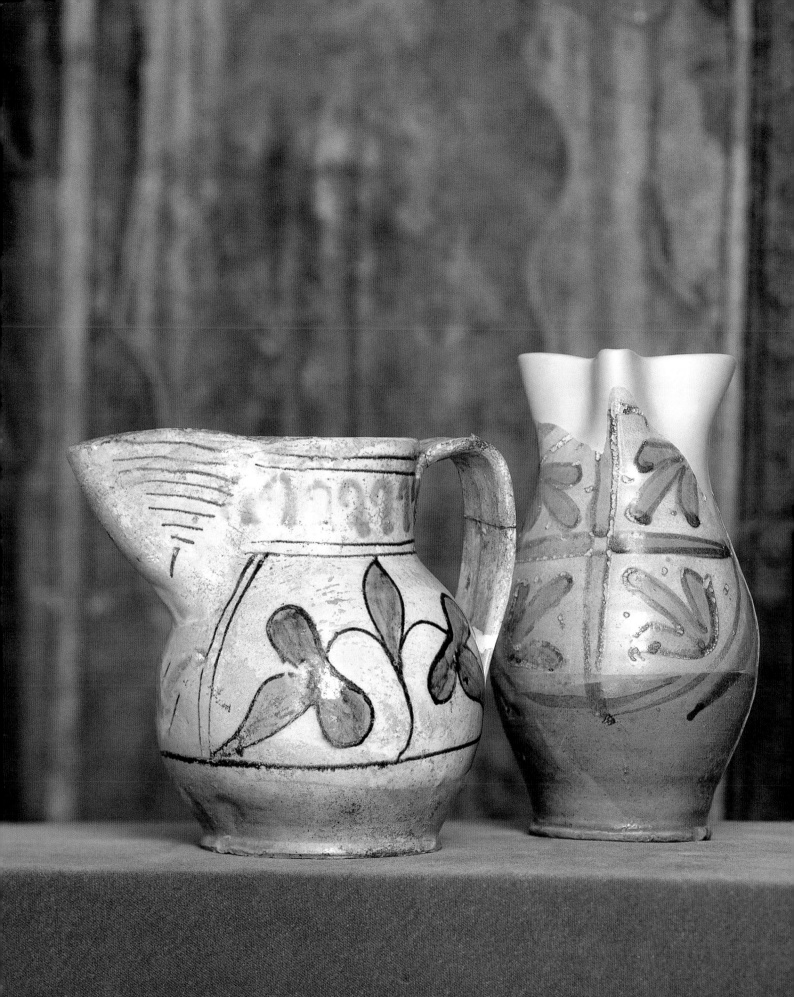

centers as the churches of San Francesco in Assisi and San Pietro in Perugia, the work of the Derutan craftsmen became well known. Wholesalers from Perugia would often lend money to a potter from Deruta, who would then pay off the loan in goods.

By the beginning of the fifteenth century, tin-glazed jugs were becoming more common, showing up in taverns, churches and monasteries, and on the tables of a newly forming middle class. This increased production is linked to an increase in the quality of life, when more people could afford this slightly more sophisticated form of tableware.

This is one of Deruta's least understood periods, though well documented throughout the rest of Italy. The lack of a large corpus of Derutan pieces makes it seem that the town may not have been producing ceramics in these years, yet archival references attest to great activity. While many of these fragile works have obviously not survived, there may also be pieces in public and private collections that are not recognized as being from Deruta. Continuing scholarship and excavations are shedding more light on this time.

The fifteenth century saw several changes that affected the decoration of ceramics in north central Italy in general and in Deruta in particular. One of the most important developments was the expansion of the color range. Cobalt blue, imported from Persia, joined the original green and brown palette. An orange yellow also begins to be produced using iron and animony. This period, referred to as the *Stile severo,* or Severe style, is distinguished by a rather cold range of colors employing these pigments.

The color range expanded even more around the mid 1400s. Dark purple/brown manganese was diluted to become a vivid violet; similarly, cobalt led to azure and blue; the vivid copper green was lightened to become a brilliant turquoise. The additions of oranges, yellows, and browns warmed

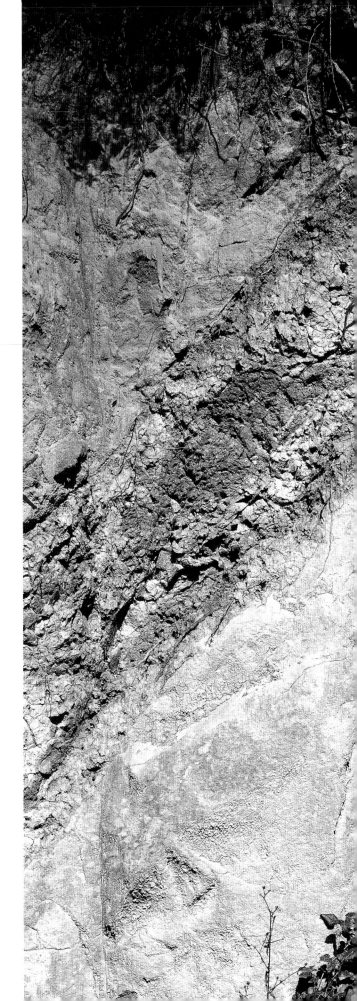

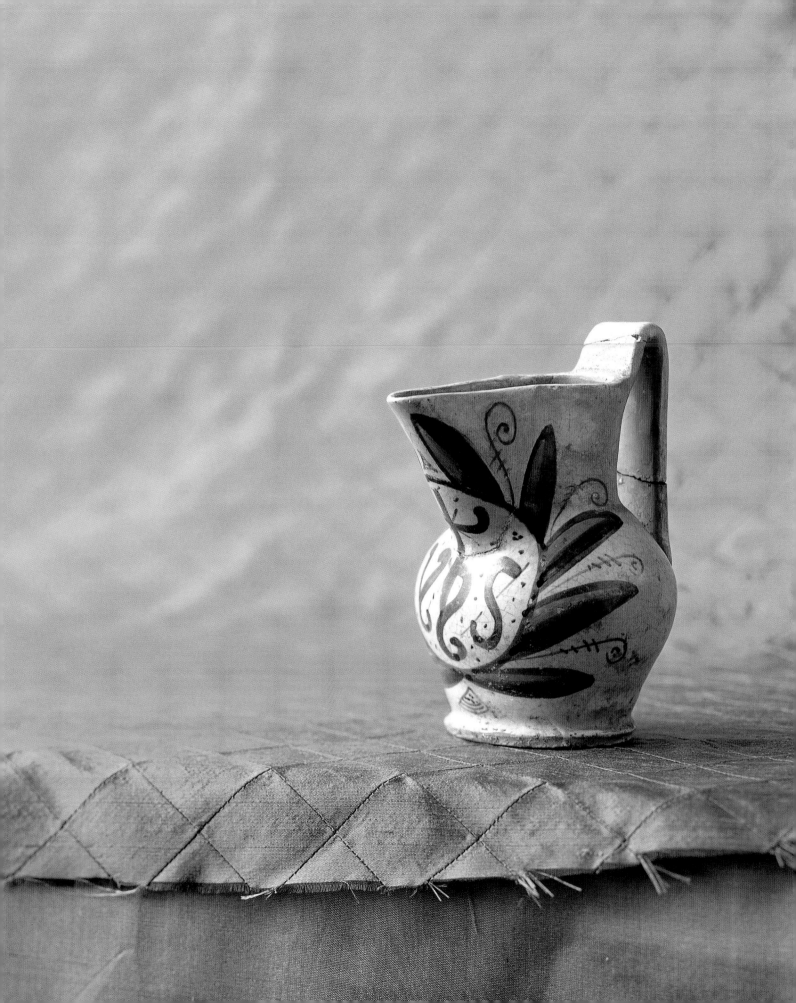

up the overall effect. In addition to this expanded palette, the patterns of decoration and the forms themselves became more complex, leaving the Gothic simplicity of the previous period behind.

The rims of the plates became wider and were able to carry new and expressive patterns. Scrolled leaves, stylized flames and rays, peacock feathers, and Persian palmettes were combined to create new and exciting visual motifs. While many of these patterns appear throughout northern central Italy, certain variations appeared only in Deruta.

One pattern specific to Deruta was a divided triangular motif around the rim, with slightly curved tips. Another local custom was the drawing of garlands, spirals, or wreaths by scratching through a layer of purplish-brown glaze to uncover the white base. This was a very unusual technique that is rarely found elsewhere. The so-called San Bernardino rays were used by the Derutan potters to create new and varied designs (see page 21).

The potters of Deruta were also abandoning the early motifs in favor of other shapes and patterns, which were to dominate the next century. Objects tended to open out, providing more room for decoration. A plate from the Corcoran Museum of Art illustrates this "transitional period." The primary subject, in this case a dragon, is surrounded by concentric bands of rigid geometric shapes. Here the central image is still relatively small, but the shape of the piece is less concave, more of a platter than a bowl. Over the course of the next few decades, the central image would predominate, and the rim would become a kind of frame.

Many pieces now known to be from Deruta are part of this transitional phase, called Petal Back by scholar Bernard Rackham. He recognized certain Derutan characteristics in a group of plates and bowls previously attributed to other towns. One of the common characteristics is the harmonious range of colors, including blues, oranges, and yellows with highlights in violet and azure. The central theme, when there is one, is often classical in its source. The characteristic that lends its name to this group is the design sketched on

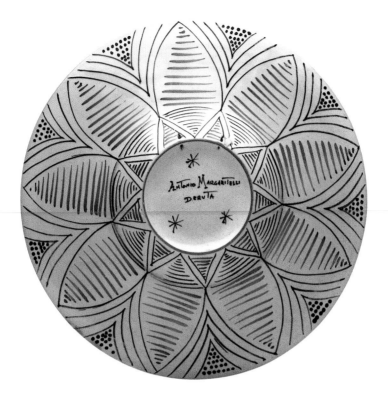

the back of these plates and bowls, a series of radiating petals in orange and blue. In Deruta, the "hidden" or usually undecorated portion of the ceramic pieces — rather than left bare or treated with a translucent glaze — came to bear this distinctive pattern.

Until the end of the fifteenth century, the pieces that were being created still reflected the basic utilitarian shapes that had always been produced. During the early Archaic period, the decoration more or less emphasized the form of the object. During the Severe style period, when the decoration became more complex and detailed, the glazing itself slowly begins to supersede the shape, often applied with no respect for the restrictions of the form. This development reached its natural conclusion in the second half of the fifteenth century, when a new type of ware was developed. What was originally an object (albeit beautifully decorated) created for a specific, practical use now became a format to express the painters' skills. Bowls became almost flat, thus losing their usefulness. They were eventually transformed into pure display objects to be hung on the wall and admired rather than to hold mundane portions of soup. This trend toward purely luxurious collectibles achieved its full flowering during the sixteenth century.

Left: A design of radiating blue and orange petals, referred to as "Petal Back," applied to the back of plates, distinguishes a group of works dating from the turn of the sixteenth century. Some of today's potters, such as Antonio Margaritelli, faithfully reproduce this detail on the reverse of their plates and bowls.

Right: The design of this plate is firmly rooted in the fifteenth century, since the central design is still subordinate to the wide, decorated rim.

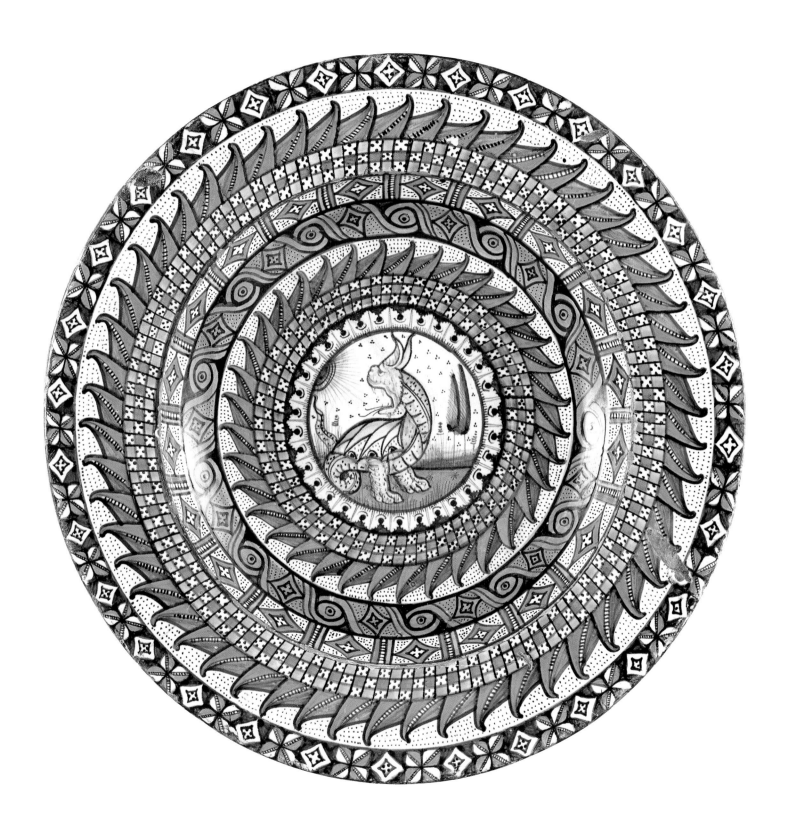

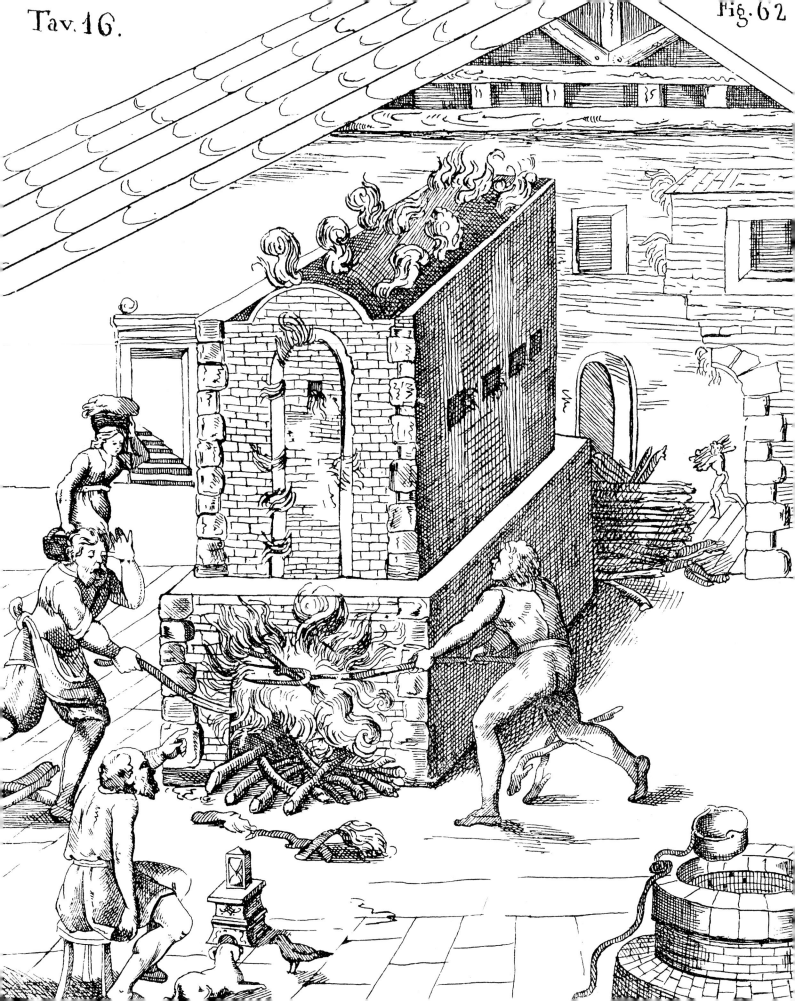

Fig. 62

The Renaissance

The same atmosphere that gave rise to some of Italy's greatest works of art also inspired the ceramic production in Deruta. Both economically and aesthetically, the sixteenth century in Deruta was profoundly successful. Production was the highest that it would be until the present day. Inquisitive and canny potters sought out and mastered new techniques that would push them to the forefront of the field. The innovation of printmaking allowed the craftspeople of this isolated town to participate in the Renaissance revolution in imagery, giving them copies of the works of the great artists of the day. They then borrowed these designs for their pieces.

Ceramics in the Middle Ages and the Renaissance was, by and large, an anonymous craft. The finished piece was the result of a collaborative effort, from the working of the clay to the final firing, and it is for this reason that signed works are so rare. Although specific names cannot be linked to specific pieces, profiles of the leading workshops can be pieced together.

The Masci family was certainly one of the leading families in Deruta in the first quarter of the sixteenth century. In 1498, when the family decided to split up their holdings, they listed their properties in the official land register. The document, which is a wealth of information, refers to the family's *laboreria maiolicata*, or majolica workshop. This is one of the first references to the word *majolica* in Deruta. Although we use the word today to refer to all types of tin-glazed ware, at this date, majolica refers to a specific technique that the Masci family specialized in: lustreware. Only later, in the eighteenth century, did *majolica* come to refer generally to all types of tin-glazed ware, both polychrome and lustre.

The Masci family's properties were impressive, covering every aspect of ceramic production. They owned at least three workshops and a kiln, and a shop in the main square where they sold their wares directly to the public. They also owned damp cellars for working the clay, as well as gardens and cloisters for storing wood to fuel the kilns. Although it is not possible to identify any specific works by the Masci (none are signed), their wealth, which stemmed from the monopoly they had on lustreware, made them leaders in Deruta.

Not even riches were immune to the effects of war and disease. By 1528, the pottery craft in Deruta was in crisis, and the local guild drew up a letter to Perugia declaring that drastic measures needed to be taken, since all of the master craftsmen had died during years of war, famine, and pestilence. The financial incentive must have been enormous, and it helped put Deruta back on track. By the following year, the town was already

Left: The sixteenth-century writer Cipriano Piccolpasso explained and illustrated the complicated firing technique needed to produce lustreware in his treatise *The Three Books of the Potter's Art.* Large bunches of brushwood were added to the fire to create a rise in temperature; the resulting vacuum caused the oxides to fuse and the lustre to appear on the surface of the piece.

producing enough pottery to be able to export to Rome. However, the Masci must have been particularly hard hit, since their name disappears forever from the registers.

Luckily, the technique that made the Masci family's fortune did not die out with them. In fact, the first half of the sixteenth century in Deruta was dominated by the new technique of lustreware. Leandro Alberti, in his *Description of the Whole of Italy* (1550) wrote: "The earthenware made [in Deruta] are renowned for being made to look as if they were gilt. It is such an ingenious technique that up to now no other workman in Italy has been found to equal them, although attempts and experiments have often been made. They are called majorica wares."

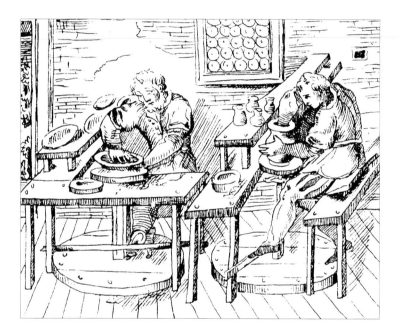

The craftsmen of Deruta probably unraveled the mysteries of the lustre technique some time in the last decade of the fifteenth century, but it was not until the first years of the sixteenth century that they truly mastered its secrets and made it their own. The "recipe" for this rather complicated procedure is recorded in a manuscript preserved in the Victoria and Albert Museum in London. Cipriano Piccolpasso's treatise *I tre libri dell'arte del vasaio* (The Three Books of the Potter's Art) carefully explains and illustrates everything there was to know about the potters' craft in the sixteenth century. From the gathering of raw clay to the final polishing, *The Three Books of the Potter's Art* provides enormous insight into the working methods of the day.

Once the decoration was finished and dry, the final coating, called the *coperta,* was applied. This was a transparent glaze that would provide a shiny and smooth finish and make the already bright colors even more brilliant. The piece was now ready for the second firing, which fused the pigments, transforming the glaze into the glasslike finish. Most often the piece was considered finished at this point, ready for sale. Yet if a work was to

Left: Piccolpasso faithfully reported everything there was to know about the potters' craft in his treatise. Equipment such as the wheel was illustrated.

Right: Deruta was well known throughout the Italian peninsula and beyond for its mastery of lustreware. Imitating the sheen of more costly metal work, the golden-hued glaze was often paired with a brilliant azure for a bold effect.

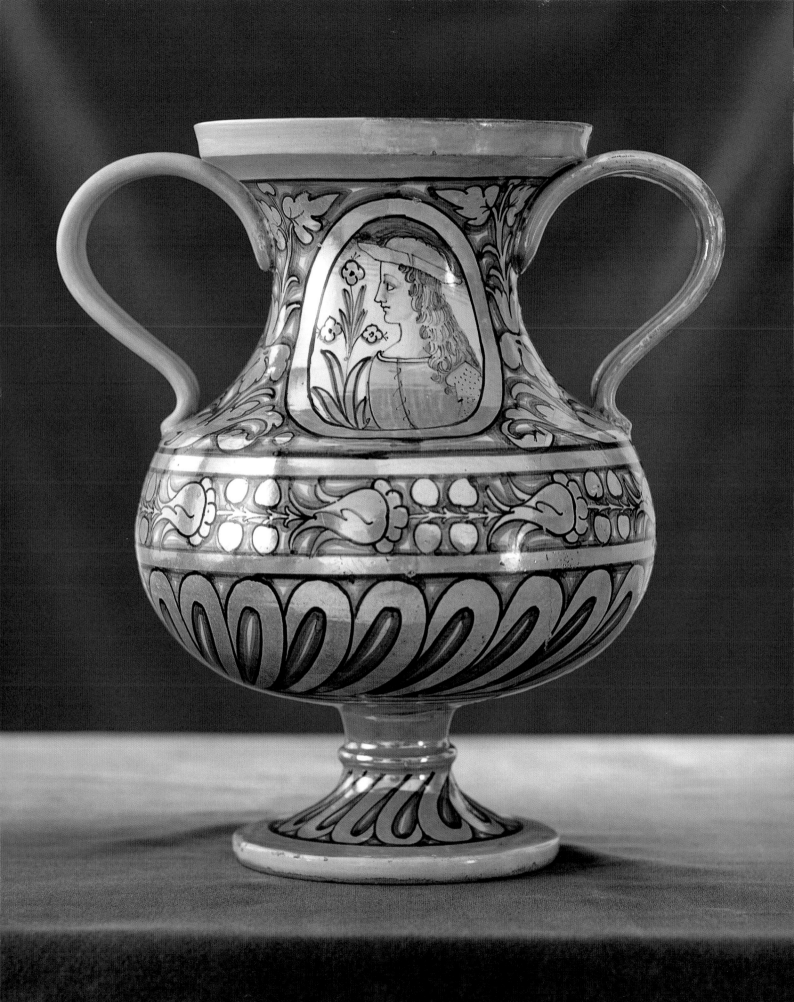

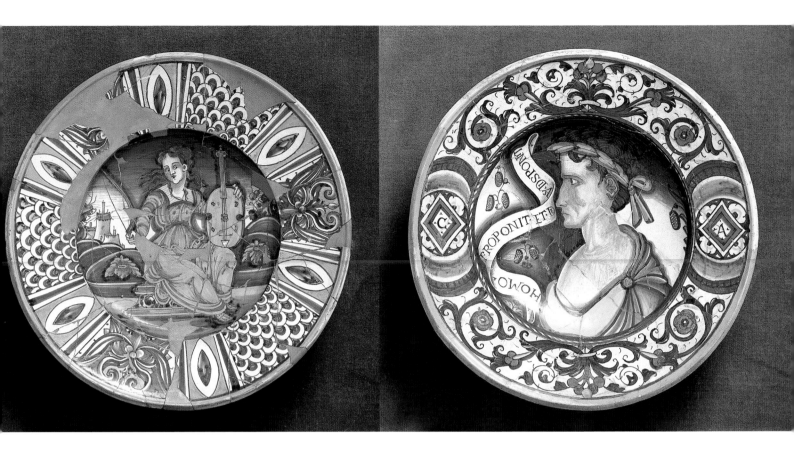

be lustred, three more steps were needed. The brassy yellow lustre glaze, which was formed of a silver oxide, was applied atop the already-fired first coat of polychrome glazes.

The piece was then placed in the kiln for a third and final firing. This last baking was the most difficult, much harder to control than the previous two. If anything went wrong and the work was ruined, it was costly at this point, since so much effort had already gone into the piece. For the lustre glaze to be effective, the temperature within the kiln had to rise quickly, which was achieved by the introduction of brushwood to the fuel. The chamber temperature would increase and the resinous fuel — Piccolpasso suggests using Spanish broom — would give off a dense smoke within the kiln. In fact, Piccolpasso recommended the construction of a special type of kiln, with an internal perforated cylinder to allow the smoke to circulate. At this point, if all went well, magic occurred. The carbon of the smoke would unite with the salts in the metallic pigments, leaving behind a thin coating of either silver (for yellow lustre) or copper (for red lustre, less popular in Deruta). Once cooled off, the pieces were carefully polished with a cloth, to bring up the iridescent metallic shine that characterizes lustreware.

Left: The seated woman playing a violin was an allegory of Music and is the central image to this large display plate. which would have been used as a decorative element in a sixteenth-century home.

Center: Idealized portraits of historic figures. such as Caesar. were often the subject

The difficulty in mastering this complicated technique is proven by the number of "test" shards that have been found. These fragments would be haphazardly brushed with the lustre pigments and then fired, to ascertain correct kiln temperatures and glaze mixtures.

The enormous popularity of lustreware was the result of several general developments in Italy. By 1500, ceramic ware had become the tableware of choice. Although metal and wood were common in the preceding centuries, the attractions of glistening glazed ware over precious metals quickly became obvious. A decorated ceramic dish offered a less costly alternative to a gold or silver platter, and one which the newly forming middle class would choose over the more common

of display plates, meant to reflect the owner's interests and pretensions.

Right: A typical border decoration on a plate was accomplished by dividing the band into separate compartments, with alternating areas of geometric designs and stylized foliage.

roughly painted terra-cotta and wood. The richer class chose tin-glazed ware over silver and gold, since these precious metals could be better invested elsewhere. There was also a growing opinion that things just tasted better when served from these glistening surfaces, which appeared more "hygienic" than the tarnished metals.

Besides shifting to a different type of tableware, the upper classes now needed many more pieces to see them through a typical repast. Previously, meals were simply presented, with the main course held in a large, usually wooden platter, from which each guest could help himself. At the most, each person had a small wooden bowl and possibly a knife. By the Renaissance, dining customs had changed: Meals had become more of an event, especially at the royal and papal courts. In the Middle Ages, the main difference in the dining habits of the classes was in the quantity of food consumed; during the Renaissance, it was the quality and variety. Meals became long, elaborately staged affairs, with the "services," or dishes, playing a major role.

As the variety of dishes increased, so did the number of courses presented. By the mid-sixteenth century, large services of two hundred to four hundred pieces were being commissioned for these epicurean

extravaganzas. The concept of tableware sets, or services, was born in these years, with specific plates produced for specific uses. One bowl per guest was now unheard-of.

It would be easy to concentrate on dinnerware, since today that is what springs to mind when the word *majolica* is spoken. Yet the sixteenth century saw the rise of a whole new class of painted ceramics that filled other needs as well. One of the best-known developments, especially in Deruta, was the *piatto da pompa,* or display plate. The name explains its usage: these large, heavy plates were meant to be displayed. Earlier, a bowl or plate's shape was based on its intended use, and decorated merely for pleasure. Now a different impetus was in place. New

forms were being developed with the idea of enhancing the painted decoration for its own sake. These new display plates were quite large, up to forty centimeters in diameter, and had a wide, flat rim that acted as a frame to the central image. The plates were often decorated only on the front, with a transparent lead glaze on the back. The foot ring usually had two small holes, through which would be strung a wire to hang the plate from the wall.

A typical plate had a broad border, divided into compartments, which were

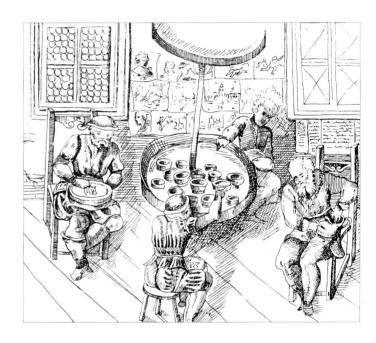

then decorated. Stylized scales and flowers were often separated by radiating bands. Executed in polychrome as well as lustre, these large plates were a type of status symbol, and would be displayed prominently within the home. (Sadly, no illustrations of Renaissance interiors showing the disposition of these plates have survived.) Display plates were usually given as gifts at major events such as births, betrothals, and weddings, and the subjects often reflected these occasions. This type of plate was very popular in Deruta and dominated the market in the first half of the sixteenth century, even when other types of decoration were making inroads elsewhere in Italy.

The subjects chosen were predictably high-minded. Since the plates were meant to be a public reflection of the owners pretensions and interests, topics included historical references or allegories that had special

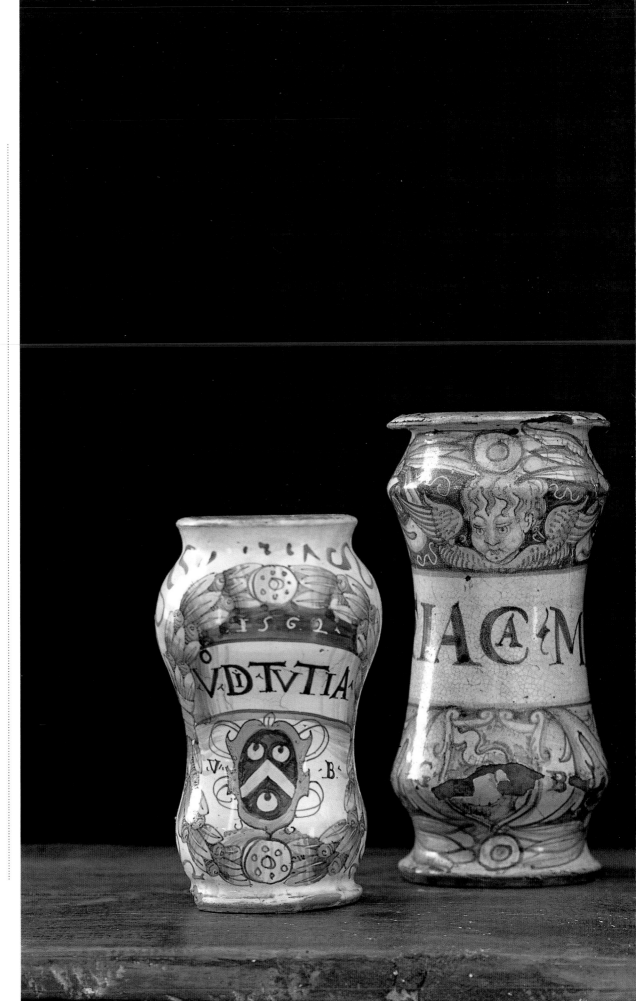

Right: Apothecary jars and jugs were used by pharmacists to hold medicinal concoctions. The jar on the left bears the coat of arms of the Picollomini family below the label *"Vo.Di Tutia,"* which was a Latin abbreviation for a common ointment used for eye maladies. The central jar is attributed to the "Master of the Pavement of St. Francis" and is decorated with a garland of stylized fruit and leaves flanking a forcefully drawn head. The spouted jar on the right stored a syrup or liquid derived from endive.

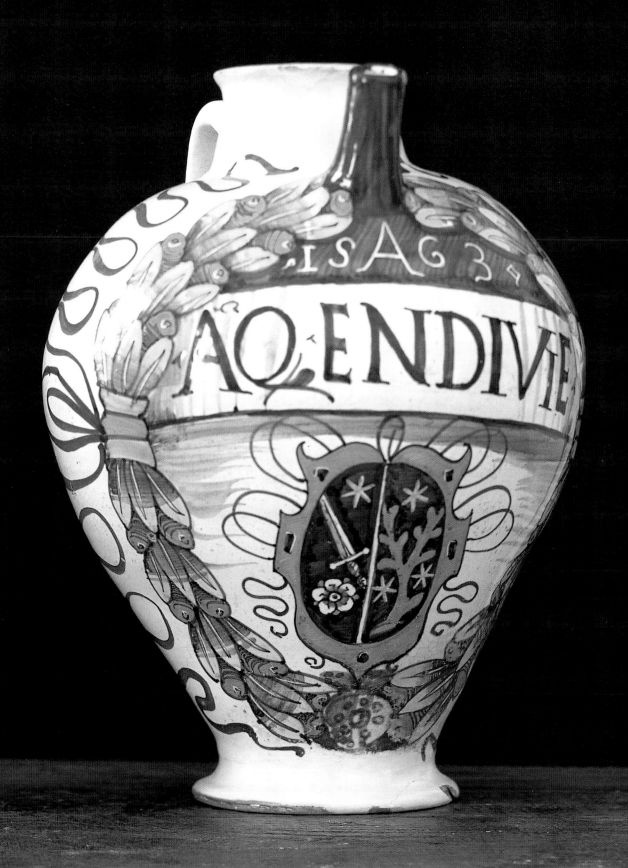

Left: Many minor decorative patterns were adapted from frescoes. The blue stylized vine is similar to those in paintings by Perugino in nearby Perugia.

Right: Decorative details from Perugino's frescoes in the Cambio, or Money Changer's Guild Hall, in Perugia were a nearby source of inspiration for Derutan potters.

relevance to the owner, as well as religious and moral themes. San Francesco, the patron saint of nearby Assisi, was a particular favorite, and large display plates with the saint's image were created for pilgrims. Another specialty of Deruta were the so-called *Belle*. These plates featured profile busts of beautiful women with "Bella" or "Bella Pulita" inscribed in a cartouch. These were not portraits, but symbols of an idealized beauty that were then given in homage to fiancée or lover.

Apothecary jars were also produced in great numbers throughout the sixteenth century in Deruta. Intended to hold spices, drugs, or syrups, these containers were in great demand. During the previous century, the wealth and importance of hospitals had grown immensely and the most important public service they provided was the administration of pharmacies, where one would consult a doctor about illnesses and, hopefully, receive some form of medication. The result was the need for great sets of jars to store the various concoctions. Due to the public nature of these businesses, the containers became quite elaborate.

Also common were the *deschi di parto* or parturition services, sets of dishes given to pregnant women. These elaborate gifts often included up to nine pieces, each with a specific function, such as holding broth for the recuperating mother and first foods for the infant.

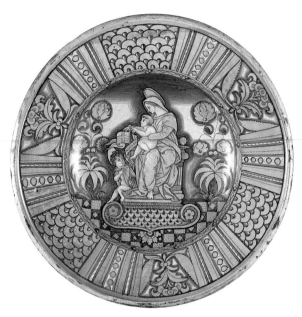

Many of the laws passed during this period reflect Deruta's wealth and increasing civility. It was decided that in time of surplus, grain would be stored and given to the needy. A fish market would be held once a week, and on the Feast Day of San Rocco and San Romano, the city would be orderly and clean. On holidays, the taverns would not serve wine, nor would butchers be allowed to sell their produce in the piazza. There was also much restoration of public monuments, including the bell tower and the fountains. The Via della Posta is a testament to the installation of an efficient postal system started at the end of the century.

Although a wealth of pieces survive from the sixteenth century, it is difficult to know exactly how the workshops functioned. It is likely that each studio kept a number of display plates in stock, ready to be sold at fairs and religious festivals. They may also have had a number of prototypes on display, from which finished plates could be ordered. Some plates may have been left half finished, so that the purchaser could choose a personalized inscription. How much influence the designer or the patron had in choosing subjects or images is difficult to determine, since Piccolpasso writes very little about this.

With the wide availability and relative affordability of prints, the designers had a wealth of images at their disposal. They also probably had access to preparatory drawings for larger frescoes. It is easy to imagine

Left: The image of the Madonna and Child was copied from Alfani's fresco and translated onto a display plate using a combination of blue and lustre glazes.

Lower left: The Madonna and Child Seated between Saints Francesco and Bernardino, a fresco, was executed in the sixteenth century by Domenico Alfani for the Church of San Francesco in Deruta.

Pinturicchio, whose wife was the daughter of a Derutan potter, giving such cartoons to his father-in-law. Another source of imagery were the frescoes themselves. Perugia was not far away, and those that Perugino had painted in the Cambio were a constant inspiration. Although figure types, such as female profiles, were commonly emulated, even small decorative details found their way into the potters' vocabulary.

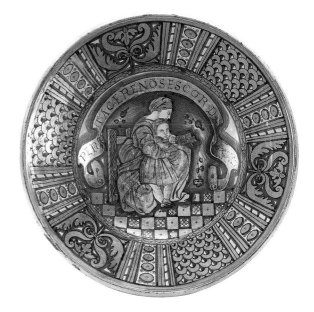

A plate now in Faenza, Italy, shows how common it must have been to take an image from a locally known work of art and transfer it into ceramic. As Carola Fiocco and Gabriella Gherardi have pointed out in their book, *Deruta Pottery,* this plate takes as its inspiration Domenico Alfani's fresco for the Church of San Francesco in Deruta. Similarly, a plate now in Museé de la Renaissance in France depicts the Madonna teaching Baby Jesus to read. The source for this image, according to Fiocco and Gherardi, is a sixteenth-century engraving, itself based upon a drawing by Raphael. The translation of these prints into ceramics brought even the art of Raphael within the reach of anyone who could afford to buy a plate.

While large, prestigious pieces, such as display plates, were an important part of production, there was another level of commerce. Smaller pieces, such as cups, saucers, bowls, and plates, continued to be produced on a large scale. Geometric and vegetal designs, as well as allegorical subjects, were common. New forms included elegantly shaped two-handled vases, and smaller pieces such as inkwells and saltcellars. The pieces that have

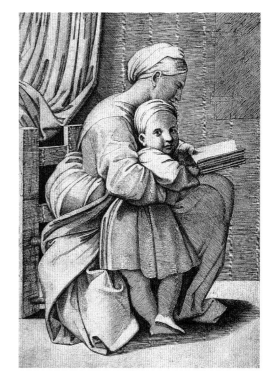

Right: The central image of this plate was taken from a popular print by Marco Dente. A typical conceit of Derutan painters was the addition of the checkerboard floor, creating a two-dimensional effect in keeping with the unshaded lustre glaze.

Lower right: A sixteenth-century engraving of the *Madonna Teaching Baby Jesus to Read* is based on a drawing by Raphael.

survived and are preserved in museums provide a deceptive overview of production. The everyday pieces were produced to be used, and used they were until they wore out and were thrown away. The more costly pieces were always prized and carefully treated. The result is that the "rare" pieces are more often preserved than "common" pieces, which were certainly produced in greater numbers.

A great variety of exquisite designs were quite popular in Deruta. *Bianco sopra Bianco,* or White on White, an extremely beautiful and delicate pattern, does show up in other areas of Italy, but some variants are specific to Deruta. A local lace-making tradition may have been the inspiration of certain patterns. In Deruta, the White on White is often paired with a deep blue border, which emphasizes the subtle patterns of the lacy design. Another common pattern is the *Corona di Spina* or Crown of Thorns, usually executed in a rich emerald green. The abstract design echoes the earlier vegetal patterns of the past centuries. In this design vines twine themselves around the borders of small plates, forming a frame to a central image.

These small-scale pieces are the most familiar product of this craft, since they survived in great numbers. There was another, more architectural, element to ceramics. In fact, the insertion of ceramics into the tradition of architecture has a long history in Italy. Some of the oldest pieces of imported Spanish lustreware are those preserved as *bacini,* or plates, on the facades and bell towers of Romanesque churches. In the sixteenth century, the majolica-tiled floor becomes an innovative decorative element.

It is pure luck that one of the most important works from the beginning of the sixteenth century in Deruta has survived, albeit in poor condition. The pavement of the Church of San Francesco was commissioned

Left: The almost caricature-like features of this female profile were meant to be understood as an idealization of beauty.

Right: Corona di Spina, or Crown of Thorns, was a common pattern in Deruta, used to embellish the borders of plates, such as these.

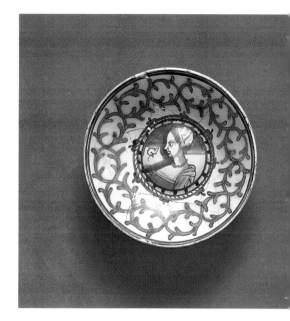

by the company of the Rosary, or Death, a lay fraternity involved with church activities. The company originally commissioned the floor in 1524 for their headquarters in Deruta's Church of Sant' Angelo. When it transferred its seat to the Church of San Francesco, the members took the tiles with them and had them reinstalled. By 1652, the pavement was in such disrepair that it was replaced. Rather than simply throwing this masterpiece in the bin, the builder decided to use this incredible work of art as the rubble base for the new flooring. And there it lay, buried and undisturbed, until its discovery in 1902.

Although chipped, broken, and almost destroyed, enough of the tiles survive to reveal the importance of the original work. Most notable are the shapes of the individual tiles. The main tiles are eight-pointed stars, with cross-shaped tiles inserted between them. Although this complex pattern is rare in Italy, it was quite common in the Islamic Persian tradition of Spain, the same source of the lustre technique. The overall color scheme of the tiles is cold, a mixture of yellows and blues, that echoes the lustre palette.

Because the tiles that survive are broken and out of their original order, the iconography remains obscure. The main tiles have images of allegories, mythological figures, the cardinal virtues, and the liberal arts. The complicated theme was probably connected to a form of humanism that lent these secular subjects a sacred connotation within the church setting. The tiles, although executed by several different hands, show a uniformity of style that characterized one studio, that of the Mancini family. Other works have been identified in the same style and are usually grouped as being by the "Master of the Pavement of St. Francis."

The graphic sources for the floor, which have been studied in detail by Fiocco and Gherardi in their book, include prints and engravings, but this master did not copy an entire composition. Instead, he picked and

Above Left: A delicate White on White pattern was usually paired with a brilliant blue frame around the rim. The pattern may have reflected a local lace-making tradition.

Right: The Pavement of the Church of San Francesco was one of the masterpieces of sixteenth-century Deruta. Even though they are damaged, the tiles remain one of the centerpieces of the local museum's collection.

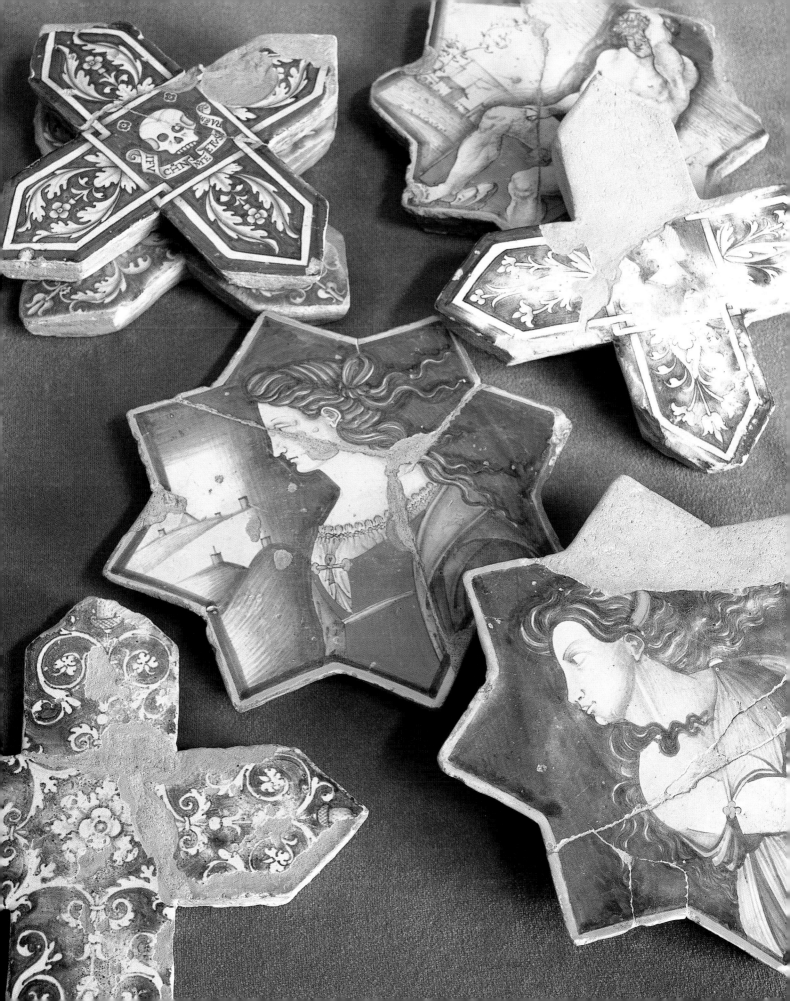

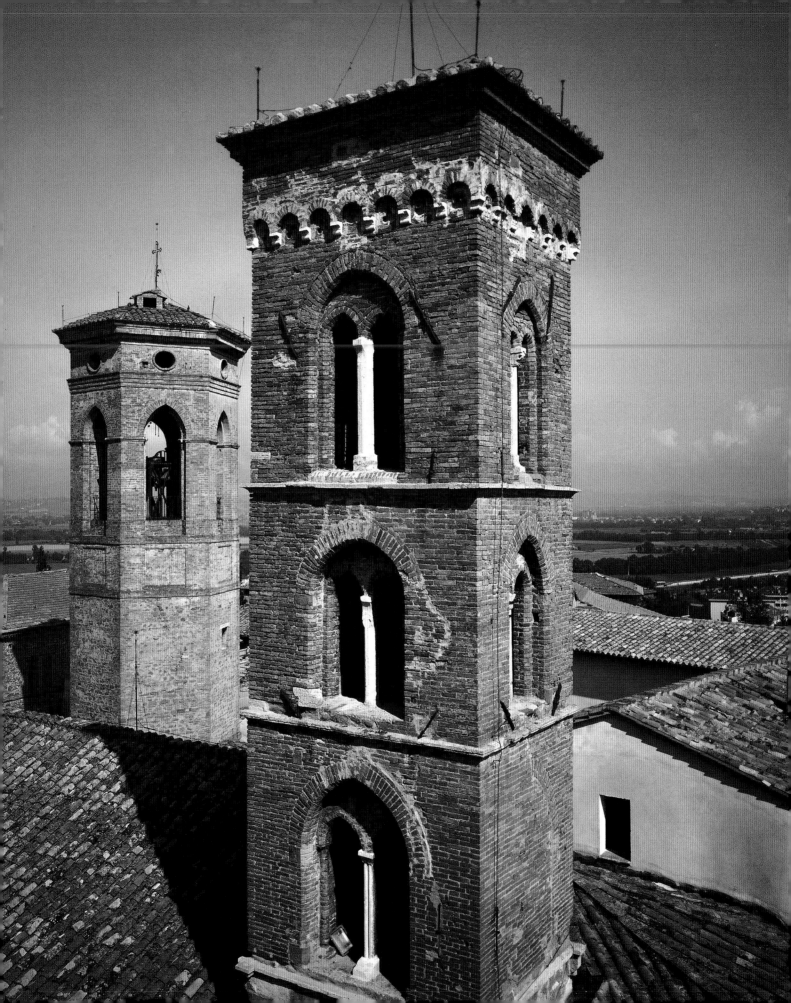

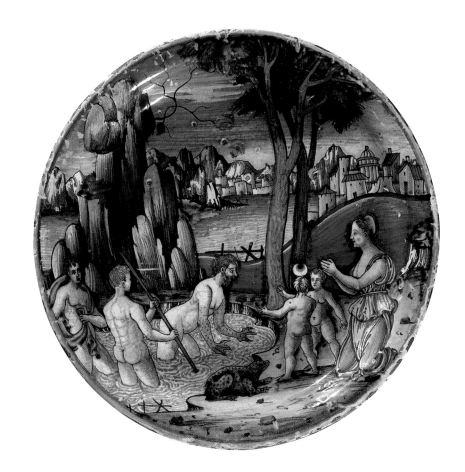

Left: The towers of the Church of San Francesco in Deruta, built in the Middle Ages, still dominate the small town's skyline. The Pavement of the Church of San Francesco and Perugino's fresco of San Rocco and San Romano were originally located in the church. Many works of art, including Alfani's fresco of the Madonna and Child, are still in situ.

Right: Mancini's plates are among the few examples of a Derutan historiated style. In *Lantona Changing the Villagers into Frogs* he has translated an illustration from Ovid's *Metamorphoses* into ceramics.

chose his figures as he needed them. He would often "cut out" a figure from a composition and insert it into a typically Umbrian landscape, giving it different attributes and transforming it to suit his needs.

Derutan potters rarely copied entire compositions, even though in centers such as Urbino, the *istoriato*, or historiated technique, became quite popular. The artists' intentions with the historiated technique were completely different. They would try to copy exactly the compositions of greater artists that were reproduced in prints and engravings. In the nineteenth century, this kind of ceramic work came to be known as "Raphael ware" for its similarity to the famed artist's paintings.

One reason this technique was not common in Deruta may be that the nature of the lustre glaze was not effective in portraying spatial depth. Its shiny reflective quality lent a distinctly two-dimensional feeling to any composition. Another reason may be that the display plates being produced were extremely popular. They had a good hold on this market and saw no reason to risk producing another costly type of work.

One potter from Deruta did venture into the field of historiated ceramics; in fact, he is also the only Derutan to have signed his works in this period. A group of plates dated from 1541 to 1545 bear the signature

"El Frate," otherwise known as Giacomo Mancini. The elaborately painted plates reproduce scenes from illustrated texts, including Ovid's *Metamorphoses* and a 1542 copy of Ariosto's *Orlando Furioso*.

The name Mancini has long been recognized as one of the most successful families in Deruta in the sixteenth century. (It may be from their studio that the Pavement of San Francesco originates.) It is possible that Giacomo Mancini learned the technique from a traveling craftsman. Francesco Urbini, a ceramic master from the town of Urbino, was part of a tradition of traveling craftsmen. Going from town to town, these artisans would set up work in a local studio both to teach and to learn. In 1537, Urbini signed a plate in Deruta. It could be partly from his influence that Giacomo began his famous series of plates.

A later work shows El Frate working in a much different mode. The Pavement of the Baglioni Chapel, in the Church of Santa Maria Maggiore in Spello has richly decorated tiles with patterns that spill from one tile to the next, creating a carpetlike effect. The colors are vibrant and intense, and the motifs of the opulent design include winged cherubs and horses, and genies blowing trumpets, all surrounding a central candelabra.

This style is much different than that of El Frate's plates. The looser, almost caricatural drawing may be partly due to the greater scale, but it also reflects part of a general trend in Deruta in the latter part of the sixteenth century. Brush strokes were becoming looser and quicker, and designs more expressive. Fewer and fewer display plates and prestige pieces were being produced. The market, though always strong, was changing. The audience for Derutan ware was becoming more general, with an increased number of works being sold at markets and fairs. The patterns that are developed at this time, the *Compendious, Calligraphic,* and *Raffaellesco,* reflect this new audience and will eventually take over and dominate during the next century.

Left: Giacomo Mancini, otherwise known as El Frate, was one of the few painters in Deruta to sign his work. The reverse of his plates are a wealth of information, often including references to the written source of his image.

Right: The large set of tiles was commissioned from Giacomo Mancini for the Church of Santa Maria Maggiore in Spello. Originally located beneath the main altar, it was later moved to a side chapel, where it remains today.

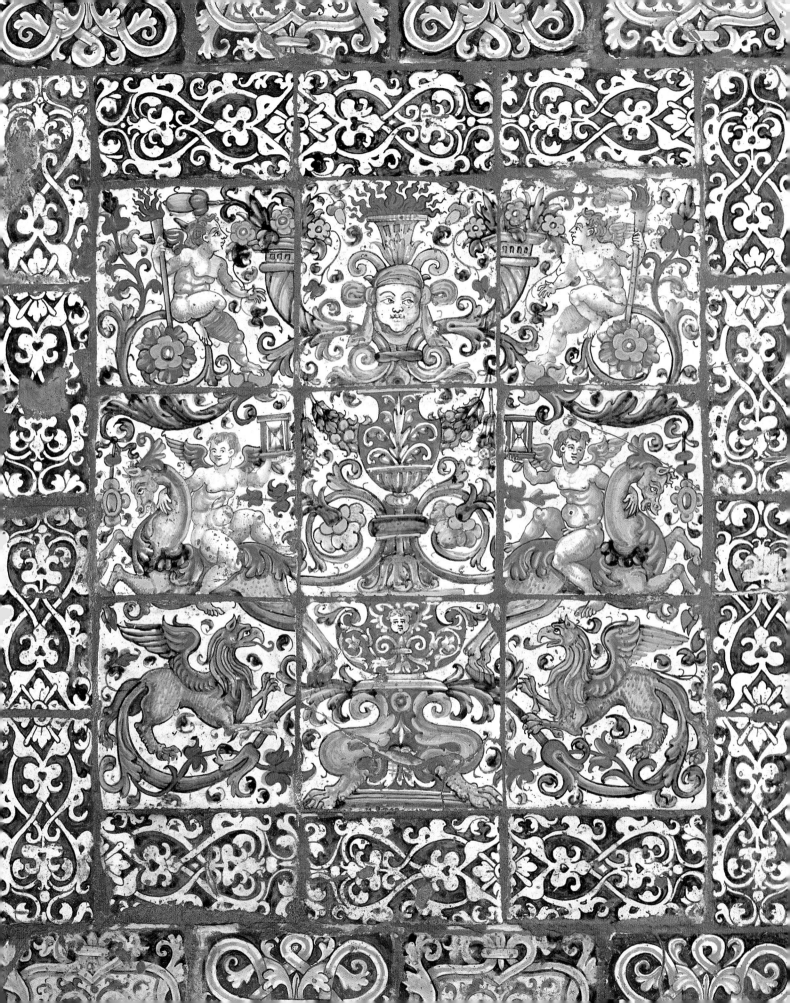

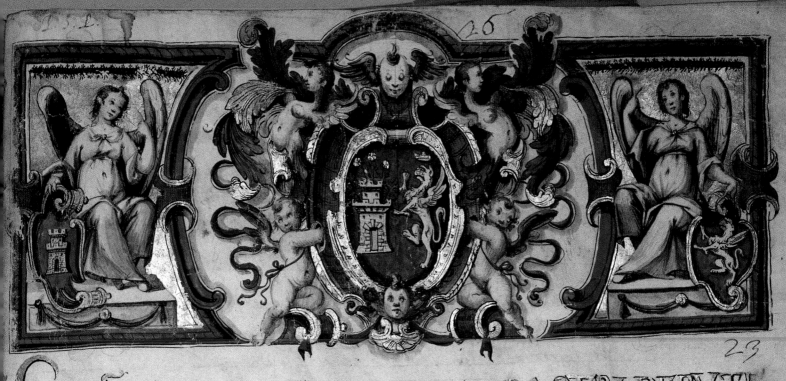

COMVNITAS ET HOMINES CASTRI DERVTI

comunis Aug.te civitatis Perusij P. S. P. allibrati et accepti ob in libro micat. ne
teris fol.° cognoscit habere tenere possidere infrascripta bona stabilia Vi3
Unu tenimentu3 de terris laboratinis arboratu3 vij in tenuta dict.° in Vilson
ticello fines cuius à tribus bona Dñi Bartolomei de Ludovicis et Perusio de
getis in dc.° et ab alio strata Romana usq. ad ceminas fumedi ad mensuram
eminas quinq. ad iustam mensura3 comis Perusij extimata3 libris octingentis.

℟. VIIJ.

ꝗ aliud tenimentu3 terre arboriu3 masq. ad ceminas fumeg. arborata3 Perusia
Castri poni3 in tenuta dict.° in V.° fines cuius ab uno strata Romana ob alio
alium strat. dc.° ba via del isola ob aliis bona ecc. S. Salvatoris dc.° ab aliis bona
heredu Joannis Corbi de code ab bona Dñi Cleçsi Adriani et prinat ab bona Dñi Heron
dñi de menicomibus q. Perusia ad mensura3 eminas quindecim ed dimi
dia ad iustas mensu3 comis Perusij extimata3 libris trib3 mille

V. M. M. M.

ꝗ aliu3 peti. terre arboriu3 arborati ponis in tenuta dict.° in V. il fosso della porta
del cerro fines cuius ab uno strat. ab aliis bona Dñi Alberti de cicionis et Peru

1503 die 4 Junij comp. P. P. Jo. ma
do machie...h clum berqu
...nij d. Corsi, io gariq...
le... io grande... P. d. Cor
...on...hide...alle... bona que
infra do... Rodrica? dc...

ꝗ MCCCXCIX ꝗ...
...
ꝗ MCCCCVIIJ ꝗ XV
ꝗ MCCCCXXXX ob XII ꝗ H
ꝗ MCDLXVIJ XII ꝗ H

ꝗ MCDLXVIJ ꝗ...

Continuation, Decadence, and Rebirth

By 1600, Deruta, like the rest of Umbria, was experiencing a period of relative peace. After years of fighting to remain independent, Deruta was finally subsumed into the Church's property. As part of the papal state, the only skirmish to disturb its tranquillity occurred in 1643, when Odoardo Farnese, the duke of Parma and Piacenza, passed by on his way to lay claim to a duchy in Lazio. Deruta defended itself admirably and remained unscathed. For the rest of the century, the protection of the papal forces guaranteed a level of equanimity.

Left: After many revisions over the years the heraldic symbol of Deruta had become quite elaborate by the seventeenth century. This page is from a record book preserved in the archives in Perugia and features the town's coat of arms: a fortified tower with the medicinal plant *ruta* springing from its ramparts. flanked by a griffin.

This adherence to the papal state did not come without a price. Throughout the previous century, taxes had doubled several times and Umbrians were pouring large amounts of money into the pope's coffers. And not only money was wending its way south, for with the Church's consolidation of power in Rome, talent also began to gravitate there. In fact, the sixteenth century saw the beginnings of three hundred years of economic and cultural stagnation in Umbria.

Deruta was not immune to these developments, but its strong ceramic industry did not disappear overnight. During the seventeenth century, production, at least in terms of quantity, remained stable. In terms of quality, the influence of the political and economic situation was beginning to make itself felt. While in the previous century Deruta had produced works of art that are still considered masterpieces, the seventeenth century spoke a language that did not always include *masterpiece* in its vocabulary. The seeds of most developments in ceramics in Deruta at this time had been sown in the preceding century. The intense creative impulses of the Renaissance gave way to a looser and more popular set of aesthetics, more in keeping with the changing, localized market.

The *Compendiaria* or Compendious style, which dominated the seventeenth century, did not originate in Deruta, but in Faenza, a pottery center to the north. The style differs completely from the heavily decorated Renaissance designs. During the Renaissance, the decorative language tended toward naturalism, and included a varied palette of colors. In the Compendious style, rapid and sketchy outlines were used to create small, almost cartoonlike figures.

The Compendious style also tended to use a limited palette of one or two colors, with the result that the white background was emphasized. With more space given over to the milky white base, the decoration in the

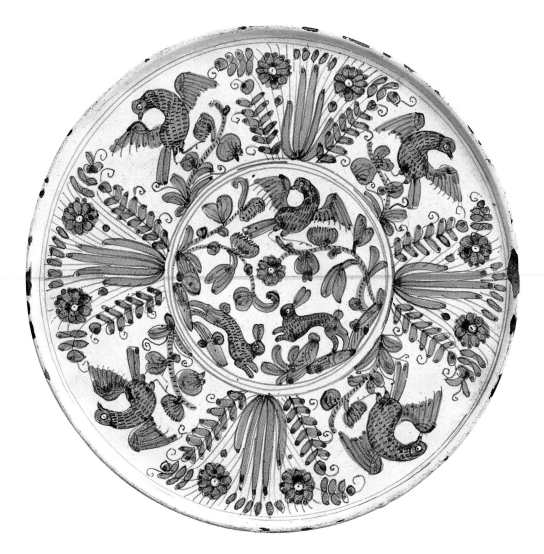

center of a plate or bowl becomes a small fraction of the overall composition. As the amount of white increased, so too did the demand for a white of the purest snowy brilliance.

Two other patterns that became popular at this time differ completely from this style. While the Compendious is all light and air, the *Raffaellesco* and *Calligrafica*, or Raphaelesque and Calligraphic, represent an almost *horror vacui* approach to ceramic design. The term *Raphaelesque* derives from the name of one of the stars of the High Renaissance — Raphael. During the early part of the sixteenth century, Raphael and his workshop painted a series of frescoes decorating a loggia in the Vatican, and some of its main decorative motifs were grotesques: fantastic compositions combining plants, animals, and humans. The main inspiration for this type of decoration was a series of ancient Roman frescoes that had recently been excavated. Because the frescoes appeared to adorn the walls of caves, *grotte,* the term for these compositions became *groteschi,* or grotesques.

Left: Plants, birds, and rabbits decorate the plate in a limited palette of blue and white, echoing the color scheme of Chinese porcelain. The pattern is called Calligraphic, and was probably derived from Chinese textiles and rugs.

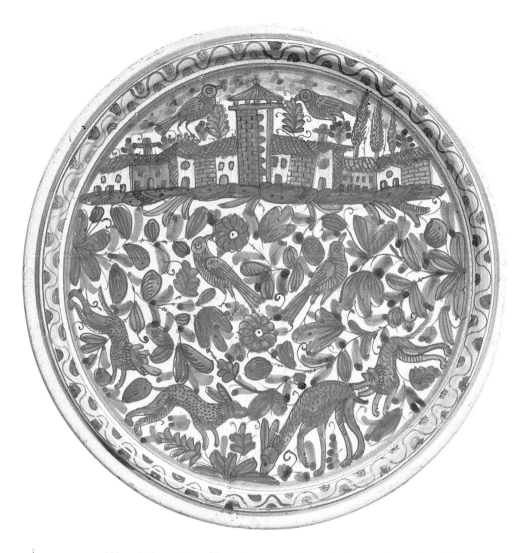

Right: Variations on the Calligraphic pattern included different color combinations, the most common of which was a yellowish orange paired with a light blue. The carpetlike pattern here gives way to a fortified cityscape.

Although the potters of Deruta may never have actually seen the works of Raphael, they were aware of them through prints. Umbrian artists like Perugino and Pinturicchio also executed numerous frescoes using this design in the nearby towns of Spoleto and Perugia.

In fresco painting and relief sculpture, the grotesque motifs were used as a rich and varied backdrop to the main subject. In pottery, this motif took on a life of its own, becoming the main vehicle of expressive content. Since no "main" subject was usually included, the designers were free to cover every available square inch with fantastic figures. Even when there was a central scene, it was usually relegated to a smaller portion of the overall design.

The Calligraphic had a more exotic origin. Like the Raphaelesque, the thick pattern of leaves and animals completely covered the pieces. The intertwining vegetation was sometimes relieved by small, picturesque hunting

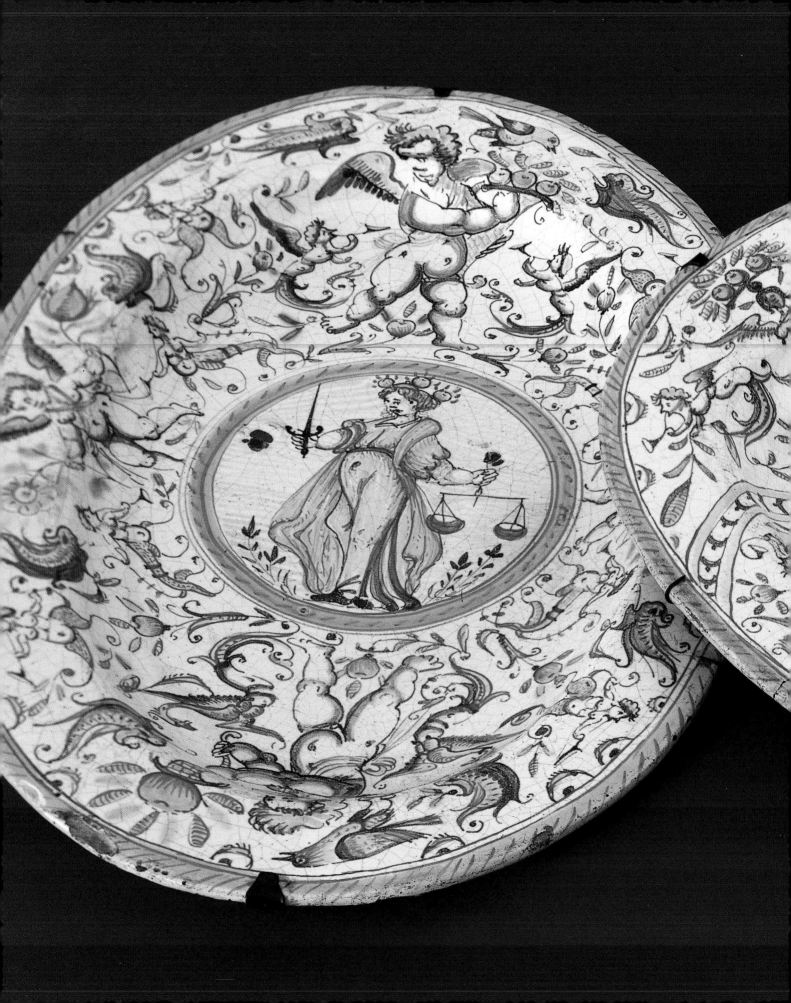

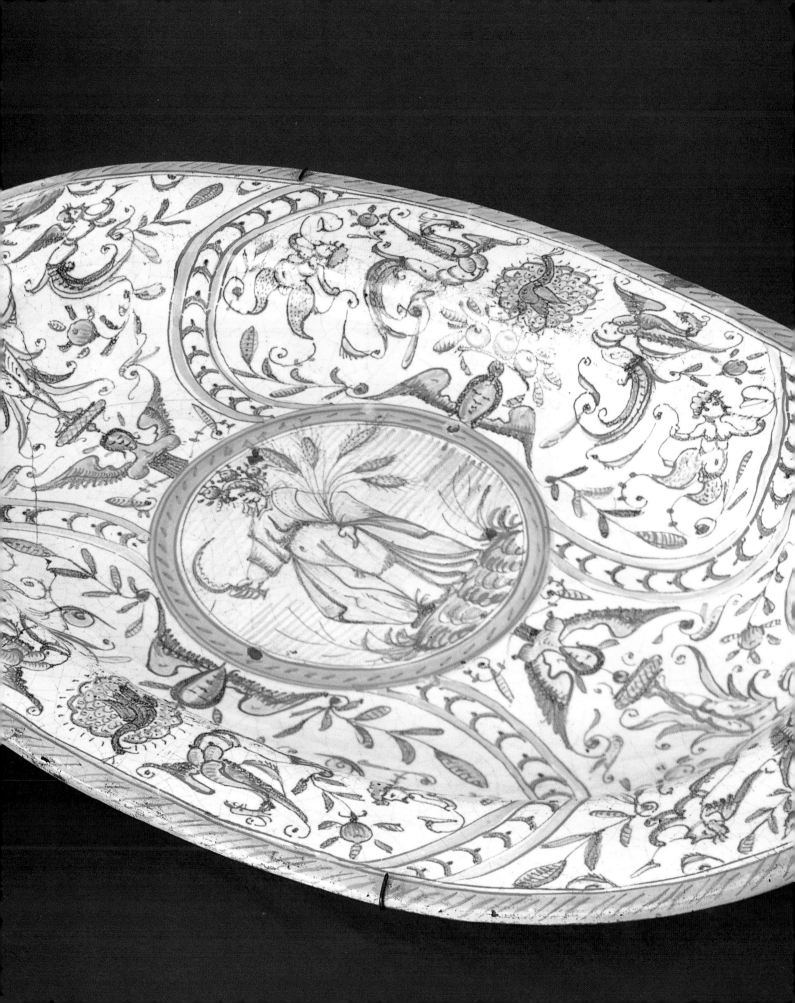

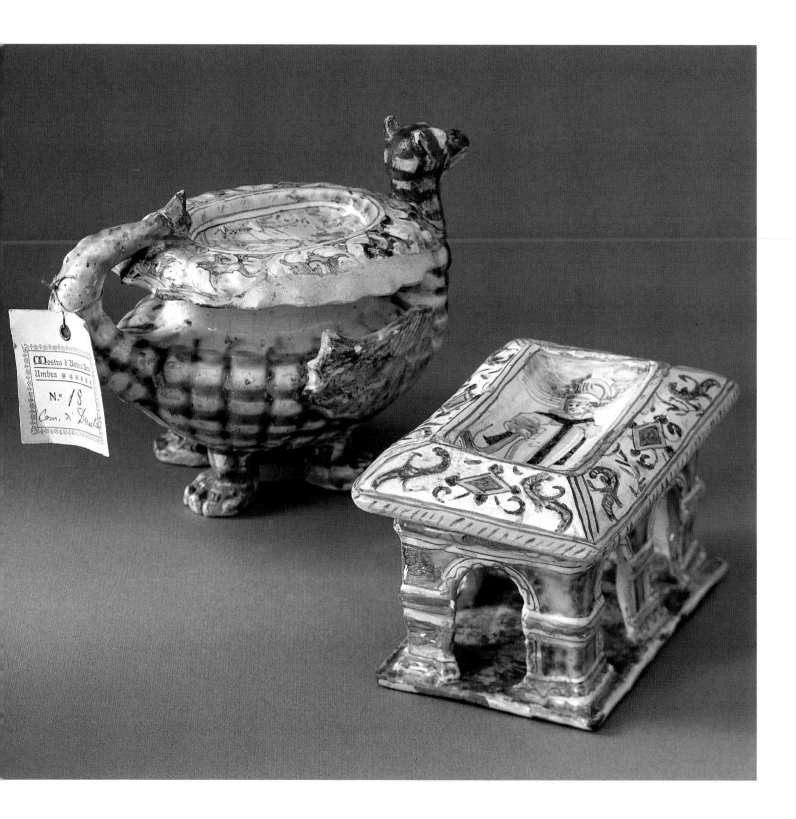

Preceding pages:
Griffins, peacocks, and
cherubs cover these two
oval platters in the
Raphaelesque pattern.
The central scenes,
relegated to a small por-
tion of the overall
design, are allegories of
Justice and Summer.

Left: In the
seventeenth century,
potters from Deruta
began to experiment
with new forms usually
reserved for other
media, such as metal
work. Salt, still an
expensive commodity,
was proudly displayed
within tabletop fantasies
such as this classical
temple and dragon.

Right: The composition,
derived from a print,
may have been
painted in celebration
of a wedding: it tells
the allegorical tale
of the god Hymen,
portrayed crowned
with flowers.

scenes or rudimentary cityscapes. The inspiration for this tapestrylike pattern seems to have been Eastern in origin and may have been derived from Chinese porcelain, or Middle Eastern interpretations of Chinese ware.

During the seventeenth century, new forms emerged and formerly popular shapes were left behind. The sixteenth-century *piatto di pompa*, or display plate, disappears by mid century. In their search for inspiration, designers began looking to other art forms and crafts. As they became more skilled, the potters were able to emulate the complex forms of metal work, which had a long tradition of tabletop objects. Centerpieces like saltcellars and footed dishes allowed the potters' imaginations to run wild. Dragons and classical buildings could be transformed, by an indentation at the top, into impressive containers for salt. Inkwells, usually made of bronze, became lighthearted excuses for fantastic forms and glazes. Even holy-water basins became more imaginative, with cherubs, Madonnas, and holy figures bursting from the surface.

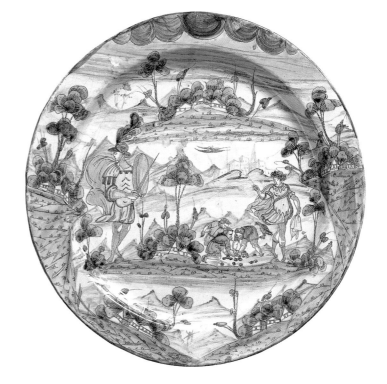

The historiated style, which had never really taken root, nevertheless continued into the seventeenth century. El Frate's heavy reliance on printed matter gives way to the looser and freer interpretations using the Compendious style. Although the original inspiration for these sketchy figures may have been a print, the composition gives full rein to the painter's imagination. Six small hamlets are scattered amid cartoonlike bushes, while the figures themselves appear to have no relationship to one another. There is still a raised border to the plate, but no attempt was made to differentiate it from the rest of the composition. The harmonious color scheme, with no one color predominating, is typical. Like the Calligraphic and the Raphaelesque, the decoration covers the whole piece.

Signed works were still a rarity in the seventeenth century. The Mancini family remained powerful, and Pietro Paolo Mancini is one of the few painters who did sign several of his pieces. But he was the prior of the local

Church of San Nicolò by profession and a potter only by hobby, so his work does not have relevance to general artistic developments.

Much more intriguing are the works of anonymous, professional designers. While these men never signed a piece, their styles can be identified and names that relate to their works have been given to them. In this way, we identify the "Master of the Fall of St. Paul" as well as the "Master of the Acteons." One of the greatest tools used to unravel the different styles and studios of this period in Deruta is the group of tiles located in the nearby Church of Madonna dei Bagni.

Left: Hundreds of brightly colored majolica plaques line the walls of the Church of Madonna dei Bagni.

Right: The brick Church of Madonna dei Bagni is located in a serene, isolated setting amid the forest, just outside Deruta.

The history of the church dates back to a fateful day in the early years of the seventeenth century. A traveler happened to stop at a spring in the woods to refresh himself with a cup of cool water. After sating his thirst, he left his cup behind. A few days later, a priest came across the abandoned cup. Since the decorative image within the bowl of the cup was a Madonna and Child, the priest positioned it in the crook of the branches of a nearby oak tree, thus creating an impromptu open-air shrine.

Over the years, the cup fell to earth many times and was eventually reduced to a fragment, but travelers continued to reposition it in its precarious niche. One day in 1657, Cristofano di Francesco was on his way from nearby Casalina to the fair at Deruta. Fed up with the constantly falling object of veneration, he took matters in hand and nailed the image firmly to the tree. In exchange for this favor, he asked the Madonna to intervene in the sickness of his invalid wife, whom he had left bedridden at home. The next day, upon his return from the market, he found his wife out of bed and in perfect health. Word of

this miraculous recovery soon spread, and it was not long before the site of the shrine became the focus of a new religious cult.

The merchant Cristofano was the first to thank the Madonna della Quercia (Madonna of the Oak Tree) or Madonna dei Bagni (Madonna of the Spring), as she came to be known. He commissioned a small ceramic plaque depicting his wife's recovery due to the Madonna's intervention. The small, brightly colored tile was then tacked up to the oak tree, where it was soon joined by others attesting to the powers of this humble image of Madonna and Child.

The tradition of creating a memento to commemorate a prayer answered is called ex-voto and is com-

mon in the Catholic religion. Churches throughout Italy are filled with these tokens of gratitude, which are placed at the altars of obliging saints and Madonnas. The unique aspect of the ex-votos of the Madonna dei Bagni is the medium used to create them: majolica. (The more common offering is a simple tin relief depicting the cured body part — a leg, a heart. Wealthier patrons commissioned oil paintings.) The Madonna dei Bagni appears to be the only church with such an extensive collection of majolica ex-votos.

These impromptu acts of reverence were codified in the official approbation of the cult in 1657 and the construction of the church in 1687. The walls of this modest building provide the most complete overview of ceramics in Deruta for the latter part of the seventeenth century and all of the eighteenth. More than six hundred ceramic votive plaques now cover the walls in a multicolored song of thanks. The original fragment of the cup is conserved in an ornate baroque frame behind the main altar.

The majority of the plaques, most of which are dated, are from the second half of the seventeenth century, when the cult was still young and enthusiasm was high. The two masters who stand out are the "Master of the Acteons" and the prosaically named "Master of the Snub-nosed Profiles."

Left: The care of domesticated animals presented a daily risk and animal attacks were a constant threat in this rural community, as shown in this tile.

The tiles are usually rectangular and many have a very well-drawn brick wall to define the space. The backgrounds are usually blue or yellow, and the style is always clear and easily understandable. Ex-votos continue to be commissioned up to the present day, and these simple tales of thanks document centuries of dangers and diseases that could befall one in this corner of the Italian countryside.

Ceramic production was high throughout the seventeenth century in Deruta. In 1655, the Pozzi workshop sold 4,965 pieces to the Abbey of San Pietro in Perugia, and in 1687, another workshop provided 4,925 pieces. Many of these were most likely for everyday use, such as tableware or kitchenware. Pots, pitchers, and jars used to prepare and store food were often either glazed internally to retain liquid, or decorated with the less-expensive transparent lead-based glazes. These cheaper pieces, when decorated in majolica, were done quickly, with a loose hand and little attention to detail. While production remained high, quality lagged. Many fragments survive in the Deruta museum, decorated with rapidly drawn saints, Madonnas, and cherubs.

Right: Most of the tiles date from the late 1600s, when the cult was in its infancy. But sporadic commissions trace a trail of perils over the centuries to the present day. The twentieth century, with the advent of mechanization, presents a whole new set of dangers.

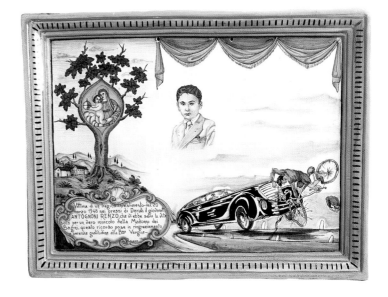

During the eighteenth century, however, the economic situation in Umbria sank deep into crisis, and manufacturers suffered from a lack of capital investment. Perugia and Orvieto were no longer centers of trade and commerce, and the great international fairs of the Middle Ages had become small local markets. In 1786, Goethe recorded his impressions of Umbria and compared its abject misery to wealthier Tuscany to the north.

While Umbria in general suffered, Deruta still managed to enact some urban improvements. The town fathers reorganized the town hall archives, restored the roads and the ancient hospital of San Giacomo, and refurbished their seats in the local parish church and reconstructed the fountain in the main square.

The potters of the eighteenth century were conservative, following the stylistic impulses of the preceding century, rarely venturing into new territory. Some pieces come close to expressing the rococo taste

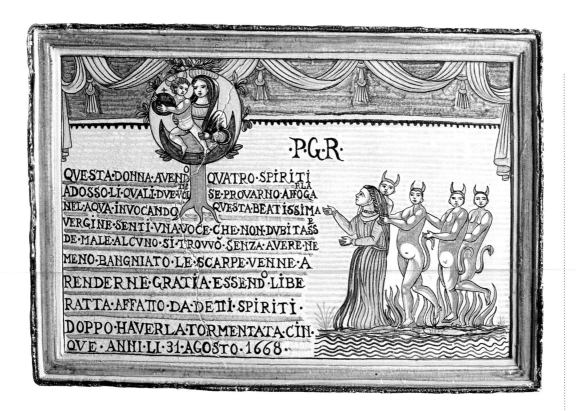

Left: Physical harm was not the only type of danger to be avoided. The spirit, easily possessed by the devil, had to be guarded as well.

Lower left: Lightning bolts become sinuous and seem to seek out the victims with their arrow-shaped tips.

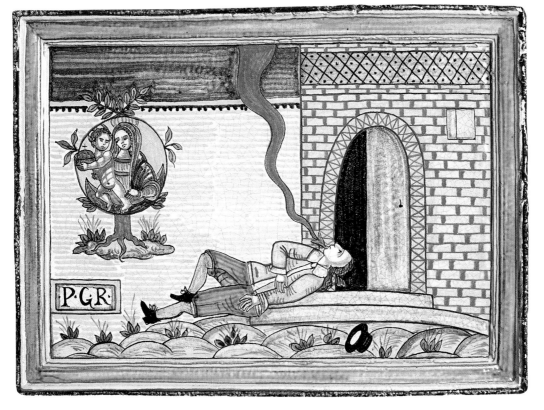

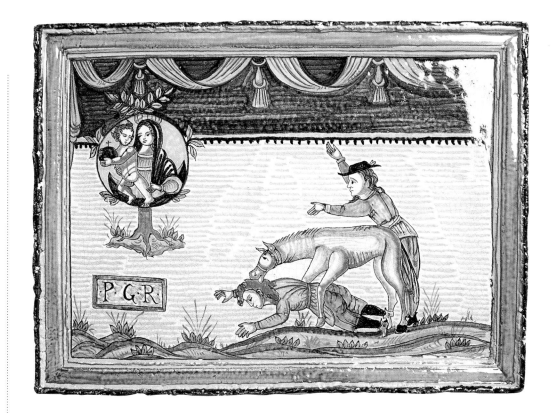

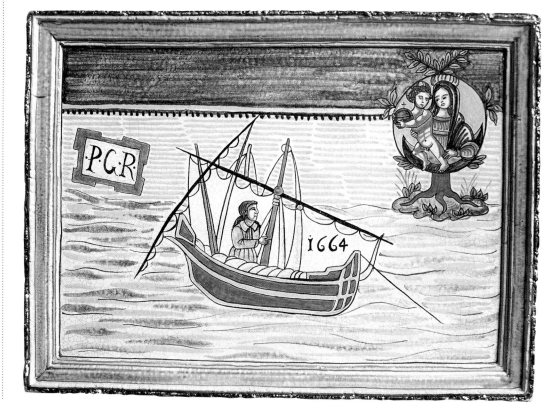

Right: The straight-forward representation of accidents, here a horse gone mad, have a stagelike composition, with tufts of crudely drawn grass representing a field.

Lower right: Shipwrecks were not common, since Umbria is landlocked, but sailors home from the sea must have thought it prudent to express their thanks.

prevalent in Europe at this time. The forms became slightly more elegant, attempting to echo in ceramics the lighter forms of the more popular porcelain ware. A repetitive abstract design often covered the entire piece, leaving a small cartouch free for the insertion of an idyllic scene or landscape.

One of the main figures in the second half of the eighteenth century in Deruta was Gregorio Caselli, who often signed his works. Although Caselli himself may not have been a potter, his factory was the most important of the period. Several pieces signed by Giò Meazzi, the leading painter in this firm, survive in the Deruta museum and attest to a rare but continuing high level of quality.

The set of tiles now in nearby Bettona also were probably produced by the Caselli factory (see pages 70-71). They were crafted to adorn a wall, perhaps the surrounding of an oven or sink in much the same way that a backsplash is used in contemporary kitchens. The small tiles are decorated with playful animals, plants, flowers, and tools, images that had been made popular through playing cards and board games of the period as well as through widely distributed prints used as patterns by embroiderers and lace makers.

Throughout the eighteenth and into the nineteenth century, production levels in Deruta began to decrease. Umbria's brief period under Napoleonic rule, and the eventual unification of Italy in 1861, did little to alleviate the general economic crisis in the region. The manufacture of ceramics in Deruta was particularly hard hit, because the market, already limited to local consumption, became smaller. The situation was exacerbated by competition from other ceramic centers in Italy, such as Castelli d'Abruzzo to the south. Still more competition came from the north, where several centers gained prominence with ceramic imitations of the increasingly popular porcelain.

However, even these centers were not immune to the advent of industrialization throughout Europe and the fierce competition of English earthenware. The ceramic industry up and down the peninsula was faltering, and Deruta, already suffering, reached its lowest ebb.

The few remaining factories continued to churn out a substantial quantity of work, but it was for everyday use and not of very high quality. This kitchenware, quickly dipped in a white glaze, was used until it was thrown away. However, there were events that would eventually lead to a rebirth in Deruta.

The second half of the nineteenth century saw a growing interest in Renaissance majolica throughout Europe, especially in France and England. Some of the great majolica collections in Paris and London (which still

Right: A small footed pitcher echoes the more refined shapes of porcelain, which was becoming increasingly popular throughout Europe. The turquoise dolphin-shaped handle balances along the slightly fluted edge, lending an elegance to the sober scale pattern that covers the body.

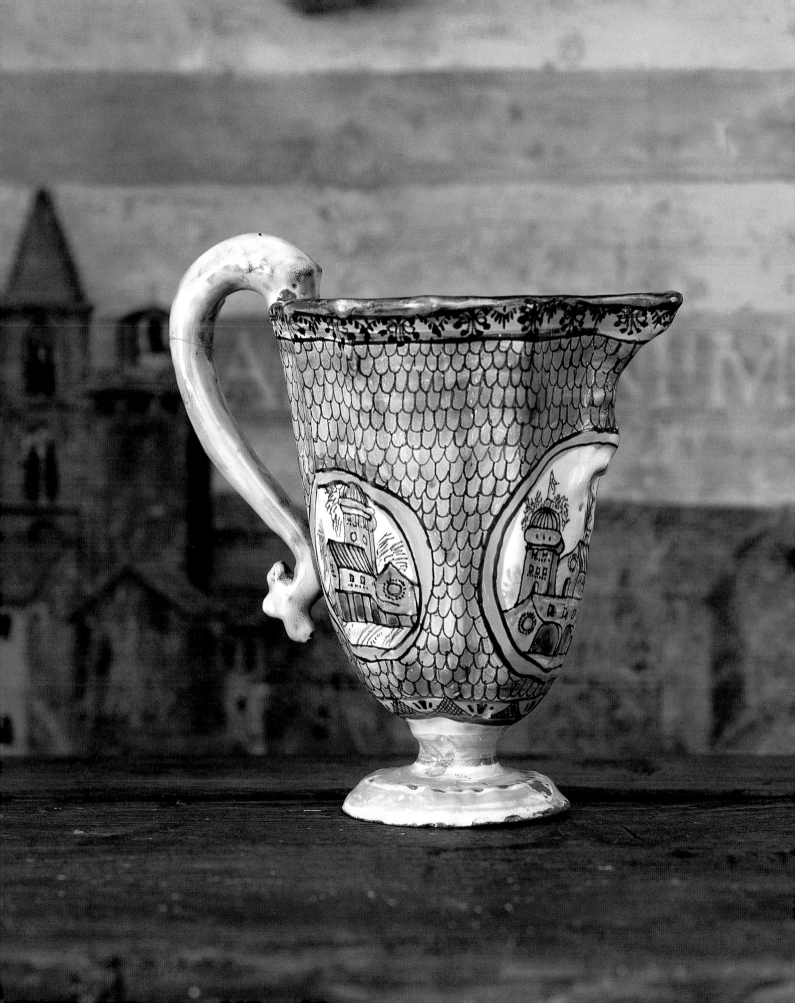

Left and right:
The subjects of this
lighthearted set of
decorative tiles were
probably copied from
playing cards or
lace-making templates
popular in the
eighteenth century.

exist today) were formed at this time. One of the largest, the Campana Collection, contained numerous Derutan masterpieces; it was acquired by the Louvre. The new South Kensington Museum in London (now the Victoria and Albert Museum) focused its collection on the decorative arts and formed the basis for one of the greatest majolica collections in the world. This commercial interest in antique majolica was accompanied by numerous studies by scholars and archaeologists, and some of the earliest scholarship dates from this time.

Derutans were beginning to realize that their nearly forgotten heritage was a precious commodity, not something to let slip away. The city council, in 1872, announced it would sponsor an Industrial Exhibit "for the encouragement and betterment of the making of majolica in the town." The town fathers acknowledged that the state of affairs in Deruta had sunk so low that it was impossible even to "place a student in a factory in the nearby area for the purpose of perfecting the art of pottery." There was no one left in Deruta to pass on the traditional techniques of this age-old craft. The fields of painting and design, which had brought fame and fortune to the small town in the not so distant past, were now a barren desert. The desperate need for some sort of qualification and teaching was clearly recognized, yet the artisans of Deruta had to wait until the first years of the next century to begin to take the first steps toward another Renaissance.

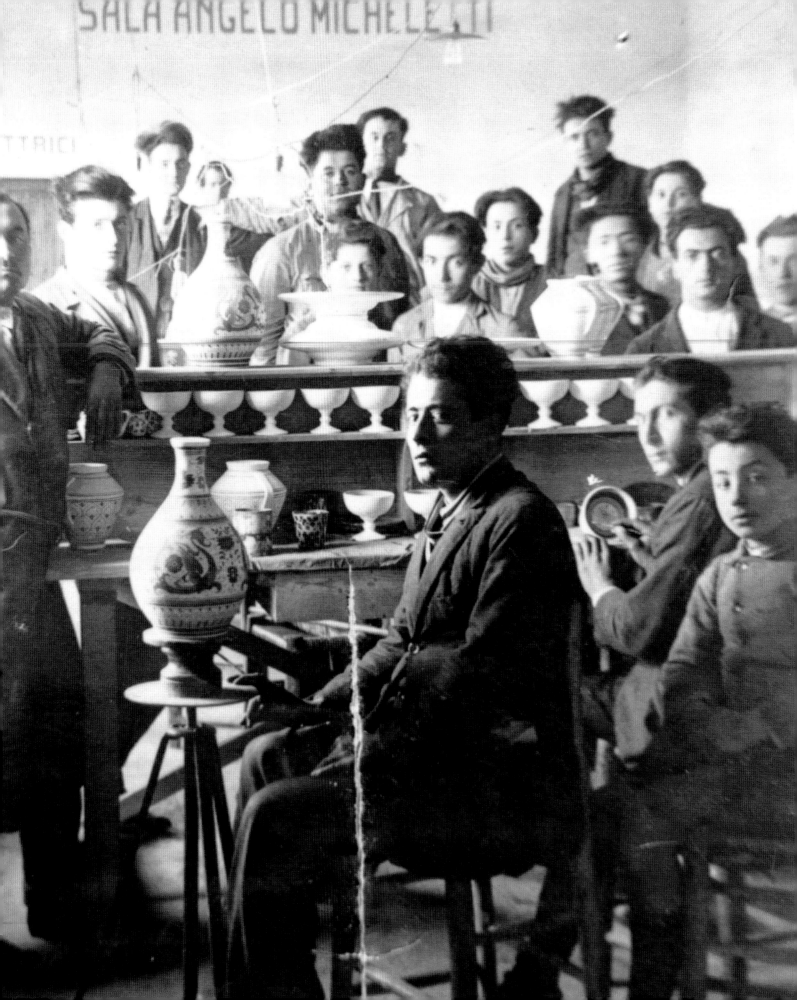

SALA ANGELO MICHELETTI

The Twentieth Century

Even though ceramics have been produced continuously in Deruta for over five hundred years, techniques and skills were not always handed down to the next generation. Economic crisis, combined with changes in taste, left a lot of precious knowledge by the wayside. It was not until the first years of the twentieth century that much of this knowledge was revived and again put in the service of Deruta ceramics.

In the twentieth century, Deruta revisited the "lost" traditions of the Renaissance that had made the town famous throughout Europe. The event that most clearly illustrates this "unearthing" of precious techniques and traditions is the rediscovery of the tiles of the *Pavement of San Francesco*. Buried for centuries, the tiles were discovered in 1902, during the restoration of the church. Although broken and chipped, these incredible testaments to a past splendor inspired the community to pull its resources together to recapture its former glories and make them their own again.

Left: Ubaldo Grazia (seated at the wheel) in the decoration room of his factory, c. 1925. The tables visible in the background are still used today in the light-filled room which is set aside exclusively for the precise work of painting.

Right: Alpinolo Magnini took the tradition of allegorical display plates and applied it to a modern use. The portrait of his father was intended as a birthday gift and is inscribed *Alpinolo Magnini to his father on his birthday of XX October MDCCCXCVII.*

Angelo Micheletti, a doctor and self-taught painter, and Francesco Briganti, a scholar, were instrumental in Deruta's rebirth. In 1901 the pair joined forces to form a museum, Il Museo Artistico per i Lavoranti in Maiolica, or the Artistic Museum for Majolica Workers. From the very beginning, these two men viewed Deruta's cultural heritage as a learning tool to inspire artisans. The original nucleus of their collection included precious, locally found fragments, donations of carefully preserved pieces, and modern reproductions of famous works in distant museums. The *Pavement of San Francesco* was given pride of place and today remains the centerpiece of the collection.

Following the founding of the museum, Deruta confronted the problem of formal training by forming the Istituto del Disegno, or Institute of Design. From the beginning, the focus of the curriculum was a profound

73

study of the town's accomplishments. Professors emphasized mastering old techniques and used imitations of Renaissance works, some of them in the museum, as teaching tools. Travelers were asked to send back watercolor copies of Derutan plates in foreign collections so they could be studied by scholars at the museum as well as by designers in training.

Alpinolo Magnini was another seminal figure in this period. Born to a well-to-do family, he was sent to the Fine Arts Academy in Perugia to study drawing and design. After spending some time in Laverna, where he was known as a specialist in the study of ceramics, he was called back to Deruta in 1907 to become curator of the recently formed museum and head of the design school. In these positions he was to influence and train an entire generation of artisans.

Above left: Magnini painted this commemorative portrait of composer Pietro Mascagni, with titles of the musician's works within decorative cartouches.

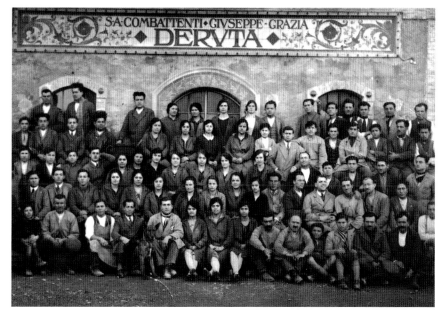

Upper right: A group portrait of the workers from the Grazia factory, taken about 1925 in front of the new building. The majority of the women were painters, while the men were in charge of the more physical jobs of turning the wheels and fueling the kilns.

Lower right: Although some of the turn-of-the-century factories have been transformed into apartments, the old part of Deruta, perched upon the hill, remains unchanged in appearance.

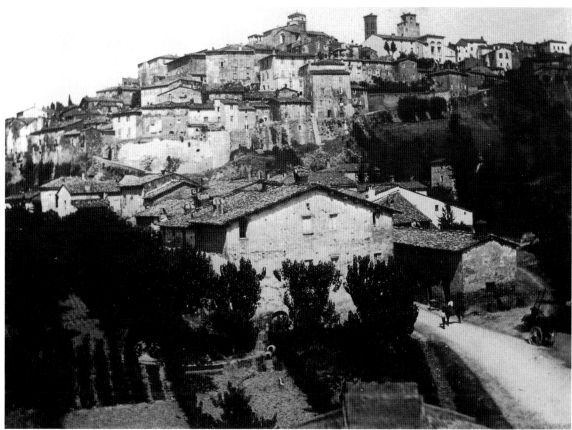

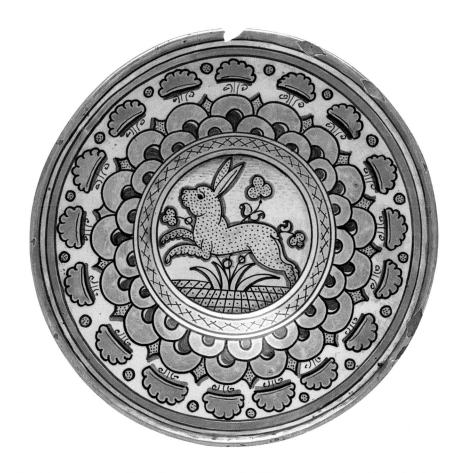

Left: Deruta has been making terra-cotta bricks since the thirteenth century. This large building is one of the few surviving turn-of-the-century factories. Originally producing unglazed building materials, it was eventually converted into a showroom for the majolica firm Ars Deruta.

Right: Although the lustre technique is from the sixteenth century, the stylized flowers and overall feeling reveal this to be a plate made by Ubaldo Grazia in the 1930s.

Magnini, apparently, had boundless energy, and in 1910 he assumed the additional task of technical director of the new Società Anonima Maioliche Deruta, a cooperative that united the scattered artisans in hopes of conquering a broader market. Through his continued study of archaeological sites and fragments, as well as museum pieces in foreign collections, Magnini began to reestablish Deruta's historic past.

Magnini led the artisans of Deruta toward what would influence them through the next century: a neo-Renaissance style that first emulated and would eventually reinterpret the masterpieces of the sixteenth century. Thanks to his careful study of locally-found fragments, many pieces in foreign museums came to be attributed to Deruta. He also managed to map out the sites of now-defunct workshops in the Borgo. And it was Magnini who invited painter Davide Ziporovich to work in Deruta from 1923 to 1927, during which time Ziporovich executed a series of plates based on famous works by Michelangelo, Raphael, and Botticelli. These plates gave rise to a type of plate that is still popular today.

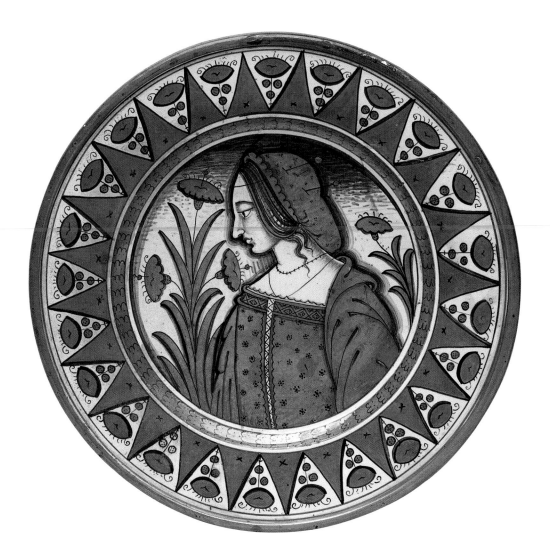

Ubaldo Grazia, together with Magnini, sought to unravel the recipe of the lustre glaze that was synonymous with Deruta in the sixteenth century but was a complete mystery to its artisans four hundred years later. Eventually their reproductions became so exact that they were difficult to distinguish from earlier ceramics. Slavish reproduction of antique pieces was not an end in itself, however, nor was it a way to satisfy the growing market for Renaissance majolica. It was rather the exploration of an artisan who was extremely proud of his past, and who sought to absorb all it had to offer.

Born in 1887 to one of the most successful families producing ceramics in Deruta, Grazia worked in the first decades of the 1900s as the head of operations of the Società Anonima Maioliche Deruta. In 1922, he decided to branch out on his own and opened Società Anonima Industria Maioliche Artistiche Giuseppe Grazia. At first, the business occupied the already existing Grazia firm in the

Left: Grazia decorated this neo-Renaissance plate using his newly discovered lustre technique. The feminine profile is a recreation of the sixteenth-century *Belle* that made Deruta famous.

Right: Amerigo Lunghi's *Enthroned Madonna* still decorates the church of Madonna delle Piagge, located next door to the Grazia factory.

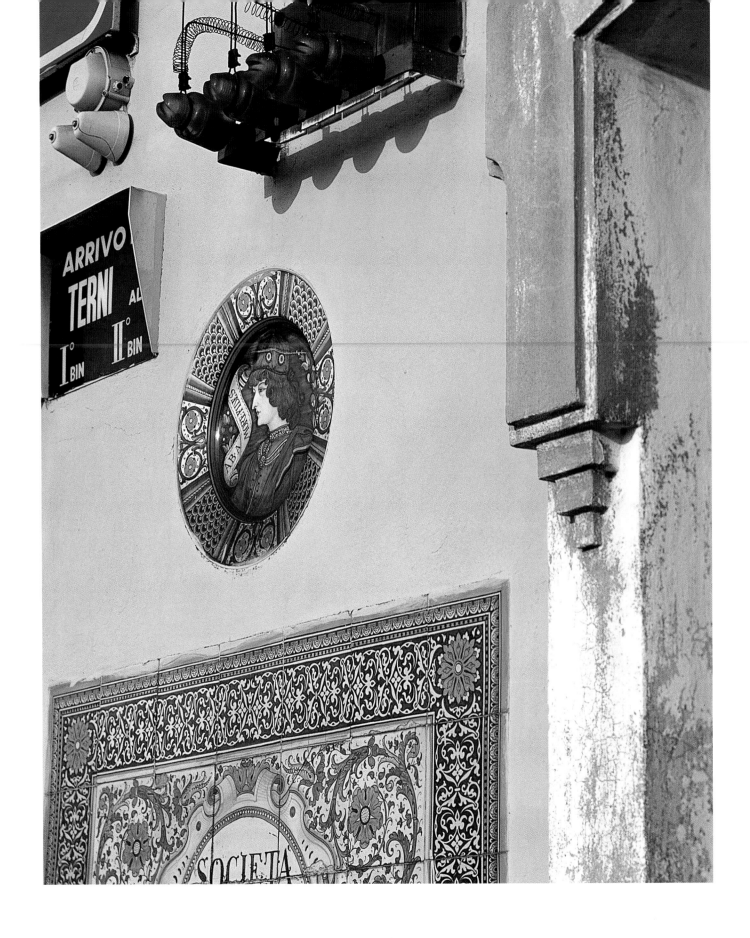

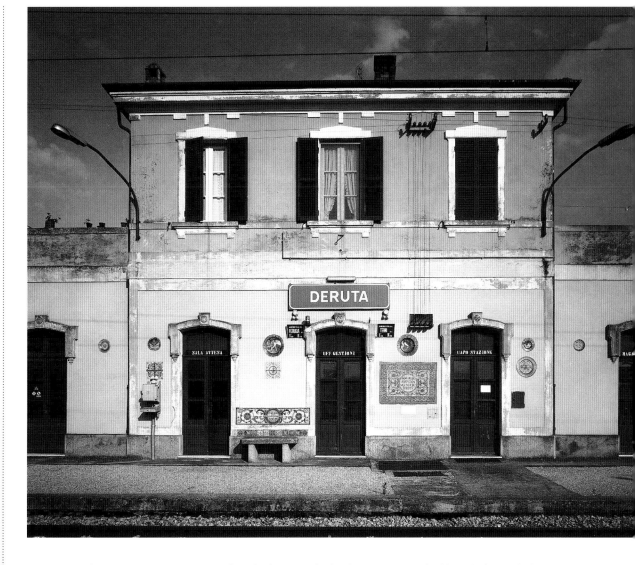

Left: The tiles decorating the train station are part of a historicizing aesthetic and adapt Renaissance patterns for new uses. A sixteenth-century display plate is reproduced as an architectural embellishment.

Right: The Deruta train station is actually located nearby, in San Nicolò di Celle. The station still retains much of its 1920s and 1930s majolica decoration.

old section of town, just outside the walls. Shortly, Grazia made the decisive move to build a new factory below the town along the main road. This factory incorporated all that was modern in the manufacture of ceramics: electric wheels, clay processing machines, and, later, kilns.

Another innovator was Amerigo Lunghi, an artist who entered the field of ceramic design relatively late in life, having worked as a photographer and painter until he was nearly thirty. Ceramics was not unfamiliar to him, though, since his mother was from the Grazia family. Lunghi was commissioned to execute a ceramic panel for the Church of San Francesco depicting St. Catherine of Alexandria, the patron saint of Deruta ceramists. Many

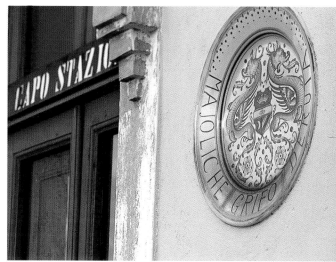

Ubaldo Grazia's
majolica advertisements
for his company
decorate the train
station. Derutan
ceramics were shipped
worldwide from here.

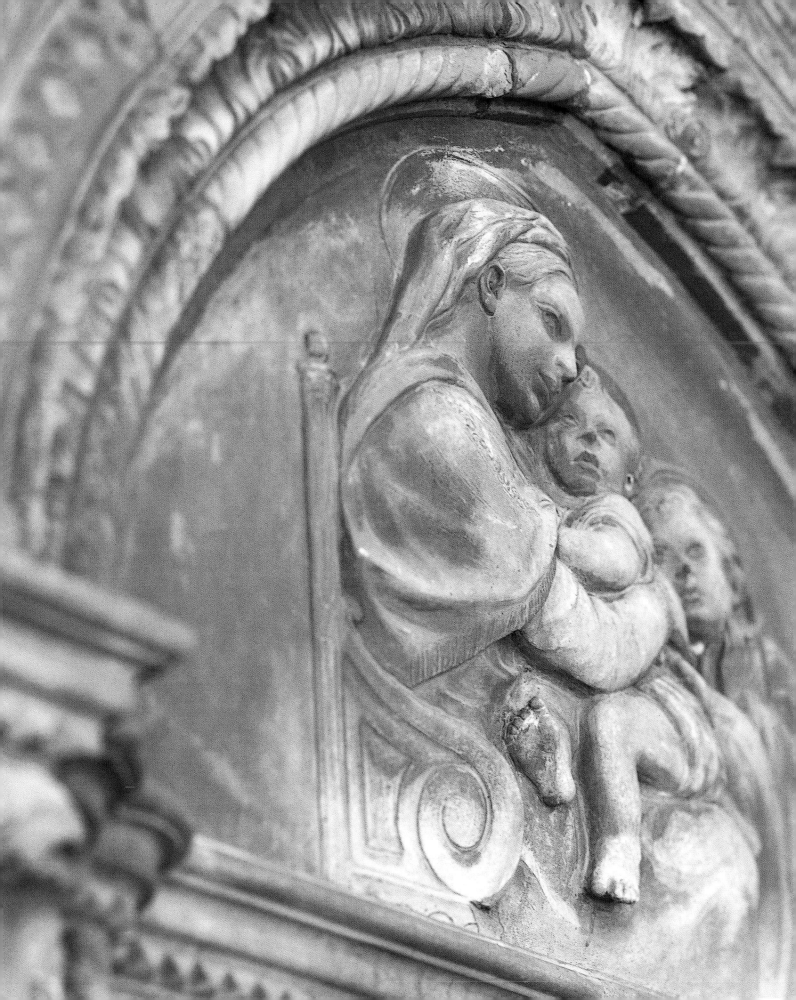

of Lunghi's works still adorn outdoor shrines and buildings throughout the town. *San Francesco Preaching to the Animals* adorns the Parish House, while his *Enthroned Madonna* decorates the small Church of Madonna delle Piagge. His fame spread throughout Umbria and many of his works, including saints and Madonnas, can be found in Foligno, Assisi, and Perugia.

Lunghi's figurative panels were part of a larger trend toward historicism, which involved the decoration of buildings with terra-cotta embellishments and majolica tiles. Many turn-of-the-century structures in Deruta still sport the brightly colored tiles, either framing windows, edging cornices, or simply placed in the middle of facades for visual interest. The train station, located in nearby San Nicolò di Celle, still bears much of the original decoration executed by the Grazia factory in the 1920s and 1930s. The cemetery is also a repository

Left: This terra-cotta relief adorning a family tomb, based on a painting by Raphael, was executed by the firm of Biscarini of Perugia in the nineteenth century.

Right: The Deruta cemetery, located just outside the main gate of Sant' Angelo, contains many examples of turn-of-the-century majolica decoration and terra-cotta ornamentation.

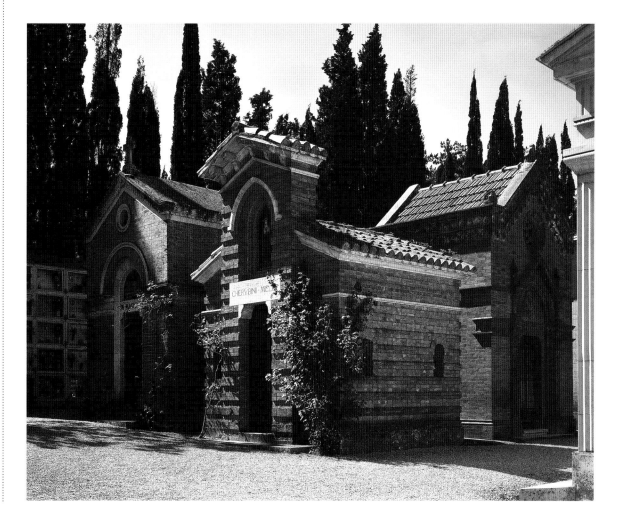

of architectural decoration, with private tombs tracing the history of this art over the last century.

Lunghi became artistic director at the Grazia factory in 1924, incorporating new styles into the traditional repertoire. A plate he executed at the time, featuring two silhouetted feminine heads in a decidedly art nouveau style, reflects the ideals of the new factory in the inscription on the reverse: "*Deruta La Nuova*," or The New Deruta.

At the Grazia factory, a new mark was developed that proudly incorporated the Deruta coat of arms. The factory's catalogue listed over seven hundred different items, executed in sixty-three patterns. Some patterns reproduced motifs that had their history in Deruta: *Ricco Deruta, Bianco su Bianco, Raffaellesco*. Other patterns reflected ceramic production throughout Italy over the last six centuries: *Orvietano, Decoro '400*. Some of the items were solid-color forms in art deco shapes. Here was a company that was out to capture a world market. Many of the patterns developed during this period remain the most popular ones today.

Early in the twentieth century, two competing trends coexisted: the desire to maintain strong local traditions, and the desire to venture into new stylistic areas, including art nouveau, modernism, art deco, and futurism. The market encouraged artisans to adapt traditional forms such as sixteenth-century display plates and apothecary jars to modern purposes. Commemorative family portraits replaced the idealized feminine profiles of the Renaissance. Gradually, the traditional designs found greater success, and modern patterns were rarely produced.

Much of the innovation taking place was connected to the modernization of manufacture. Electric kilns and wheels streamlined production and made certain tasks obsolete, such as the gathering of wood and brush for

Left: Much of the twentieth century majolica decoration in the Deruta cemetery remains anonymous, such as this Madonna adorning a family crypt.

Right: Alpinolo Magnini executed this panel in the Grazia factory to adorn his family tomb.

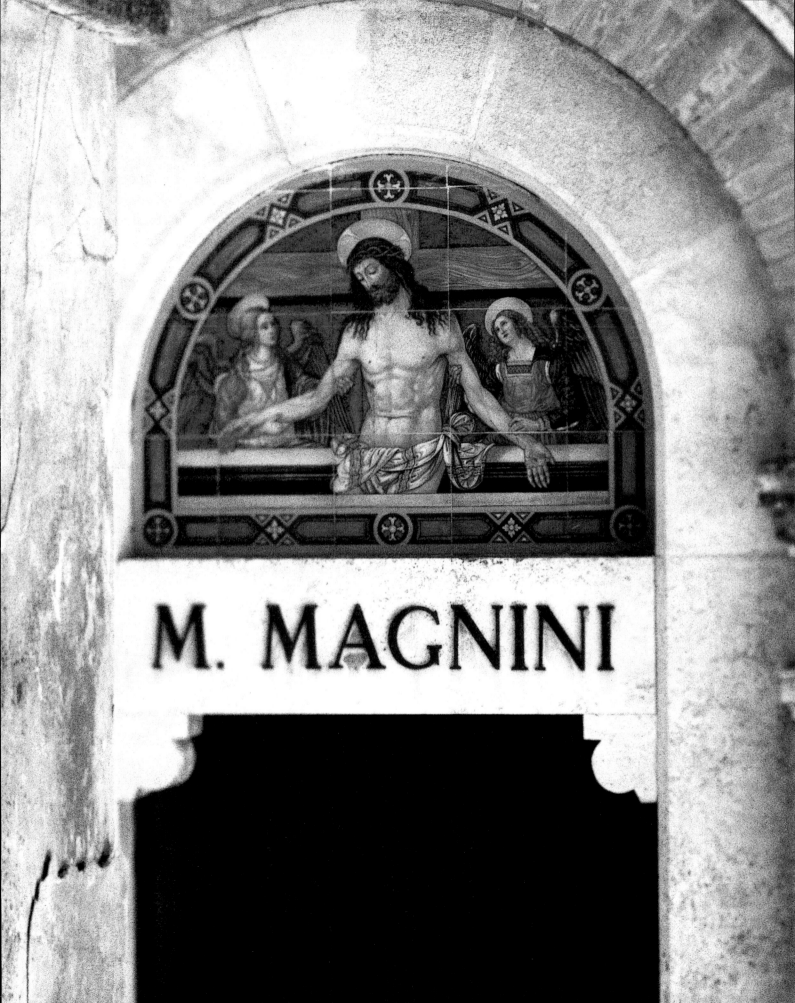

M. MAGNINI

Left: Some of the best examples of twentieth-century architectural decoration can be found in the old section of Deruta.

Above and following page: Colored majolica tiles were combined with terra-cotta and stucco ornamentation and used as architectural decorations.

fuel. Similarly, industrially produced glazes, delivered in neat bags and already ground and ready for mixing, not only expanded the color range but also made the entire glazing process easier.

The period between the wars was one of great expansion. The big factories were running night and day to meet orders; Grazia alone had over two hundred workers. Barrels of ceramics would be crated up and loaded onto horse-drawn carriages to be taken to the train station in San Nicolò di Celle. From there the barrels would travel by train to Livorno, to be put onto ships bound for the United States and other destinations.

After World War II, there was a general economic boom in Italy. In Deruta, this encouraged many men trained in the large factories to strike out on their own, opening smaller workshops. Exports continued, and the local market in Italy, fueled by an ever-increasing tourism, demanded a constant flow of ceramic ware.

With the techniques of the past centuries mastered, Deruta artisans felt ready to confront the tastes of their international clientele. New designs, some much less labor-intensive (and less costly) were created to appeal

to 1950s and 1960s tastes. These modern pieces were produced alongside the traditional models in the same workshops. Deruta was now trying to adapt to a market from which it was culturally and geographically very much removed. These were no longer local, artistic expressions but the development of a commercial export product. However, there always remained a strong link with traditional aesthetics, and one of the biggest factories, Grazia, kept its own museum so that its designers would be instilled with a strong sense of their past.

When Grazia built his factory on the Via Tiberina half a century ago, it was the first to expand beyond the boundaries of the old walled city on the hill. Although today there are still a few shops in the Borgo, the old part of town, the productive heart of Deruta is almost entirely in this new area at the bottom of the valley. With over three hundred registered firms producing ceramics in Deruta, the variety of sizes, quality, and quantity of works is vast. Whether they receive an order of four thousand coffee mugs for a chain of restaurants in the United States or a one-of-kind masterpiece for a client in Japan, the potters of Deruta have made the market their own once again by successfully working with traditional designs and techniques.

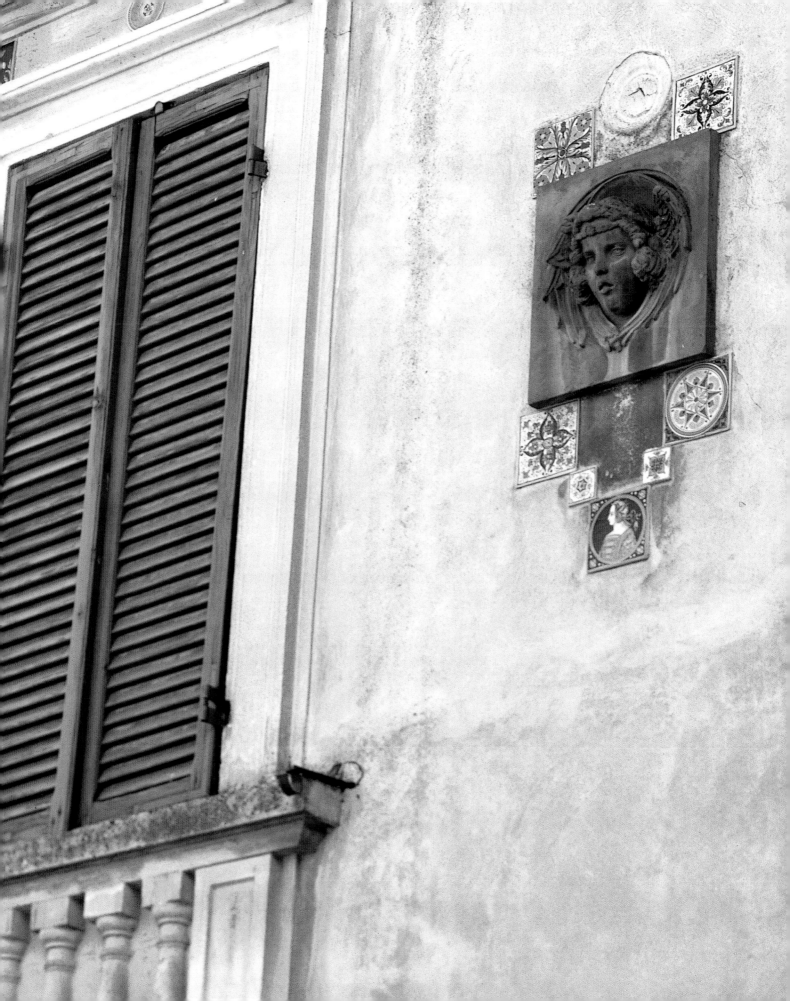

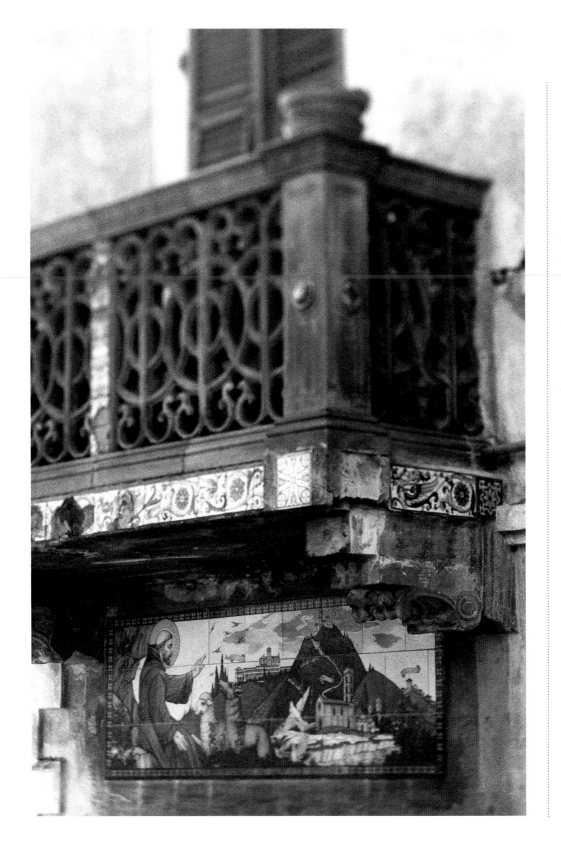

Left: Amerigo Lunghi
influenced a whole
generation of painters
toward a neo-
Renaissance style in
ceramic decoration.
His *San Francesco
Preaching to the
Animals*, a large-scale
ceramic mural, was
executed for the
exterior of the Parish
House in the 1930s.
The splendid terra-cotta
balcony was produced
by the firm Biscarini
in Perugia.

Right: A small
tabernacle outside the
Parish House
celebrates Divine
Maternity.

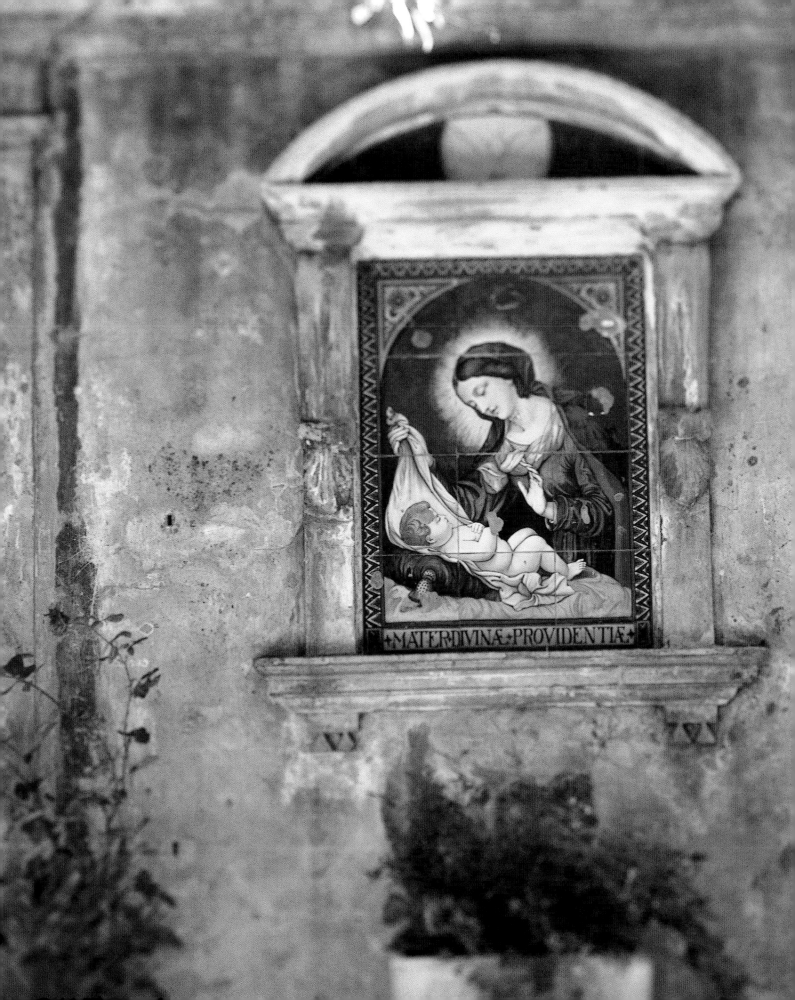

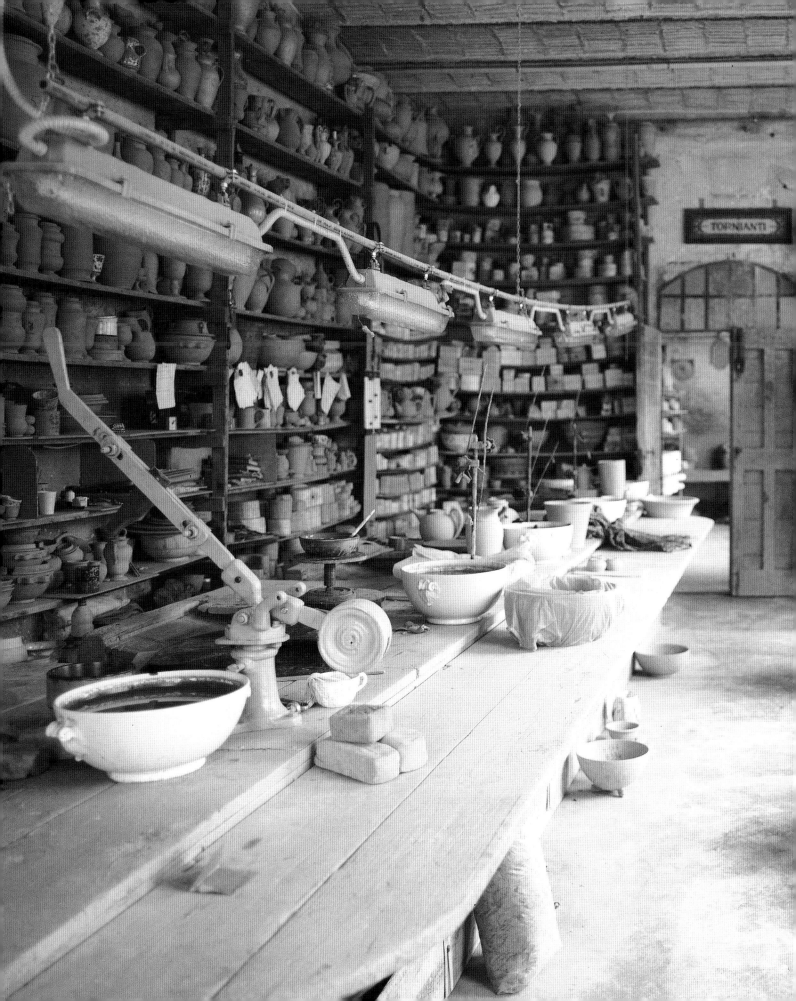

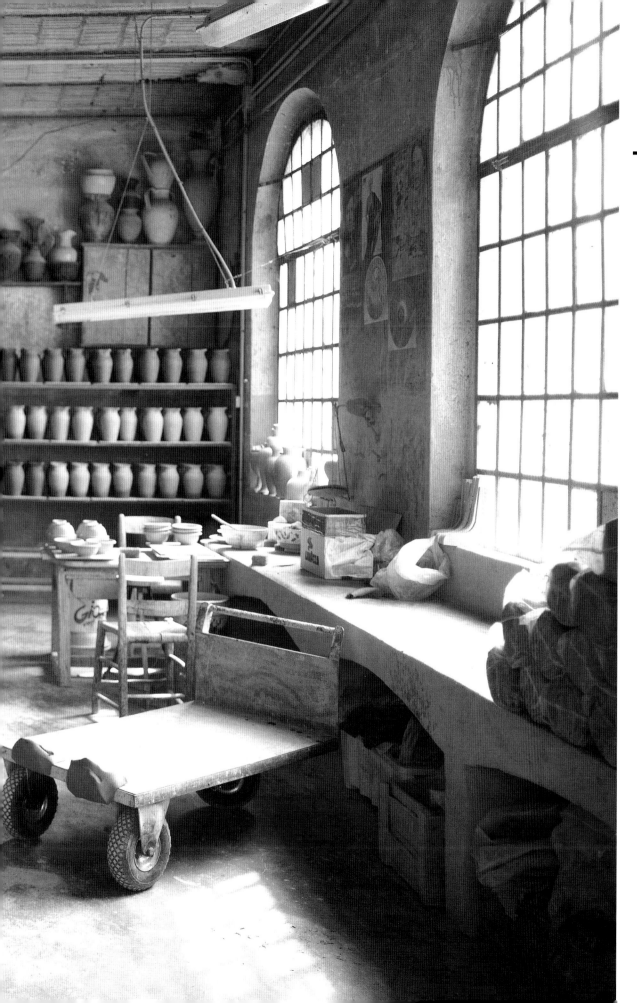

II.

Tradition

From the Earth of Umbria

Deruta's expansion over the last thirty years echoes that of myriad small hill towns scattered throughout central Italy. The original walled nucleus of the town remains nearly intact, while the new buildings blanket the valley below. Until recently, the fertile plains that flank the Tiber river were dedicated to the cultivation of wheat, corn, and sunflowers, with the crops providing a colorful backdrop. Now the plow stops where the blacktop parking areas of the ceramic stores and workshops begin.

Umbria is still heavily farmed, giving rise to its nickname *Umbria Verde,* or Green Umbria. Olive oil and wine are two of its most notable products, but only a small portion of the population, about nine percent, farms the land. Approximately one-third of all Umbrian citizens are employed in industry or manufacturing with the rest employed in the service sector, predominately tourism.

The rolling green hills and heavily wooded slopes are sparsely populated, because most of the people live in towns and cities. After World War II, the ancient system of land share-holder of the 1500s — *mezzadria* — finally came to an end, and the farmhouses that dotted the landscape were abandoned and left to ruin. Only in recent years have foreigners and city-dwelling Italians discovered their charm and set about restoring them into summer homes. Deruta, like its larger neighbor Perugia, has grown over the past half century. Yet while Perugia, and Terni to the south, owe their expansion to industrialization, it was the explosion of small-scale ceramic manufacture that changed the landscape of Deruta. Since no enormous factories were required, the changes wrought have been softer. From a distance the town appears to have poured down the hill, pooling itself upon the plain below.

While the majority of Derutans no longer work the fields, the ceramics they produce retain a strong connection to the land. The surrounding forest and hills, with their abundant wood and clay, initially made the

Preceding page: The form room at Grazia Deruta stores the archives of past works. Rows upon rows of bisque ware preserve shapes and measurements.

Left: Umbria's nickname *Umbria Verde* refers to the heavily farmed fields and thickly forested hills.

Right: Traditional techniques and designs are often the starting points for pieces made in Deruta today. Antonio Margaritelli's Renaissance fragments, found during local excavations, provide precious information and inspiration.

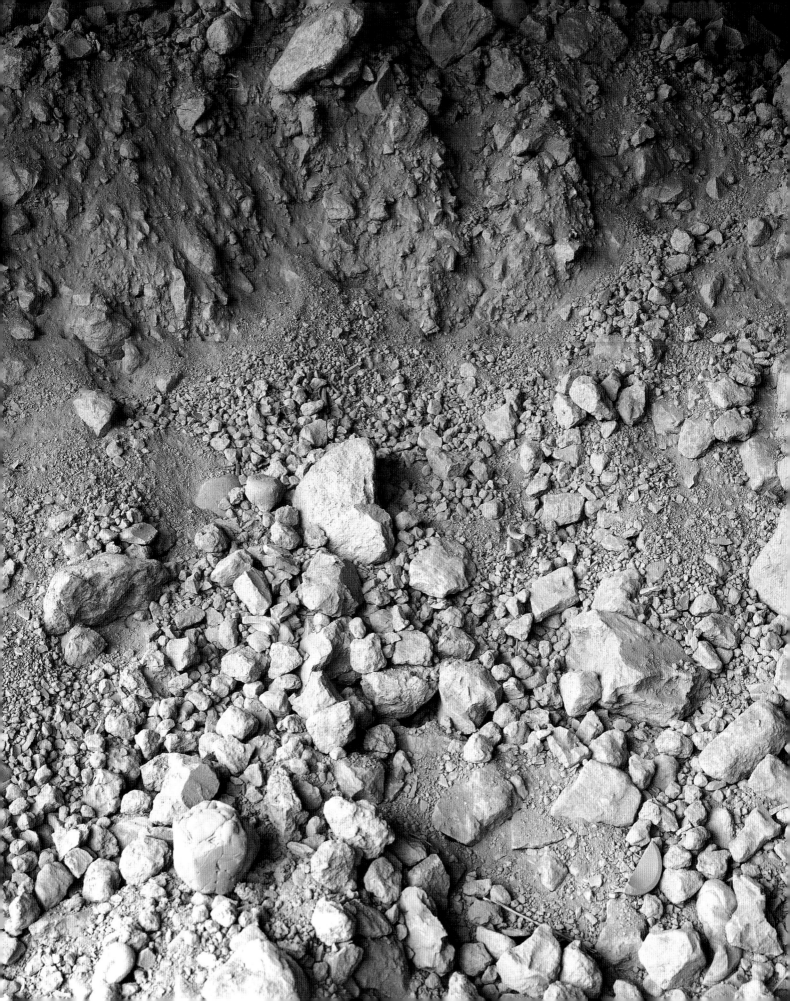

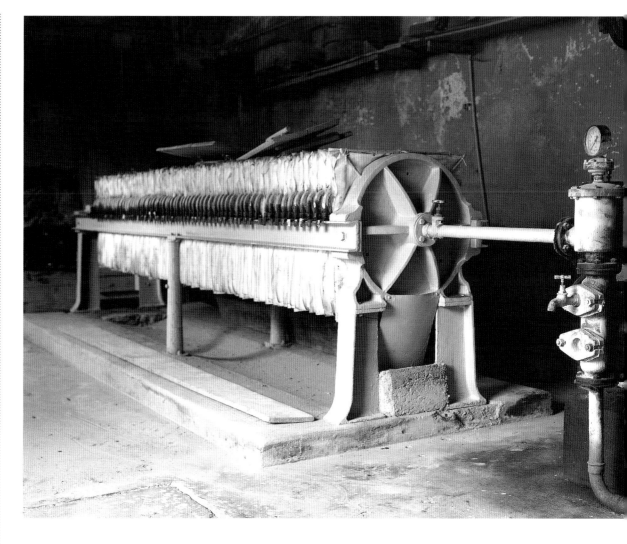

Left: Traditionally, most firms stockpiled dry clay, to be processed as needed. While most prefer the easier option of buying their clay ready to use, in plastic wrapped blocks, Grazia Deruta still remains true to this tradition.

Right: A series of filters removes the impurities from the wet clay, rendering it smooth and homogeneous. It will be stored until it is needed.

location of this craft possible. Most of today's craftsmen get their clay from nearby Città di Castello, and the kilns are fueled by electricity, not wood. Yet a sense of history and permanence endures.

The process itself connects Deruta to its past. Although modern manufacturing has changed certain tasks and made others obsolete, the process remains essentially unchanged from that of five hundred years ago. While Piccolpasso's illustrations of sixteenth-century workshops seem charmingly antiquated when compared with the workrooms of today, the actual procedure is surprisingly similar. Modernization has not improved on time-tested techniques. From the large firms that create items for a mass market to the lone artisans who create a limited number of unique works, every piece comes from the earth and every piece is decorated by hand.

Left: The mixing
machine may look like
a museum relic, but
it is still used to process
the raw clay that
Grazia buys by the
truckload from a source
in northern Umbria.

Right: Once the clay
is processed, it can be
stored in a damp cellar
for several years.
All of the firms are
very careful about the
quality of their clay,
since it will determine
the success of the
finished product.

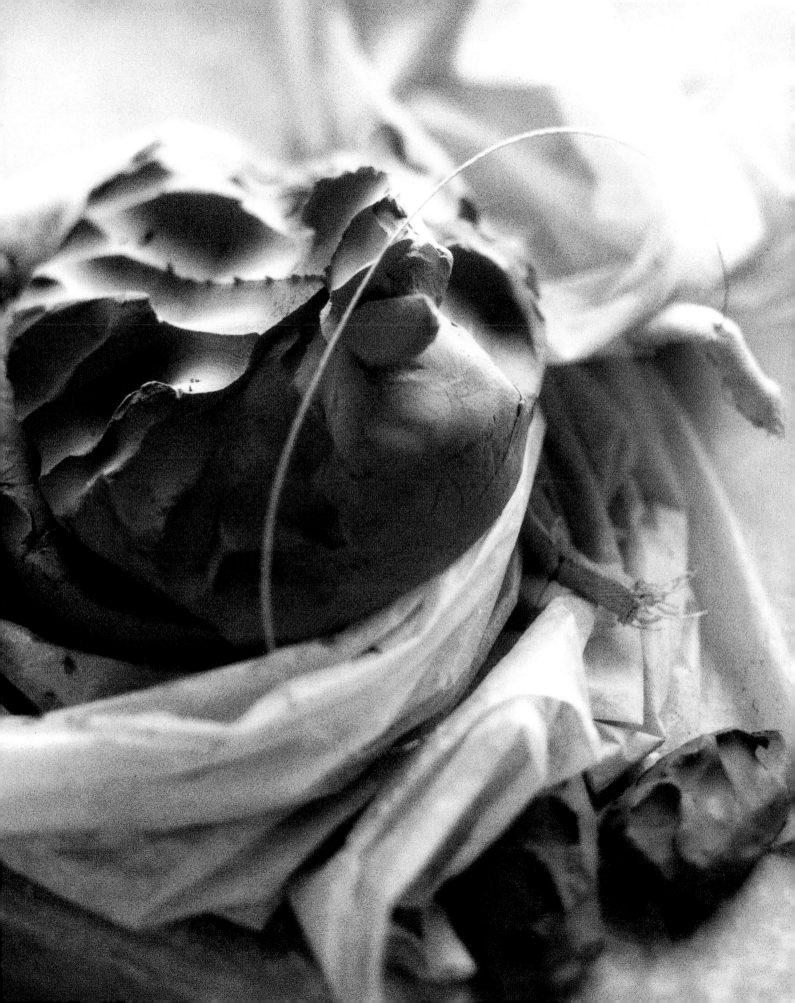

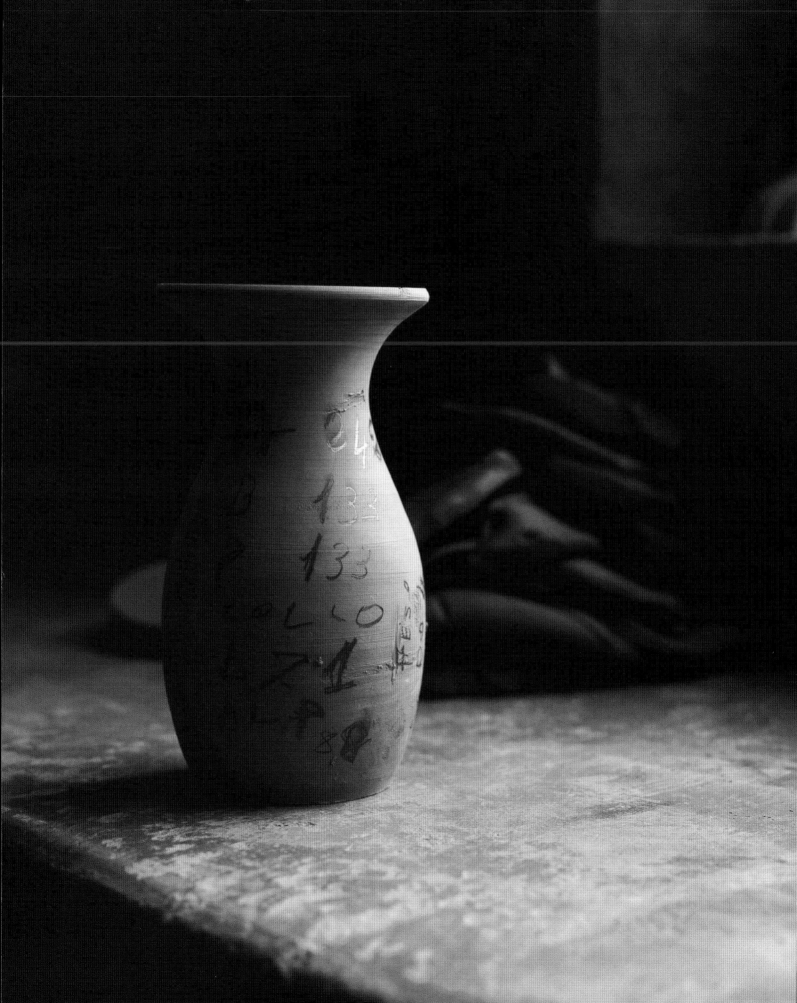

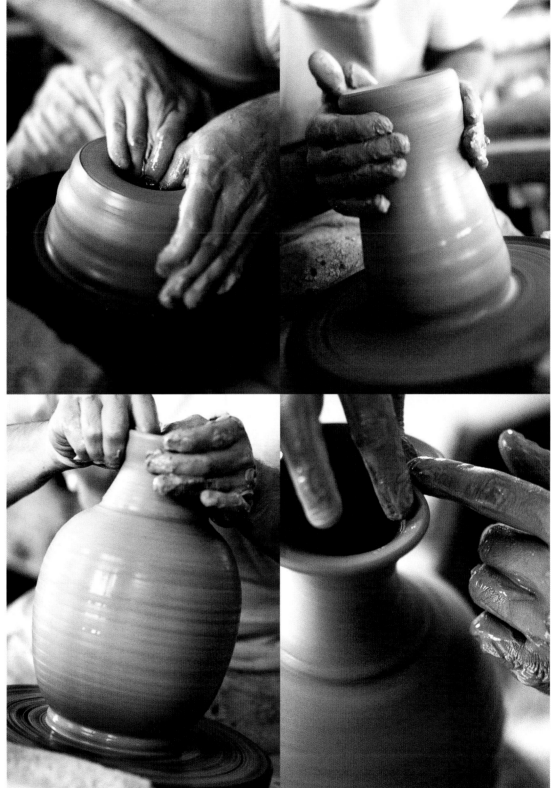

Left: An annotated piece of bisque ware acts as a precious archive of past masters' works. A sample of each form is preserved, marked with the turner's notes regarding thickness.

Right: Wheel work is very specialized and remains the domain of men in Deruta. Working from a sample, each form is pulled up until the desired shape is achieved. Although today's wheels turn by an electric foot pedal, not much else has changed since the sixteenth century.

Left: Attaching handles to pitchers and cups is traditionally a woman's job in Deruta, since it requires delicacy and patience rather than physical strength.

Right: Once off the wheel and half dry, each piece is carefully gone over to remove any imperfections and smooth out rough edges.

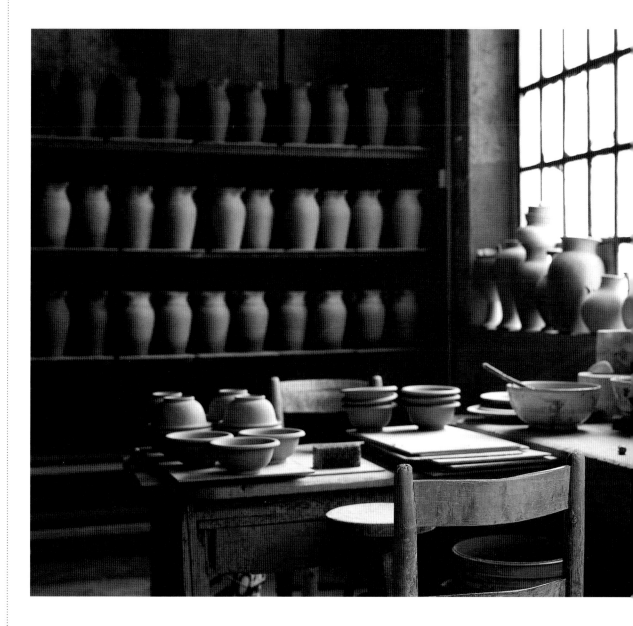

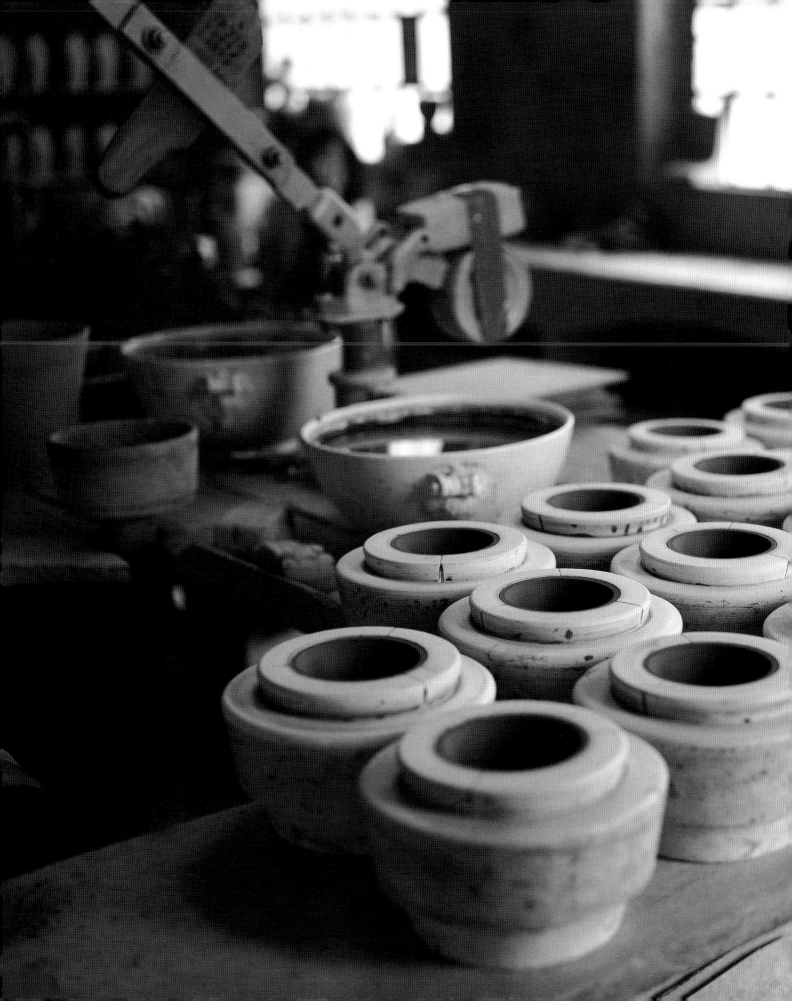

Left: Not all shapes
can be turned on a
wheel. Flat forms such
as platters, plates,
and shallow bowls are
built up using plaster
molds. Each plaster
cast is carefully crafted
by a master and can
be used about two
hundred times.

Above: The mold room
at Grazia Deruta.

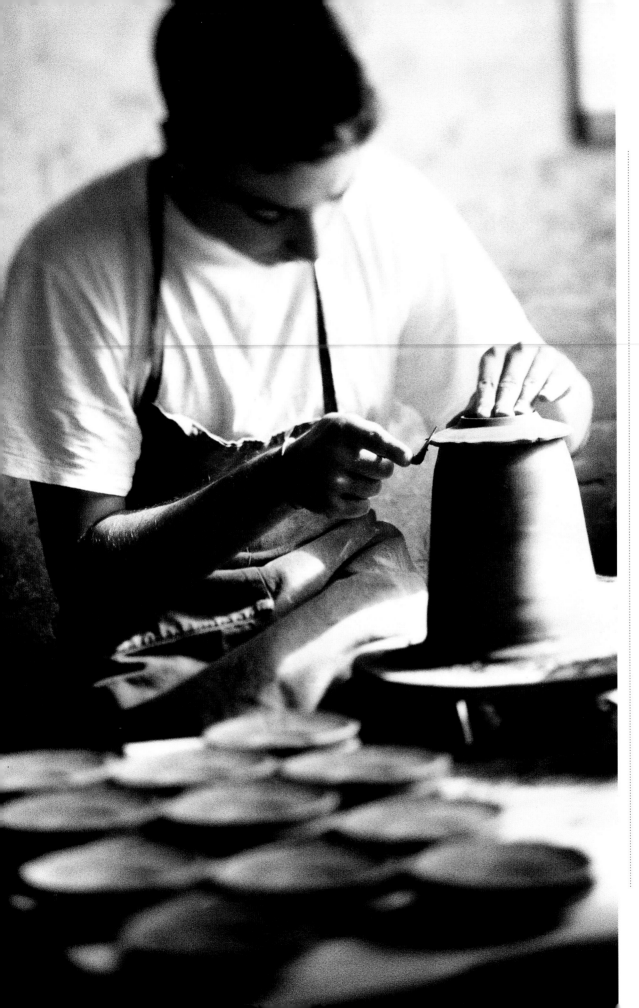

Left: Building up a form from a mold is much more complex than pulling it up from a wheel. Once the piece is half dry it is carefully refined and set aside to dry completely.

Right: After the first firing the piece is referred to as *bisque ware*. Most studios like to keep a supply of bisque ware in stock and ready to be painted to fill an order on short notice.

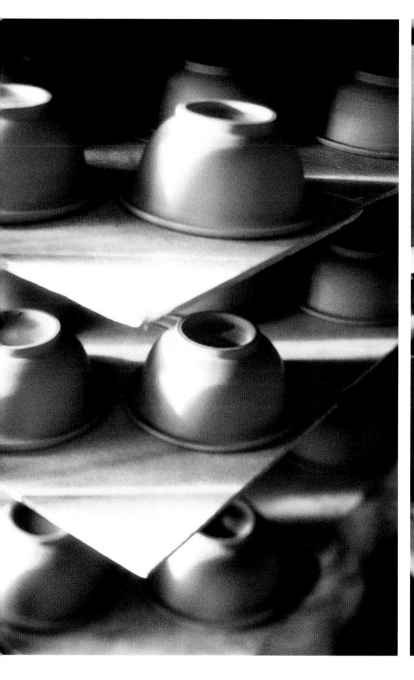

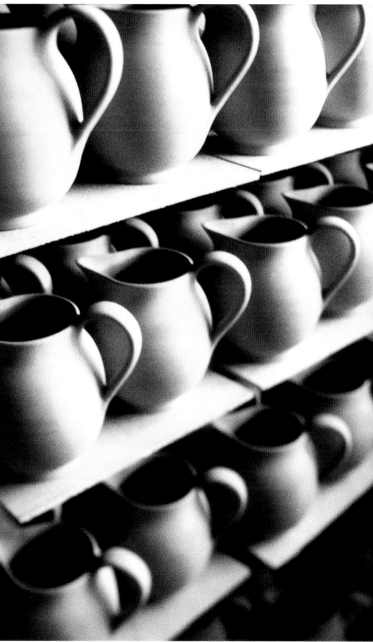

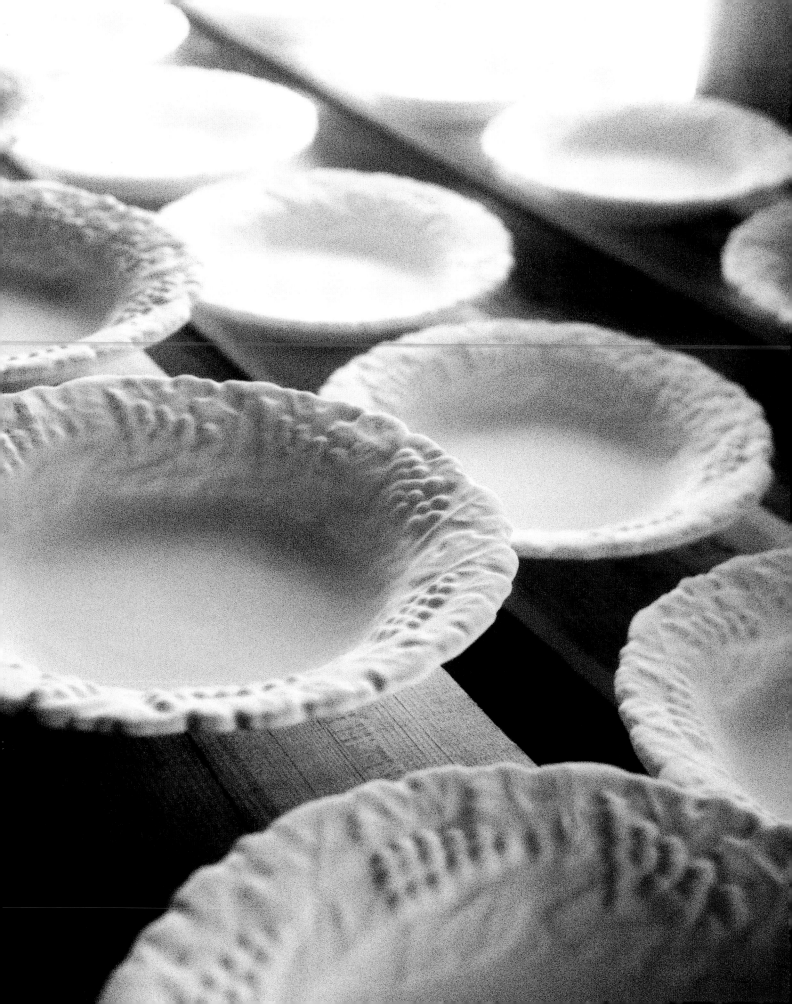

Left: Once reaching the bisque stage, pieces are dipped in a bath of white glaze, which provides the backdrop of the main design.

Right: Intricate designs are laid down on the white underglaze using a stencil method called pouncing. The pattern is traced onto a thin sheet of paper, and the outlines are then perforated with tiny holes. The stencil is laid against the piece to be decorated, and a small, carbon-filled sack is gently beaten against the surface, leaving behind faint lines that will disappear under the final glaze.

Left: Most painters order their colors in powder form from industrial suppliers. Patrizio Chiucchiù is one of the few remaining artisans to mix his own colors, here seen in their raw, mineral state.

Right and far upper right: The pouncing provides a faint outline for the decorator to fill in with colored glazes.

Far lower right: Spruzzatura di vetro is literally a "spray of glass" that is applied to the piece before the final firing. The glass coating, which is costly, is not used by all ceramic firms. Although it raises the price of an object, it adds brilliance to the glaze and also makes the color more able to withstand daily use.

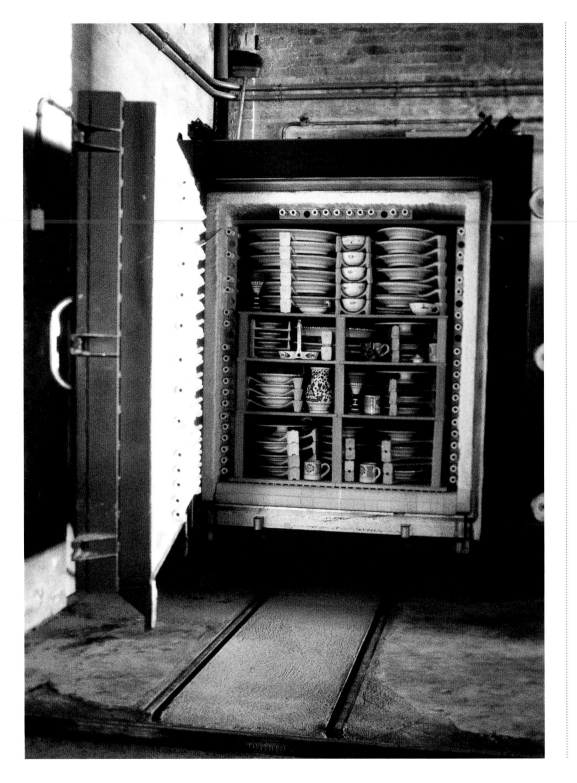

Left: Everyone in Deruta carries fond memories of wood-fueled kilns, but today's electric kilns have taken over. Some of the most sophisticated have trolleys that run along tracks directly into the kiln.

Right: Even when one is familiar with the complicated process that transforms lumps of clay into brilliantly colorful and luminescent works of art, the finished piece always appears something of a miracle. The fire has worked its magic and rendered the pale opaque pigments glasslike and ready to withstand the centuries.

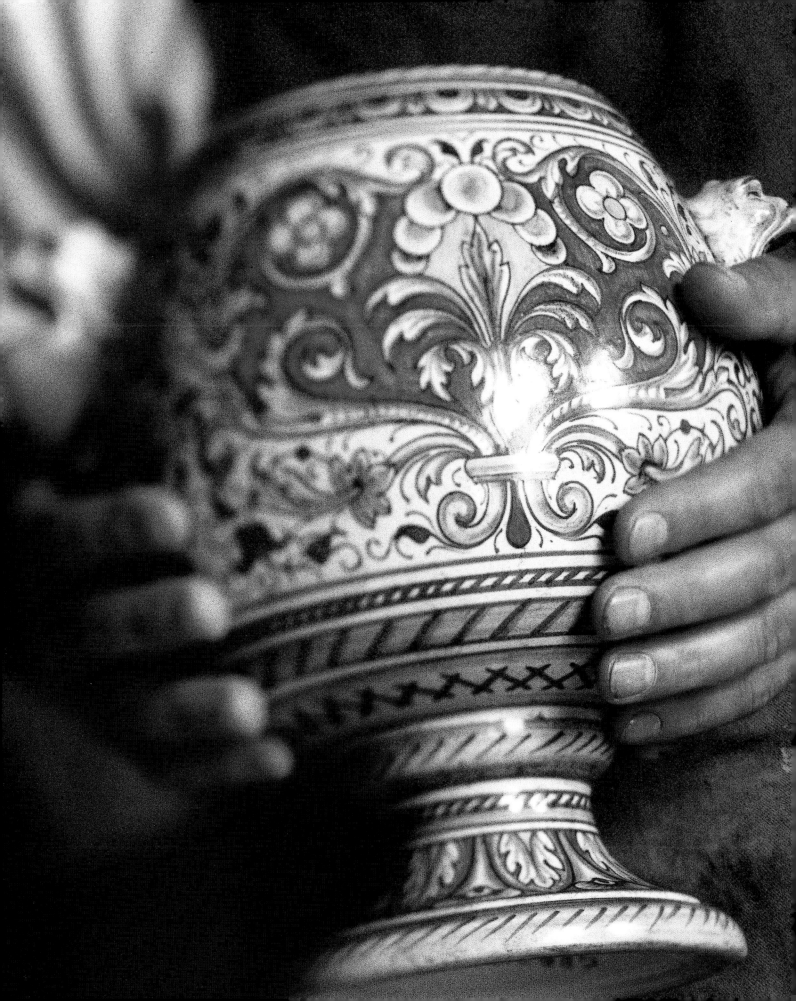

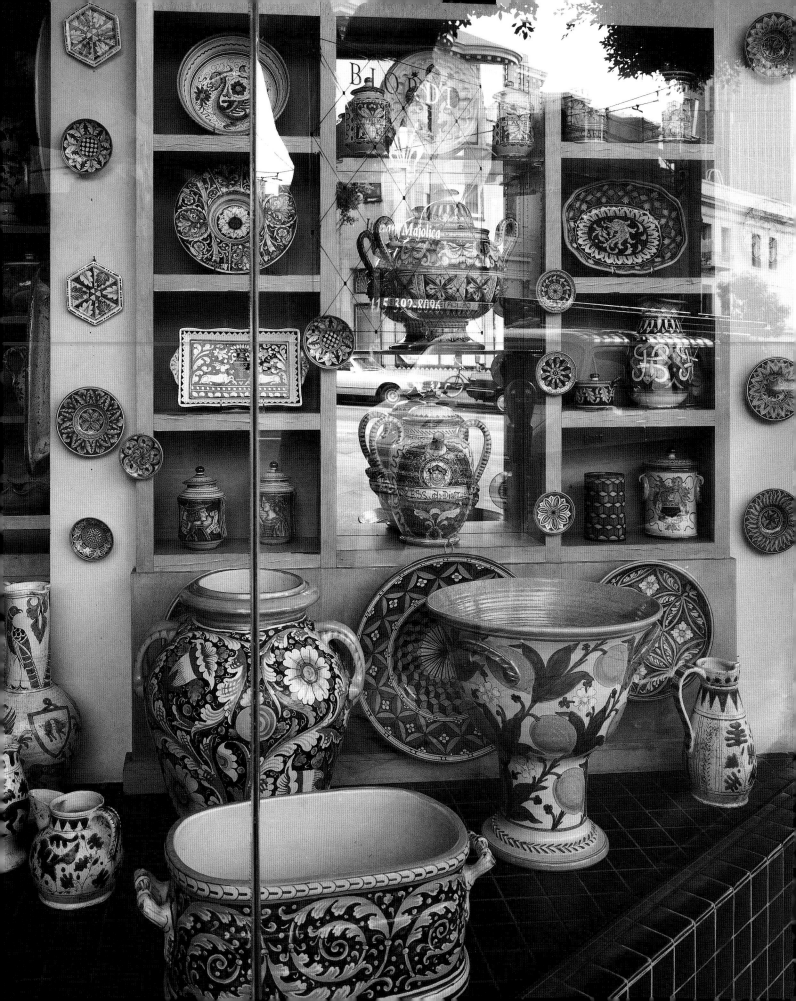

Exporting Brilliance

To visit Deruta today is to step back in time. The sheer quantity of handcrafted objects, which keep alive an ancient tradition, is a sure cure for the overly modernized world. The Borgo, Deruta's old section of town, remains intact, and the majolica for sale in the shops is similar to those produced centuries ago. Recent developments, like the expanded museum in the old cloister of the Church of San Francesco, serve to put the modern production in perspective and frame it within its long history. The museum houses the town's vast collection of majolica. In addition to a permanent display of centuries of Deruta ceramics, the new museum hopes to sponsor related exhibitions that will encourage more scholarship on many of the neglected periods.

Left: A visit to Deruta is the best way to view antique examples of this town's ware, as well as contemporary production. Luckily, for those not able to make the trip, ceramics from Deruta are readily available in dozens of stores throughout the United States.

Right: Although all firms in Deruta keep a full display room, most of the works produced are destined for export.

Recent donations and acquisitions have greatly expanded the museums collection.

That Deruta thrives today is due in large part to people who have never even been to this little town. While all of the over three hundred firms producing ceramics in Deruta sell directly to the public, most survive on foreign exports. Japan, Australia, Germany, and the United States have discovered Deruta's worth and been captivated by the beauty of its objects.

Masterpieces from this small town

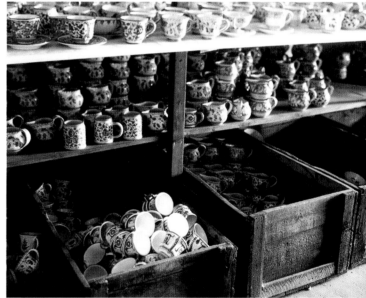

now adorn museums in Paris, London, Washington, and Los Angeles. Designers from around the world come to work and to learn in Deruta's workshops, and craftsmen from Deruta travel to Tokyo and Seattle to teach their craft. Interest in Deruta ceramics continues to grow. What started out as a small kiln supplying baked earthenware for a local market in the fourteenth century has grown to achieve worldwide significance.

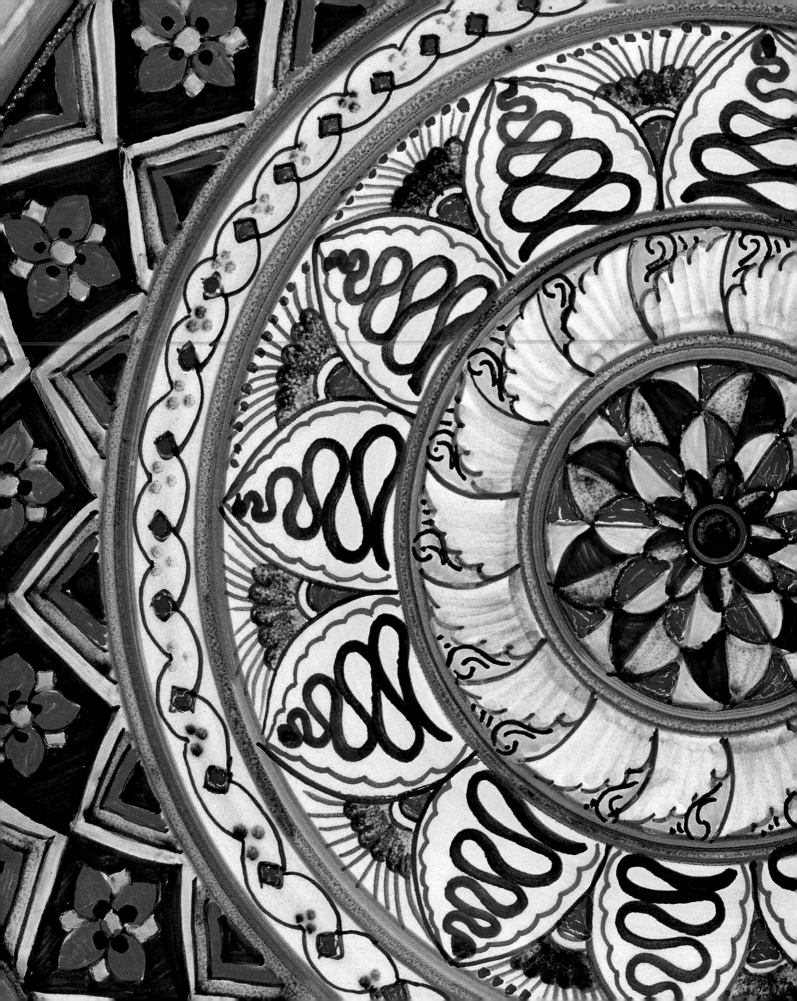

III.

Deruta
Today

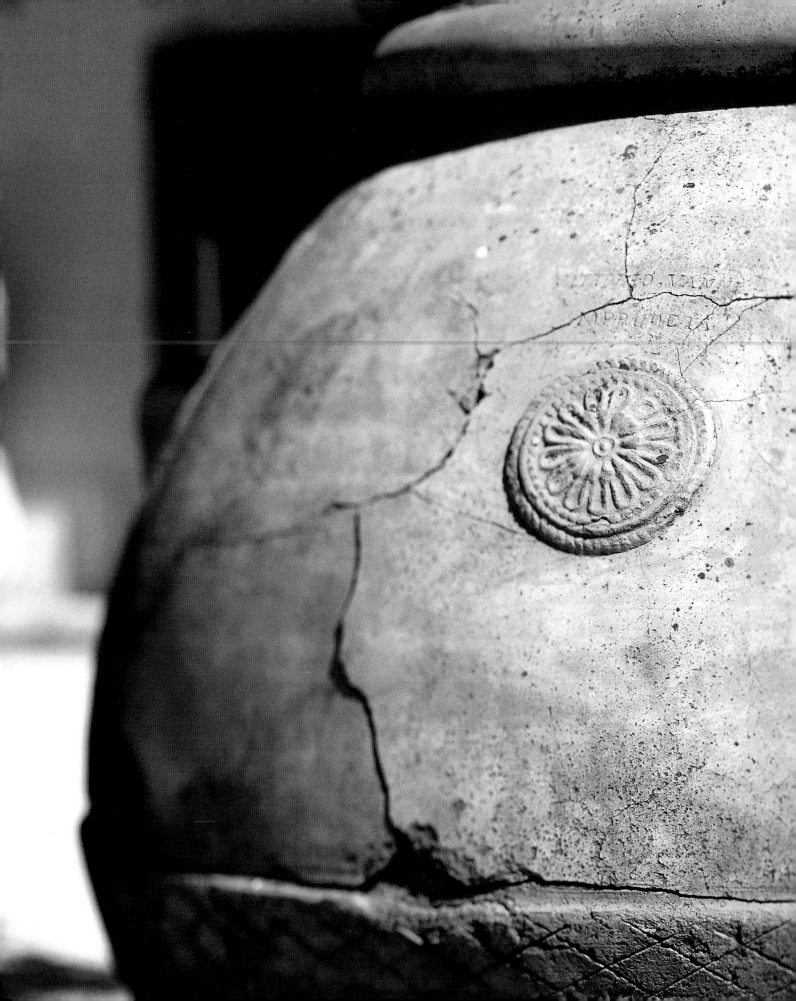

Nothing

The Living Art

The masterpieces produced over the centuries by the craftsmen of Deruta can be found in museums, at auctions, or even in exclusive Madison Avenue galleries. Yet these antiques are only one side of Deruta. Contemporary Deruta ceramics are a living art, bringing to life centuries of tradition and style.

While the stores located in the Borgo are picturesque and lend splashes of color to the gray stone buildings and narrow alleyways, most of the production takes place below, in the newer part of town. As with much of the construction in Italy in the last fifty years, there was no sense of urban planning or forethought, and the showrooms appear to have sprung up haphazardly along the main road. Most are modern, sleek and brightly lit, with showrooms in the front and workrooms in the back or in the basement. The exception is the Grazia factory, which dates to the 1920s and has remained virtually unchanged since that time. The only sense of history the modern streets have are their names: Via Raffaellesco; Via Alpinolo Magnini; and Via dei Fornai (Street of the Kiln Tenders). These names pay homage to Deruta's long ceramic tradition and root the new section of town firmly in its past.

The enormous concentration of workshops and factories in one small town has naturally led to a strong sense of competition that involves a good dose of civic pride as well as a desire to improve the overall quality of ceramics. After centuries of ups and downs, Deruta has now settled into a period of strong growth that is a direct result of their foreign markets, most notably the United States. Most potters are quick to confess that the current high standards, in terms of quality of materials as well as sophistication of design, are a direct result of the demands of an extremely discerning American clientele.

Preceding page: Antique geometric and vegetal motifs are reinterpreted by Franco Mari to create lush, contemporary patterns.

Left: The Berti brothers, of nearby Ripa Bianca, continue the tradition of unglazed terra-cotta, which has always existed alongside the more complex decorated majolica. The Bertis, who were one of the last firms to still operate a wood-fueled kiln, concentrate on large-scale garden pieces, like this enormous urn.

Right: Gialletti Ceramiche specializes in large, colorfully glazed decorative pieces for use in the home or garden.

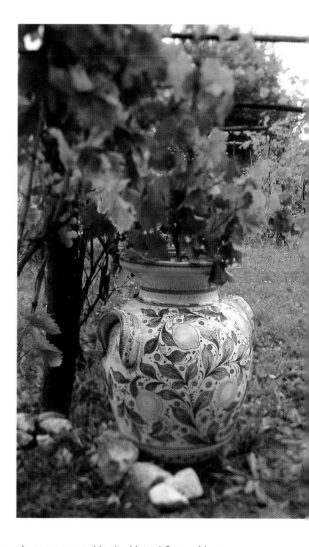

Over the centuries ceramics was the sole option when it came to a trade. The only choice to be made was where to specialize — fueling the kilns, turning the forms, or painting the intricate designs. The success of the current generation gives youth in Deruta more possibilities than their grandparents or even their parents ever dreamed possible. Previous generations often left school at age fourteen to start work as an apprentice in the family business. Today children are able to stay in school and, later, go into professions that may take them far away from Deruta. While the person selling you a set of exquisite dishes may lament that their children have no interest in keeping the business alive, they will proudly tell you in the same breath that they shouldn't, since their medical and law practices are so busy.

Another recent development in Deruta is the way in which young people who do choose to stay in the trade learn the craft. While some of the big factories like Grazia can still afford to take on a few apprentices each year, Italian tax and labor laws make this age-old practice prohibitively expensive for most. Traditionally, apprentices were paid next to nothing during their first few years of training, but today studios must pay a wage and added benefits from the beginning. The result is that anyone hired must be immediately productive. Some feel that a large number of apprentices working alongside more skilled workers, learning the craft as they went along, was the way the spirit of creativity was passed on.

A continuing source of training is the high school, and perhaps the key to Deruta's future lies here. In the past, the majority of students were from the town, but now the school is attracting students from outside its borders. While new educational reforms bring the school into line with European standards, there is less emphasis on ceramics. Yet the core curriculum still includes the basics of ceramics as well as fundamentals of restoration.

Left: Not all patterns produced in Deruta today have their origins there. The pattern *Siena* is named after the Tuscan town from which it hails. Based on allegorical representations laid down in the floor of the Siena Cathedral, C.A.M.A. has translated the detailed stone design into a graphic black and white ceramic pattern.

Right: A modern interpretation of *Gallo Verde* exchanges the traditional vivid green leaves for a sophisticated black and white version.

At first glance, there seems more that unites the diverse studios of Deruta than differentiates them. The general reverence for the past is evident in the trio of patterns that appear in just about every *bottega*, big or small. Most firms, whether they concentrate on one-of-a-kind decorative pieces or simple sets of dinnerware, tend to keep in stock a good selection featuring some variation of the classic Deruta patterns *Gallo Verde, Arabesco,* and *Raffaellesco. Ricco Deruta*, another pattern, is also common and very similar to *Raffaellesco.* Differences occur in the quality of materials (glazes and clay) as well as the skill of design and draftsmanship of the finished product.

One of the joys of visiting Deruta today is being able to sit down with a *maestro* and work out your own special pattern, whether a color variation on a traditional model or a set of plates incorporating your family coat of arms, knowing that you are taking part in a tradition that is hundreds of years old.

It is impossible to single out specific studios to visit, and the following profiles are only meant to be an overview of the different types of ceramics being produced in Deruta today.

Gallo Verde, or
Green Rooster, is a
relatively new design
developed in the
nineteenth century.
Based on thirteenth and
fourteenth century
green and white
works, the designers
modernized the vegetal
motifs and added
the rooster.

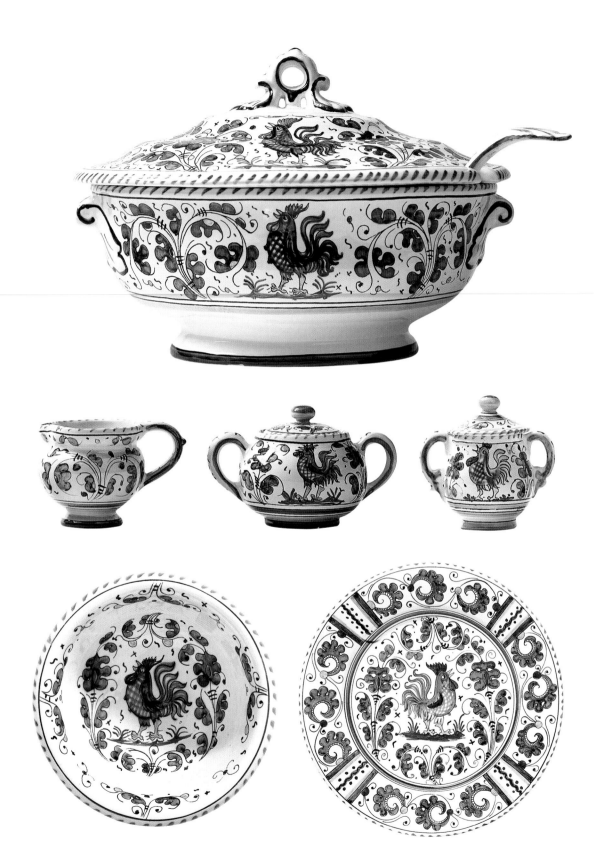

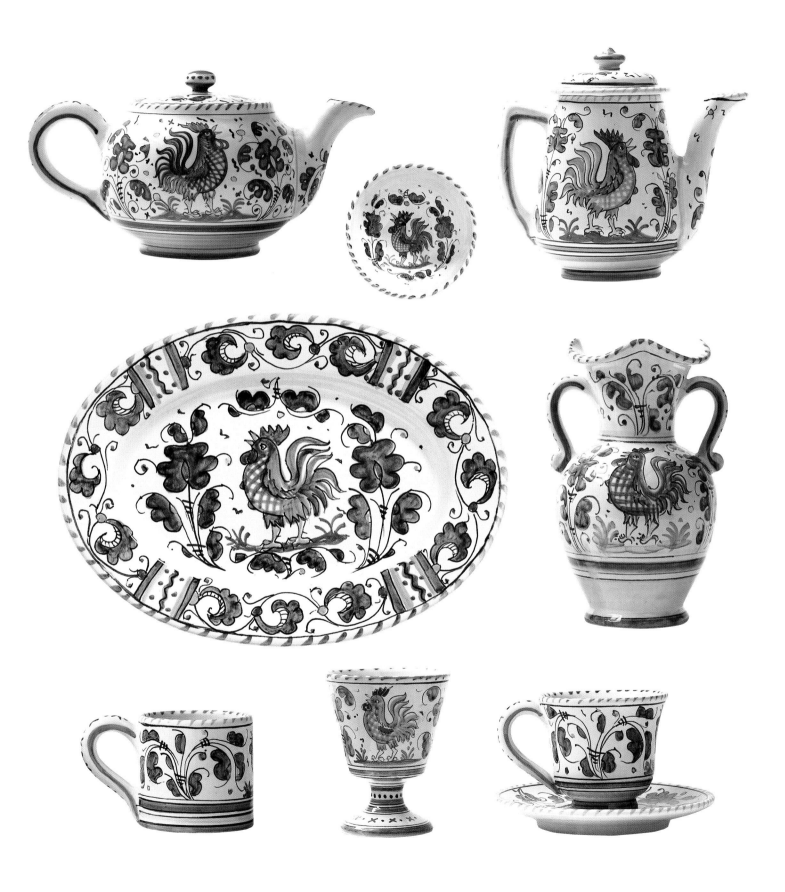

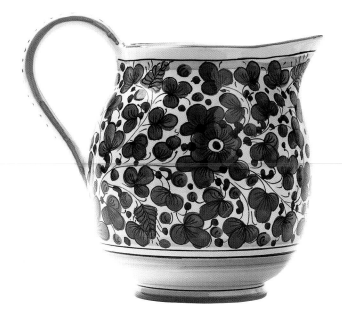

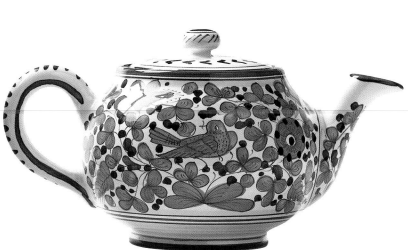

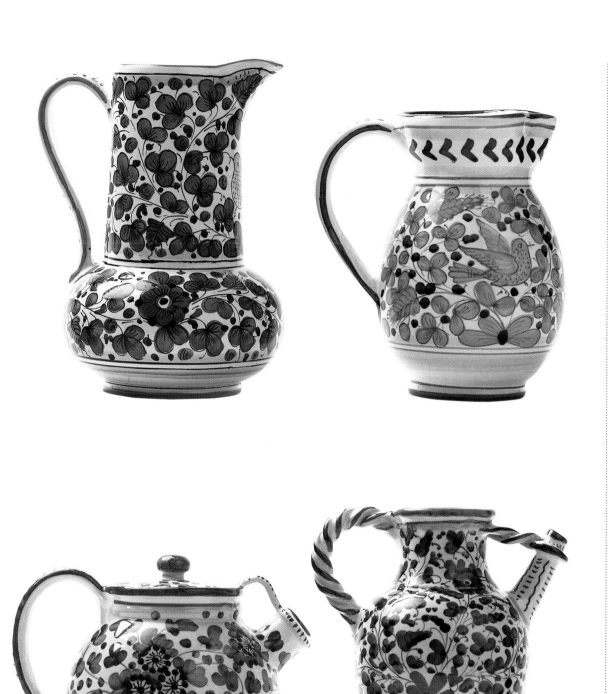

Arabesco is one of
the most beloved of
Derutese patterns and
is based upon the
seventeenth-century
Calligraphic pattern.
Today's variations
include numerous color
combinations applied
to forms never dreamed
of by seventeenth-
century potters.

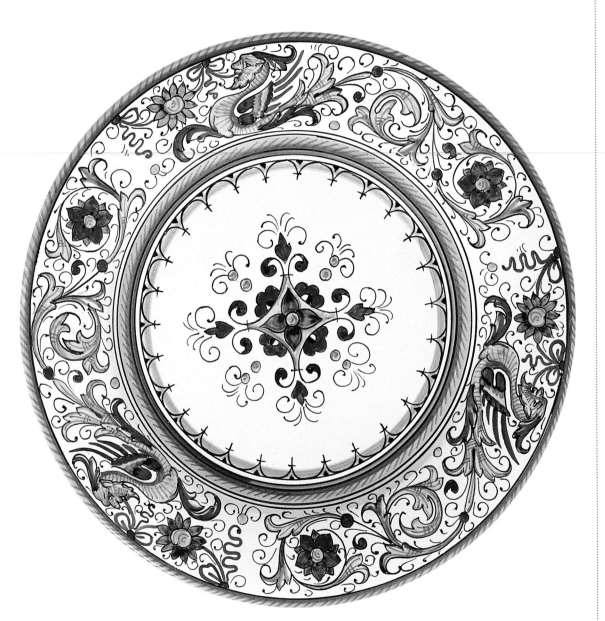

Raffaellesco and
Ricco Deruta are the
patterns most people
associate with Deruta.
The two patterns,
both developed in the
sixteenth century and
based upon decorative
details from fresco
and paintings, are
constantly reworked to
create subtle variations.

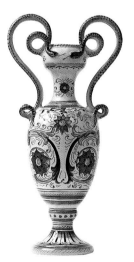

Left: Raffaellesco is inspired by the grotesques designed in the sixteenth century frescoes by Raphael in the Vatican Palace.

Right: Ricco Deruta reinterprets decorative details of such frescoes as those by Perugino in the Cambio in Perugia.

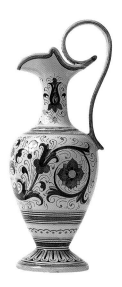

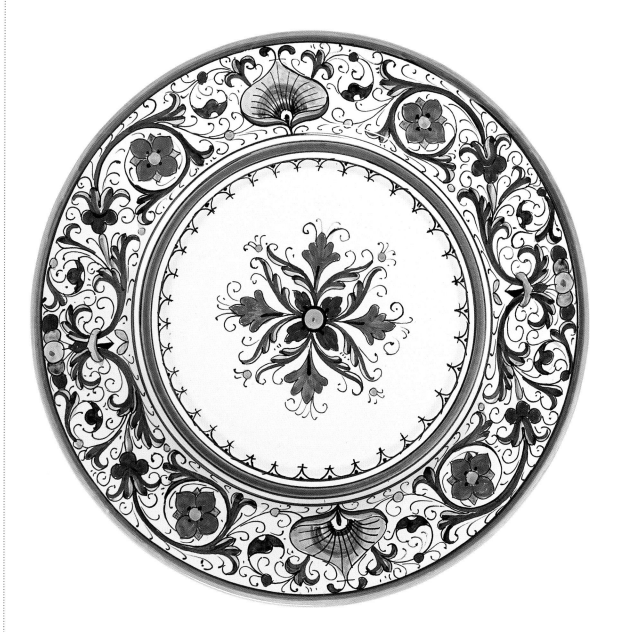

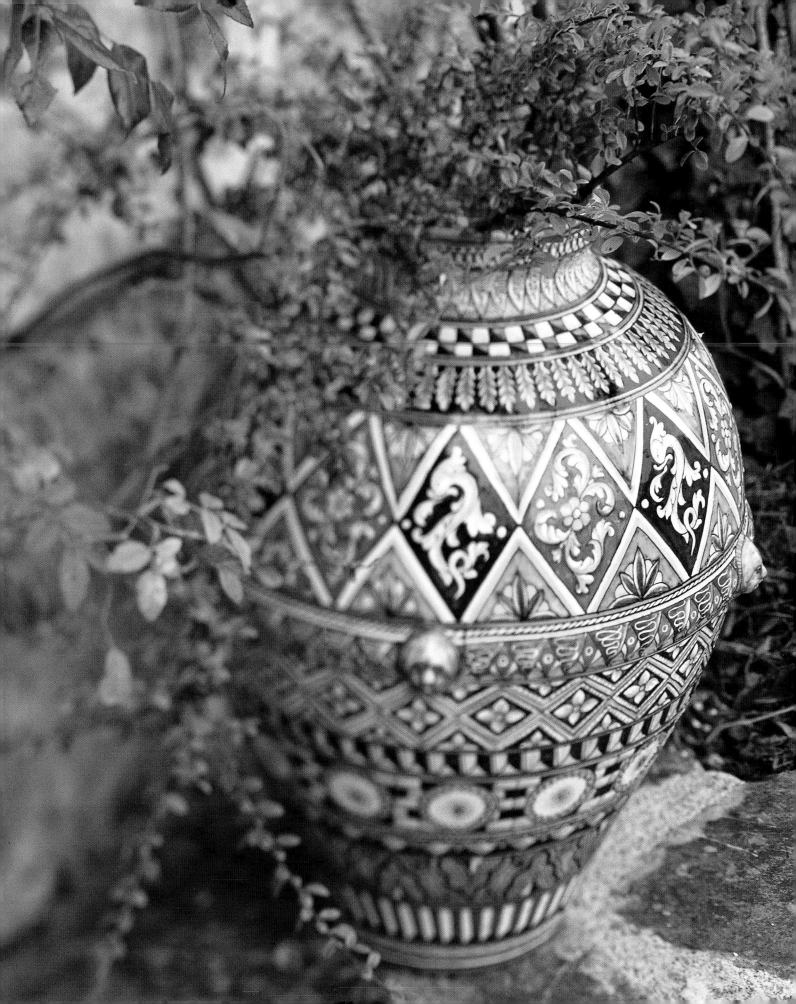

Franco Mari

Like almost everyone in Deruta, Franco Mari was born into a family of ceramists; in fact, his father founded one of the largest factories of the post–World War II period, Fratelli Mari, which produced an enormous quantity of objects for the Italian souvenir market, taking full advantage of the conveniences of modern industrialization. Today, the firm is still one of the largest in town, but Franco Mari is quick to distance his ceramics from the rather industrial works that come off their assembly lines.

Although he learned much about the trade from his father, Mari also attended the fine arts school in Perugia. He knew he wanted to strike out on his own, rather than begin his career at the low end of the assembly line in a big factory. From the start, his vision of ceramics was also clear: He saw the clay and glazes as an outlet for his creative expression and realized that he would be stifled in a more industrial commercial atmosphere.

Left: Over the years, Franco Mari has come to specialize in tableware, responding to the demand from his clients. Yet when he does venture forth into large scale decorative pieces the results are a strong and vibrant display of his vivid decorative sense.

Right: Many of Mari's designs find their inspiration far from Deruta. He developed Terra Mesa after a trip to Santa Fe, where he was impressed with the geometric forms and bright saturated colors of Native American art.

In the early 1980s, Deruta was in the middle of an economic slump, and the moment was not right for launching a new business. Rather than let this turn of affairs discourage him, Mari set off for the United States, and this trip was to prove essential in the development of his style. He soon found work at Biordi's of San Francisco, one of the oldest importers of Italian majolica in the United States. He set up a demonstration area in the store where the public could watch him work and ask him questions. "The encouragement and appreciation of the people of San Francisco was an incredibly positive experience for me" says Mari. "At that time, no one in Italy understood what I was trying to do, and no one thought I could sell the pieces I was creating. Yet in California they understood it immediately!"

Once back in Italy, he set out in a daring new direction. Taking the antique designs and patterns of the Renaissance and baroque periods, he adapted and applied them to modern aesthetics and uses. An ornate border from a Renaissance display plate became the decorative theme for a set of dinner plates. A motif borrowed from a baroque ewer wrapped its way around a coffee mug.

Mari was one of the
first designers in Deruta
to understand the
decorative possibilities
offered by the geometric
patterns of the
Renaissance.

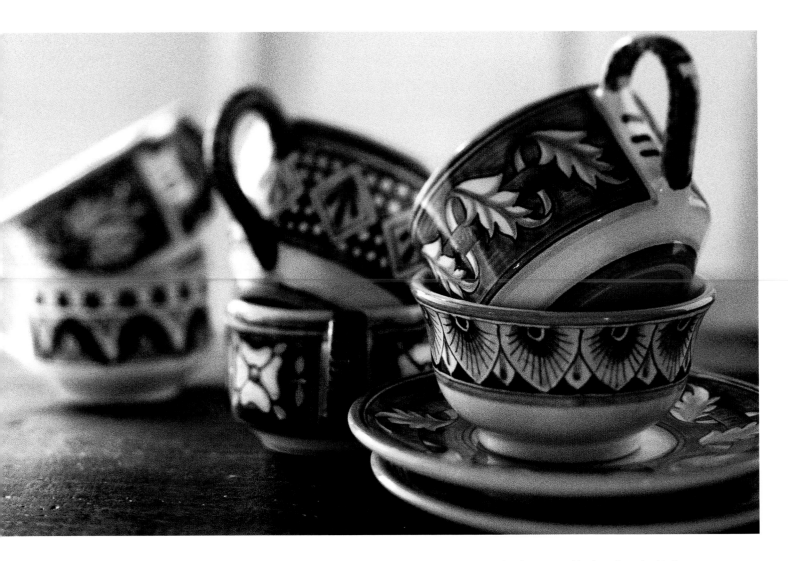

Franco Mari views his forms as a canvas, where the most important element is the decoration. He doesn't sculpt his forms at his studio; he orders them, in the bisque stage, ready to receive his designs. For this labor-intensive work, he employs fifteen decorators who work at long benches, side by side, in the basement workroom of his shop along the Via Tiberina. With the glow of bright lights overhead the painters painstakingly copy the master prototypes, which have been prepared by Mari. Every available inch of floor space is taken up by metal carts groaning under the weight of painted ware waiting its turn for the final firing in the kiln.

While many of the firms now reproduce the standard Renaissance patterns and their modern variations, Mari's is one of the few that develops completely unique patterns. His earliest patterns were based on specifically Derutan motifs, but he has recently developed several that have grown out of his travels to the United States.

After a visit to the Anasazi Museum in the Terra Mesa National Park he developed patterns called Anasazi and Terra Mesa. "I immediately felt a connection to the patterns, textures, and colors that I saw there," says Mari. Yet looking at the results on a

brightly colored coffee pot, "Native American" is not what springs to mind. These are influences that Mari has assimilated and manipulated to create something uniquely Italian. And while his exposure to America has enlarged his decorative vocabulary, his purpose is not to make American designs for American clients. The pieces remain extremely Italian.

A distinguishing characteristic of Mari's work are his glazes. They are always rich and saturated with a smoothness and brilliance, and an almost glasslike finish, that is unique to his ware. The coating gives his dinnerware an incredibly attractive quality. The mugs beg to be cupped in both hands, a steaming brew of foamy cappuccino brought up to the lips. This final transparent glaze is a family secret, which Mari inherited from his father.

As anyone buying a set of dishes from Deruta knows, one of the hardest decisions is which of the countless patterns to choose. Mari makes the decision easier by enabling his patterns to be mixed and matched. This is not a marketing trick he devised, but the result of something inherent in each of his designs that connects them to each other. This "something" is his own specific creative vocabulary.

Mari's clientele is for the most part American. "I think that only the Americans can truly appreciate the labor that goes into each and every piece," says Mari. Even his "local" clients in Deruta tend to be American expatriates living in Rome who drive to his workshop to add to their collections of his pottery. Most people freely admit to being addicts, and because Mari is constantly developing new and exciting patterns he only fuels their obsession.

Mari retains absolute creative control. While bigger firms encourage foreign designers to develop patterns that they will produce, Mari insists on his production being a reflection of his personal vision.

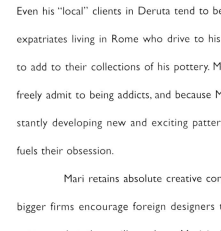

Left: One of the qualities that people most like about Mari's dinnerware is the ability to mix the patterns to create new and exciting place settings to adorn their tables.

Right: The almost jewel-like patterns in Anasazi are rendered even more precious by the clear glaze that turns a coffee pot and sugar bowl into shining explorations of tone and color.

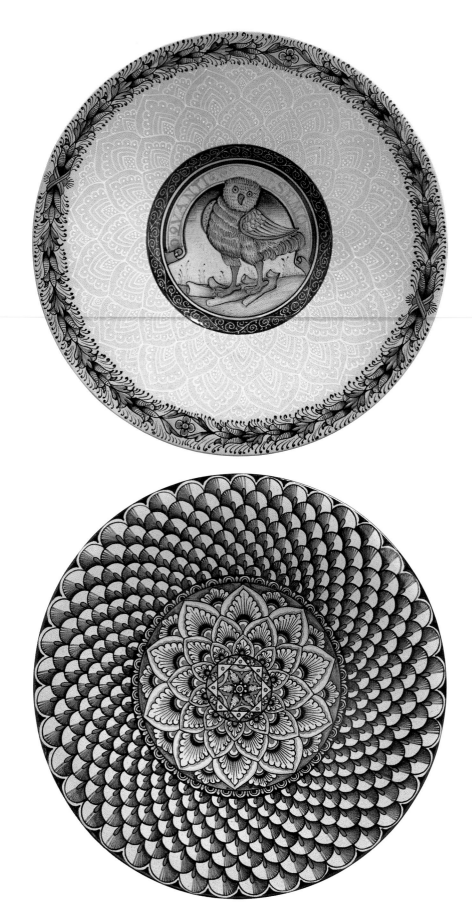

Upper left: One of the many "lost" techniques that Antonio Margaritelli employs is the exquisitely delicate White on White pattern, perhaps inspired by the local tradition of lace making.

Lower left: While other potters in Deruta now use the Renaissance geometric patterns to decorate cups and saucers, Margaritelli still gives these traditional designs the full attention they deserve, using them to decorate plates and bowls intended solely for display.

Antonio Margaritelli

From the exterior, Antonio Margaritelli's store looks like many of the other low-slung, new buildings that line the Via Tiberina. Located just past the only stoplight in town, the modern building has an intimidating steeply sloped parking area. But once you step through the glazed doors, the differences from the other shops around town are immediately apparent. No Green Rooster pattern here; in fact, the first display cabinet contains a collection of objects not even for sale. Revealing his passion as well as his source of inspiration, the most prized of Margaritelli's enormous collection of Renaissance fragments are proudly displayed, many rivaling those on view in the museum nearby.

After seventeen years at the Grazia factory, where he learned skills from his *maestro*, Virgilio Spaccini, as well as an appreciation of tradition, he opened his own workshop. He sought a deeper understanding of Deruta's past and studied treatises, such as that by Piccolpasso, and examined ancient fragments. "If a building was being destroyed, or a new sewer was being dug, I was there," remembers Margaritelli. "I was always ready to drop everything for a chance to find precious bits of glazed pots that could unravel the secrets of the past." The best time was after it rained, when the brightly colored fragments seemed to float to the surface of the newly overturned earth, glistening like the day they were painted.

Right: The high footed vase is a sixteenth-century form that Margaritelli reproduces using only colors that were available to antique painters.

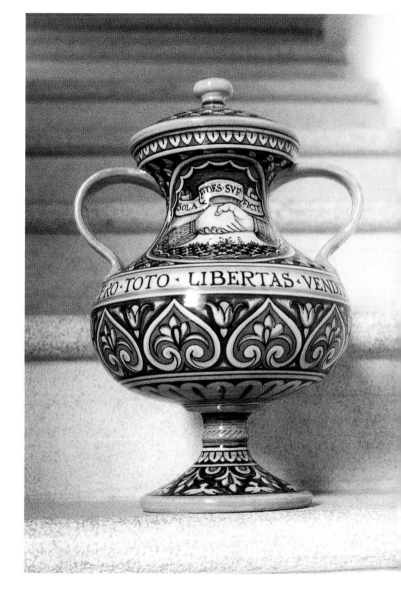

Margaritelli soon realized that these sixteenth-century fragments held a fascination and rich beauty that was missing from contemporary production, and it was these mysterious qualities that he set out to capture. Through painstaking research and experimentation, he rediscovered the old formulas for glazes and began to mix his own, using them instead of the new, industrially produced colors. When he dug up long-lost patterns, he reproduced or reworked them to create new designs. When showing off his wares, Margaritelli's manner is more professorial than businesslike. His book-lined showroom attests that he enjoys the research as much as, or more than producing works to sell.

He has only one assistant, Maria Tomassini, who has been with him for twenty years. Together, they produce only a few hundred pieces per year, each one completely unique. Because of his extremely low and unpredictable production he rarely exports his pieces. His dedicated clients willingly make the pilgrimage to his shop. "Although my work is for everyone," says Margaritelli, "I think that to appreciate it takes a refined point of view."

His passionate approach to ceramics involves continuous research. Together with colleague Patrizio Chiucchiù, he found the secrets to the lost art of lustreware. "After Ubaldo Grazia rediscovered this technique at the beginning of the century," explains Margaritelli. "He carefully guarded the secret recipe, so I was left to start from scratch." But today he makes this lustreware mostly for himself, since its appeal is limited and its cost is considerable.

Margaritelli specializes in decorative and ornamental pieces, avoiding tableware. "I like to think of my creations as books, to be picked up, looked at, enjoyed," he says. "There is always something new to be learned from one of my pieces. These are objects of attention that should make you think."

Left: Margaritelli has become well known for his version of the sixteenth-century *coppe amatorie* or loving cup. Traditionally given to each other by lovers, the plates bear the initial of the giver.

Right: The familiar scene of a potter carrying his wares to market has been a favorite theme in Deruta for centuries. Though the weekly open-air markets now concentrate on Tupperware and brooms, this design can be found in the showrooms that line Deruta's streets.

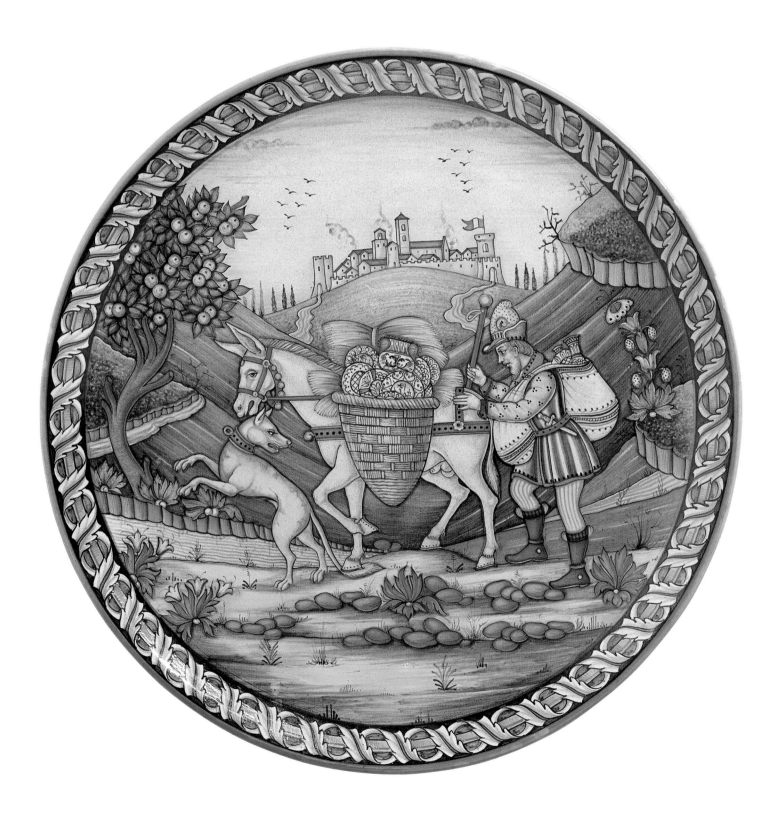

Francesca Niccacci

Francesca Niccacci is a rarity in Deruta. As far back as she can remember, no one in her family was remotely involved in ceramics. Her family's livelihood was made in the town's other main employment: agriculture. Niccacci is one of the few women in Deruta to start her own business, especially without the backing of a ceramic family. Although it is common for women to work as painters, where their delicate touch is highly valued, it is rarer for them to strike out on their own. Her workshop has grown slowly over the years and now occupies a large building on the family property, where it sits amid fields cultivated with sunflowers and wheat. She employs four painters, all women, and her husband, Amilcare Boccali, oversees the finances.

Niccacci's first exposure to the ceramic trade was during summer vacations. From the time she was fourteen years old, she found part-time employment in the bigger factories. She tried drawing and painting, for which she showed an immediate aptitude. She later attended the local institute of fine arts, where she learned the fundamentals of ceramics while focusing on fine arts and sculpture, since she had little intention of spending the rest of her days in the ceramic trade.

Upon graduation, she took a job in one of the larger ceramic factories for a year and during this time, she started studying with one of the great old masters of Deruta, Cesare Margaritelli. Still unconvinced of her calling, she headed for the university, where she majored in the fine arts. After two years she left, and for a while was a substitute teacher. "But

Left: Francesca Niccacci wraps traditional Renaissance geometric and floral motifs around sugar, cookie, and coffee canisters.

Right: The brightly colored fruits of Sicily inspired both the palette and pattern of this apothecary jar.

something was missing," says Niccacci. "I felt I was just wasting my time, waiting for something to present itself." At age twenty-two, she went to study ceramics with another master, this time Romano Ranieri.

"Then, in 1972, at my father's death, I realized that I had to take charge and decide what to do with my life," says Niccacci. So, at the age of twenty-three she set up her own shop. "I think I'm the only one in this town to have started with such a miserably small workshop," she says. "Workshop" is a bit of an exaggeration, though, since she began with only a table and three paintbrushes. She didn't even have a kiln and was forced to take her pieces somewhere else to be fired.

Niccacci's first works were panels, purely decorative pieces, almost paintings in ceramics. This type of work came straight from her masters' repertoire and can be traced back to the influence of Amerigo Lunghi, whose ceramic murals still adorn the buildings of Deruta. Her style is firmly based in Deruta's tradition. Although the religious plaques that started out business are now only a small part of her output, her emphasis is still on decorative pieces, though in response to American demand, she has recently ventured into tableware. "The most important thing to me is the design of an object," says Niccacci. "I could never have remained in a big factory, painting the same thing over and over, day after day. The excitement to me comes from laying the brush on the form and creating an image for the first time."

Although the initial designs of the dinnerware sets are Niccacci's, she happily leaves their execution to her assistants. She also creates one-of-a-kind plates and urns that are decorated in the center with exquisitely delicate Renaissance motifs or the *Belle,* her version of idealized female beauty.

Working for an American clientele has expanded her repertoire, and Niccacci is always willing to adapt her designs to specific requests. "I recently changed the color scheme of a pattern I developed to suit a client, who insisted on an olive green that I had never used and that really had no history in Deruta," she says. Although the result may appear new and slightly foreign to Niccacci, to the client only the centuries of tradition come through once the piece is lovingly installed atop a mantelpiece.

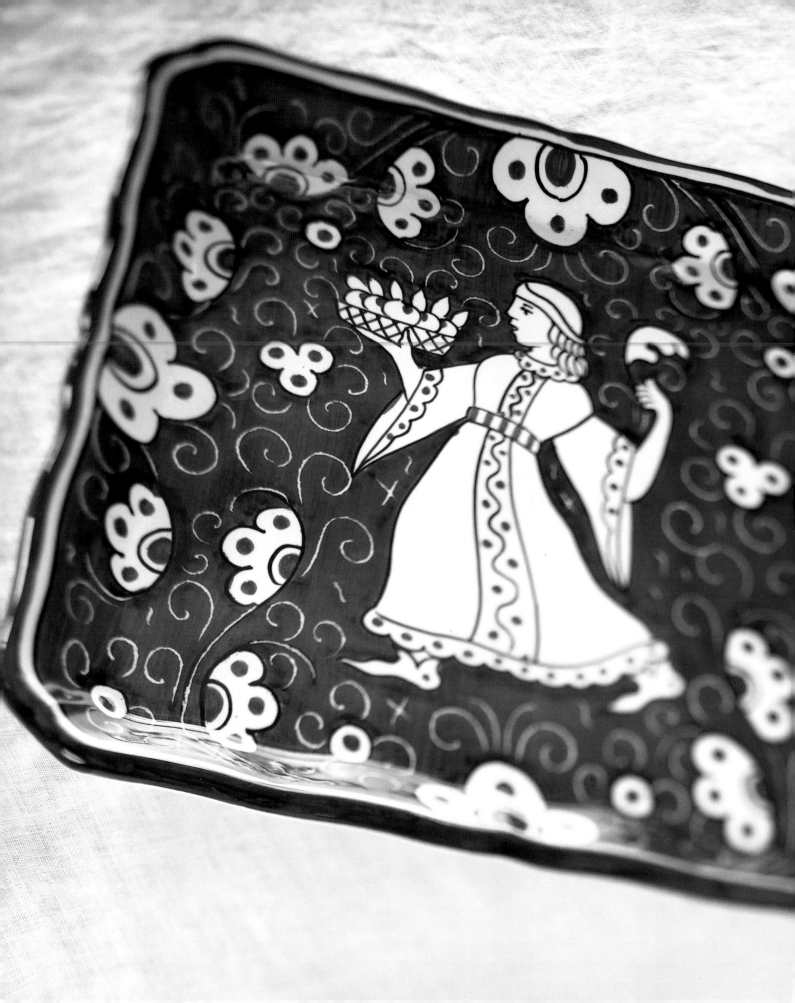

Grazia Deruta

Ubaldo Grazia's most vivid childhood memory revolves around the beating heart of his grandfather's ceramic factory. Growing up in the Grazia family, the large turn-of-the-century *fabrica* was young Ubaldo's personal playground. But on one occasion he was allowed a special treat: to stay up all night with *nonno* Ubaldo as he oversaw the firing of the wood-fueled kilns. (Although the factory had the option of using the more modern electric kilns, the wooden kilns were still functioning until the mid 1950s.) The night young Ubaldo remembers was spent amid the *fornaciai*, who controlled the fires that turned the clay and sand into brightly glazed vessels to be shipped around the world. His clearest memory of the long night is the dawn, after the most difficult work was done. His grandfather picked up a terra-cotta crock from amid the glowing coals and carefully lifted the lid. Little Ubaldo, with the exhausted workers,

Left: Renaissance figures and Archaic leaves float freely over the contemporary form of this tray in a new pattern, Figurino Archaico, crafted by Grazia Deruta.

Right: Uva Bianca, or White Grapes, is as fresh and vibrant today as on the day it was conceived in the eighteenth century. The only new additions to this traditional pattern are the contemporary forms it now decorates, including water pitchers and flower vases.

sat down to a breakfast of slowly cooked beans, fragrant with the heady perfume of the wood fire that enveloped them all in its warm embrace.

Ubaldo Grazia, named after his grandfather, knew he would one day take over the family factory, whose history stretched back to the last century. He never formally studied the art of ceramics, but knew each step of the process intimately. He had a clear idea of what his role should be from the very beginning, telling his father that he would only assume responsibility once his father retired, thus making his personal vision possible from the start.

So, in 1973, at age thirty-three, he gave up his self-styled career as a playboy and took over. Although the factory had been successful for the better part of a century, he saw the need for drastic change if they were to survive and grow.

Grazia Deruta had been dealing with a large American importer for over forty years, and by the time Ubaldo assumed control, they had reached an impasse. The oil crisis had almost doubled production costs, yet their

importer, who had never even visited the factory, had no intention of raising prices, which had remained unchanged for years. "We were at their mercy and as long as we were dealing with middlemen we had to play their game," recalls Ubaldo. He made a brave decision to deal directly with clients. He was able to embark on such a risky venture because the factory had another big, and, he believed, secure contract with an international chocolate company based in Perugia.

A third of Grazia's profits were due to their contract with the large chocolate firm in Perugia. When the company was sold in 1982, the contract was canceled and Grazia saw his business shrink by one-third, from one day to the next. "I think that was the blackest day of my life," says Ubaldo. "I had to call everyone in to my office and tell them the news."

As black as things seemed, it pushed Ubaldo into what he calls his *aventura Americana*, or American adventure. "I made a trip to New York soon after and I realized that we either had to conquer this market or close. As simple as that." So for the next four years he spent a third of each year in America, knocking on the doors of the biggest stores across the country. His break finally came when Henri Bendel asked him to provide three exclusive designs for their store, which were an enormous success. Today it is difficult to name a major American department store that hasn't sold the Grazia ware.

His *aventura Americana* has also affected his line of work. Until the early 1980s, the designs that Grazia produced were very much based on traditional sixteenth- and seventeenth-century designs. Although their catalogue of patterns was quite extensive, American clients were always asking "What's new?"

"I realized that our traditional repertoire wasn't enough. That I had to have a new line to present every year, much like a fashion designer," says Ubaldo. He decided to invite an American designer to come to the factory and work out a line. The first in a long

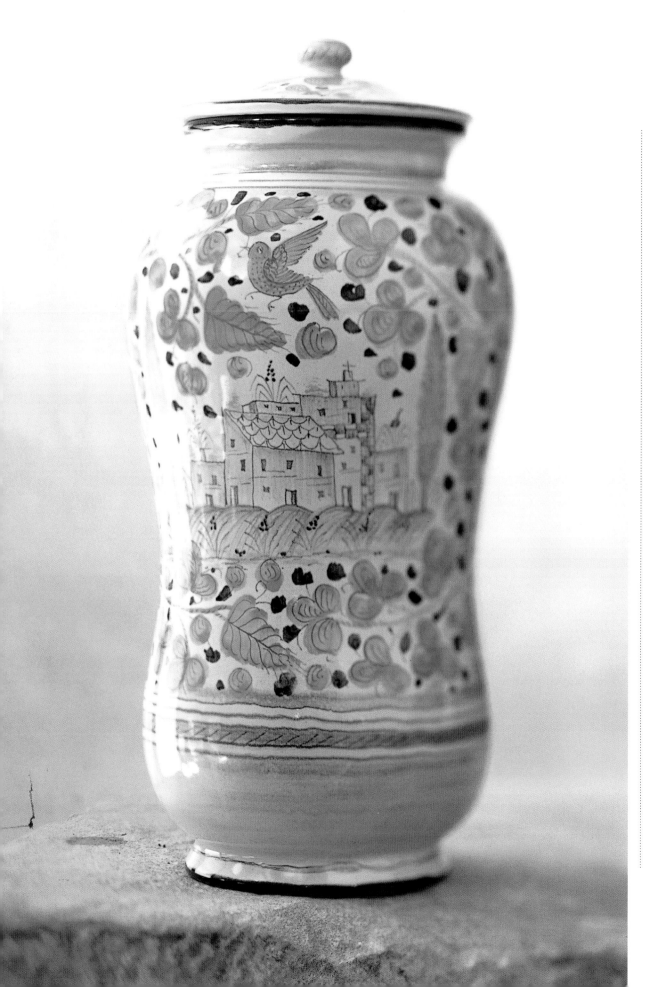

Far left: The orange and blue variation on the *Arabesco* pattern remains a perennial favorite and can be found decorating everything from enormous garden urns to diminutive espresso cups.

Left: There are always surprises for anyone willing to shift through the mountains of ware in the Grazia showroom. Many of the works for sale date back to the 1940s and 1950s. like this classically elegant apothecary jar. decorated in the seventeenth-century *Calligrafica* pattern. known today as *Arabesco.*

Left: Scroll is produced by Grazia for Tiffany's and is based upon a turn-of-the-century design by Louis Comfort Tiffany. The original design, intended for crystal, is reinterpreted in a pure white glaze.

Right: The sober form of a sixteenth-century apothecary jar, with an invented coat of arms, is put into service to hold a bunch of freshly cut olive branches.

list of artists and designers was Jaquelin Rice, from the Rhode Island School of Design. The marriage between contemporary design and traditional Deruta technique has been a happy one, and now people come from all over the world to work in the Grazia studios. Designers such as Pat Farrell, Susan Eslick, Angela Cummings, and John Okulick design their signature lines of ceramics in the Grazia workrooms.

One of the things that draws artists and designers to the Grazia factory is the liberty that Ubaldo gives them. "I realize that every designer has a different approach, and to get them to give their best, they have to

be free to develop in any direction they choose. We never start out with a client in mind, or a certain market niche," he says.

Taking a tour through the vast series of light-filled rooms that make up the factory, it's not uncommon to hear English, German, French, or even Japanese spoken. The enormous vats of glazes are the designers' palette, to play with as they will. When the will is there but the technical knowledge is lacking, helpful artisans explain the intricacies of the craft to their guests.

Another element that attracts the designers, accustomed to working with large industrial firms, is the chance to design something that will be handmade though produced on a large scale. Grazia extends these invitations in the hope of developing new patterns for his line, but he is also happy to host an artist working towards an exhibit of one-of-a-kind pieces. "Then, the only thing we ask is that they donate a piece to the local museum," he says. The Grazia family, in fact, recently donated their own private collection, containing works from the fifteenth century to the present, to the local museum.

Roughly eighty percent of Grazia's ceramic ware heads for the United States, with the rest going to Japan, Korea, and Germany. Very little stays in Italy, where the craft of ceramics is not appreciated. "Italians want Art with a capital A, and this leads to a certain narrow-mindedness when it comes to the craft of ceramics," explains Grazia, "Not only do they not appreciate the labor and artistry that goes into every piece, they are unwilling to pay for the skill necessary to produce the works."

While much of the ware that Grazia sends out is contemporary in aesthetic, he very much believes that his success is due to the fundamentals of tradition. Unlike some in the town, Grazia is optimistic about the future. The size of his operation allows him to take on two or three new apprentices a year, who learn the techniques of the trade in the time-honored way. Many stay on to work in his factory for years, some go on to carry the tradition to their own, or smaller, firms. And every so often he spots a great *maestro* in the making.

"Everyone thought I was crazy when I started inviting people outside Deruta to produce contemporary designs," recalls Grazia. "But tradition and innovation have always co-existed in Deruta. It's what keeps things going."

Right: The designs at Grazia are often derived from the family's personal collection of Renaissance fragments which are displayed in the workshop (see end papers) and provide a constant source of inspiration, as seen in this apothecary jar.

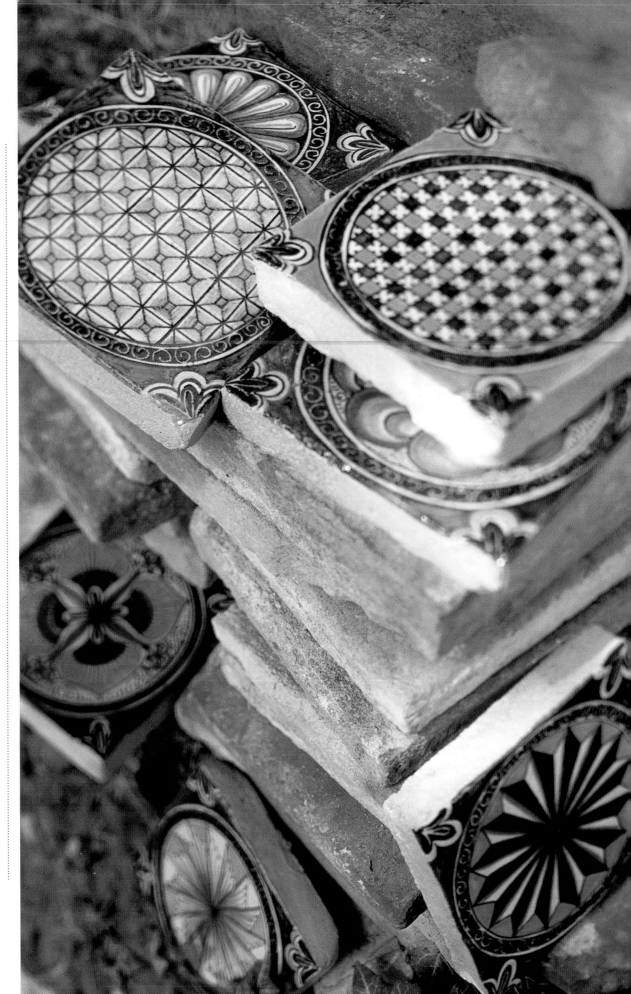

Right: Tiles are one of Patrizio Chiucchiù's passions. With clay he mines himself, he forms the tiles in handmade wooden frames. These pieces need to be held in order to appreciate their texture and heft, and the subtle irregularities that make each one unique.

Ceramiche Chiucchiù

It is fitting that Patrizio Chiucchiù's shop is located in the heart of the old town. While many in Deruta have embraced modern innovations such as industrially produced glazes, he has made a conscious choice to recapture the spirit and techniques of Deruta's glorious sixteenth and seventeenth centuries. Stepping into his minuscule shop with book-lined shelves is akin to entering a Renaissance *studiolo*.

Hunched over his small workbench, Chiucchiù works on his incredibly detailed pieces, usually cradling them in his hands. The bench is crowded with books and bowls of glazes he mixes himself. Behind him a glass-fronted cabinet holds the small cups of the raw minerals he mines and then transforms into pigments; bits of sixteenth-century majolica; and examples of his own works he cannot bear to sell.

Ceramiche Chiucchiù is very much a small, family-run business. Chiucchiù relies on his father to turn his forms, and his wife helps him with the decoration. But the extremely labor-intensive works that come from his little shop are a product of Patrizio's passion for the works of his ancestors; his production is very low. One piece can take him over a month to finish. "Although I'm always happy to sell something, there is a part of me that is very sad to see a piece leave the store," he says. "There's a little bit of me in each piece I make."

Chiucchiù, like Antonio Margaritelli, has realized that to capture the look and feel of the Renaissance masterpieces he has to use the materials of that period. "There is a reason that Deruta is located where it is," says Chiucchiù. "The hills and riverbanks are still full of the same clay and sand that potters used centuries ago." And while it would be easier to order the clay and glazes he needs from industrial suppliers, Chiucchiù is the only artisan in town who prefers to gather the raw materials himself. Once

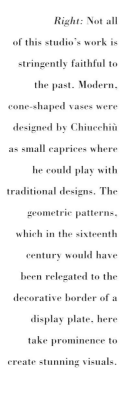

Right: Not all of this studio's work is stringently faithful to the past. Modern, cone-shaped vases were designed by Chiucchiù as small caprices where he could play with traditional designs. The geometric patterns, which in the sixteenth century would have been relegated to the decorative border of a display plate, here take prominence to create stunning visuals.

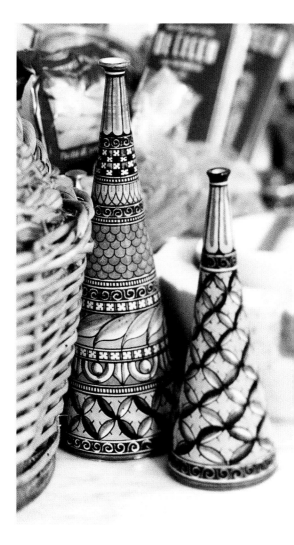

the winter swelling of the Tiber river subsides, he heads down to its banks to collect both clay and sand. The clay will be purified and processed to form the light-colored vessels he will then paint. The sand will be used as the base for the glazes that he will mix himself, with pigments based on sixteenth-century recipes. While some potters guard their hard-won secrets, Chiucchiù has a different attitude. "Perhaps I approach things from a more scientific frame of mind" he says. "I write absolutely everything down. While I'm very much concerned about the finished

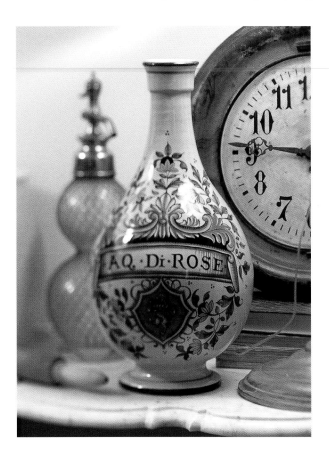

piece, there is also a certain beauty in the formulas and equations that I have to work through to reach the final stage." One day, Chiucchiù hopes to publish his findings as a tool for other potters.

Chiucchiù studies chemistry, archaeology, and art history, going back to the sources that inspired Renaissance masters. Like those of the painters of the sixteenth century, his workshop is littered with copies of the prints by Marcantonio Raimondi and Marco Dente, after works by Raphael and his school.

Chiucchiù will occasionally replicate a Renaissance piece exactly, even going so far as to give it an antique, used look. It takes an expert eye (and even then some fail) to differentiate a Chiucchiù piece from one produced five centuries ago. More often he will slightly change a design, or apply a traditional design on a modified form. "Some of the great plates of the Renaissance capture a kind of beauty that doesn't always appeal to our modern eyes," says Chiucchiù. "For instance, the great lustres are almost impossible to sell, and I often redraw the crudely drawn female faces to reflect today's standards of beauty."

Chiucchiù works with unflagging dedication and emotion when he transforms simple clay into a work of art. "If you don't do this with a passion," he says, "it just becomes a job like any other."

Left: Rose water is no longer a staple of every pharmacy, yet the faithful reproduction of a seventeenth-century apothecary jar and pattern can grace any environment.

Right: Chiucchiù's fidelity to the past does not inhibit him from improving long-established traditions. Here he has adapted a typical image from the Deruta repertoire, the so-called *Belle* of the sixteenth century. These exquisitely rendered female profiles adorned display plates. Chiucchiù painted his *Bella* on an *alberello,* or apothecary jar, here used as a vase.

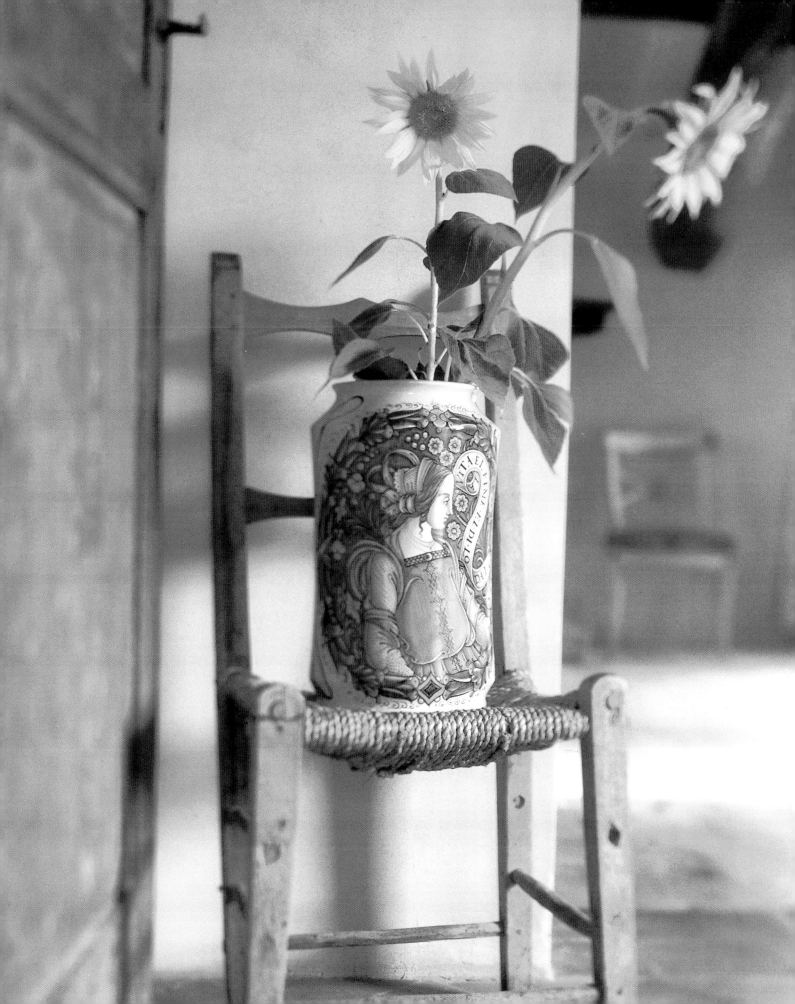

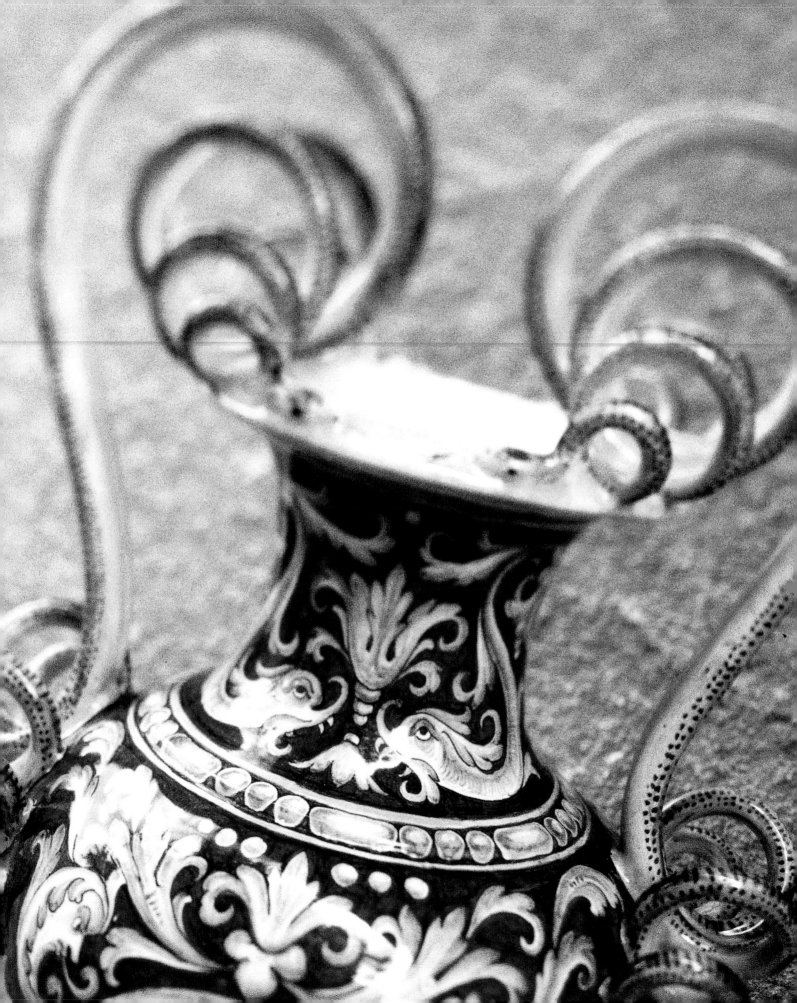

Ceramiche Sberna

These days, working in a factory at the young age of fourteen has a ring of child labor to it. Yet for Francesco Sberna, who was born in the 1920s, it was a simple choice. He knew from an early age that he wanted to study ceramics, and the only place to perfect this craft was within the atmosphere of the workshop. The rest of his education was not left by the wayside; he continued his studies in the evenings, under the tutelage of Alpinolo Magnini. At night school at the fine arts institute, he learned the history of his chosen craft and the practical aspects of traditional design and studied the works in the museum's newly formed collection.

After working in several of the larger factories, Sberna began his own business in 1959, soon to join the ranks of the other "big factories" in town. With over thirty workers, Sberna is one of the largest producers of majolica in Deruta. Their modern showroom, directly across the street from the turn-of-the-century Grazia factory, is like a glistening jewelry box, bursting to the seams with full services of all the classic patterns.

Left: Although Ceramiche Sberna concentrates on large orders of tableware, it still produces intricate, one-of-a-kind pieces, such as this sixteenth-century-inspired vase. Francesco Sberna oversees the design and manufacture of all of the works that leave the factory, but his personal touch is only applied to masterpieces such as this.

Right: Like many firms in Deruta, Ceramiche Sberna produces its own variation of a set of tableware with a geometric design based on sixteenth-century patterns.

Row upon row of services of *Gallo Verde, Arabesco,* and *Raffaellesco* tower up to the ceiling on long rows of shelving. What can't fit on the shelves is precariously stacked on the floor. At any given time, groups of plates and bowls are piled together in corners waiting to be sent off to far-flung trade fairs. While artisans like Chiucchiù and Margaritelli produce only a few dozen, one-of-a-kind pieces a year, Sberna overwhelms with the shear quantity of works on display.

"Many modern innovations have made the life of the ceramic painter a lot easier," says Sberna. "In the old days, we spent hours and hours copying designs and transferring them onto the stencils that would be applied to the works." Today, the copy machine accomplishes in seconds what used to take hours of time and years of skill.

Yet Sberna tries not to let modernization replace a skilled hand. He oversees all stages of production, particularly the training and apprenticeship of new designers. Sberna wears his years proudly and feels it is very important to pass his knowledge on to the next generation.

While most of the designs are classical and overseen by Sberna himself, the new generation will work directly with visiting designers who desire a specific look. Francesco Sberna's large Raphael-inspired display

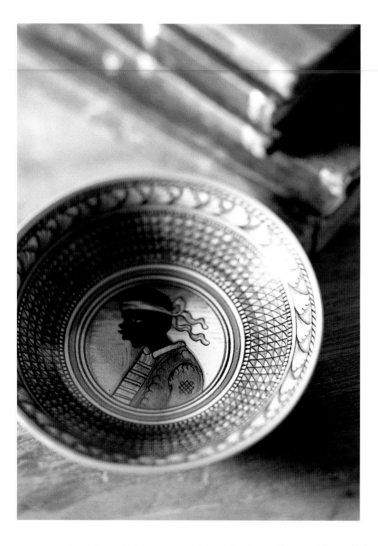

plates hang above brightly glazed sets of mugs with "greeting card" themes such as gardening, sewing, and Easter bunnies. Yet even when these lighthearted excursions into contemporary imagery make their way into the Sberna repertoire, Sberna's fine eye and traditional sense of design and style predominates. While other large factories in town may display a slapdash quality in their work, Sberna insists on a steady hand and a strong line.

Sberna is very much a family-run business and when visiting the showroom one steps into the life of the family. Daughter Anna, who runs the office, lives in the old part of town, where the family also maintains a showroom. The rest of the family, made up of three generations of Sbernas, lives upstairs. Grandchildren pass through on their way to and from school, treading carefully amid the precariously stacked breakables. Around one o'clock, the delicious aromas that come wafting down the stairs become too hard to resist, and everyone heads upstairs for the midday meal prepared by *nonna*.

Left: The *Testa di Moro*, or Moor's Head, pattern recalls a very famous set of apothecary jars made in Deruta in the sixteenth century. Many of the jars still exist throughout the world in museum collections.

Right: The tableware intended for export to the United States must adhere to rigid lead-content controls. Sberna, along with many other firms, now use lead-free glazes that convey the intensity of the old colors.

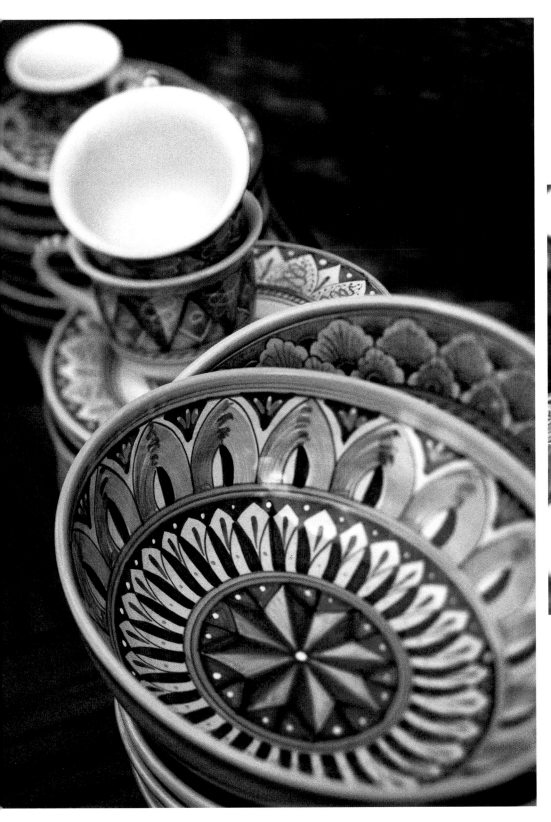

Sources

There are over three-hundred ceramic studios in Deruta, refecting a wide variety of styles, merchandise, and quality. Because of space limitations, this book has only scratched the surface of the total industry. A full listing of the firms in Deruta can be obtained at the tourist office, Pro Dertua, in the main *piazza* in Deruta.

The following stores in the United States carry a selection of ceramics from Deruta: Barney's New York Bergdorf Goodman Henri Bendel Neiman-Marcus Nordstrom Saks Fifth Avenue Starbucks Tiffany's Williams Sonoma

IN ITALY

C.A.M.A.
Via Tiberina 113
and
Via Michelotti 12
Deruta, Italy 06053
075.971.1182

Ceramica Gialetti Giulio
Via Tiberina Sud, 304
Deruta, Italy 06053
075.972.021

Ceramiche Chiucchiù
Via Umberto I, 19
Deruta, Italy 06053
075.971.0747

Ceramiche Sberna
Via Tiberina Centro, 146
Deruta, Italy 06053
075.971.0206

Fratelli Berti (Carlo and Remo)
Via dei Mille, 5
Ripabianca, Italy 06053
075.973. 273

Grazia Deruta
Via Tiberina Centro 181
Deruta, Italy 06053
075.971.0201

Antonio Margaritelli
Via Tiberina 214
Deruta, Italy 06053
075.971.1572

Franco Mari
Via Tiberina 236
Deruta, Italy 06053
075.971.1224

Vecchia Deruta
di Francesca Niccacci Boccali
Zona Industriale
Deruta, Italy 06053
075.971.0064

IN THE UNITED STATES

Amano
1677 Wisconsin Avenue, NW
Washington, D.C. 20007
202.298.7200
Store and Catalogue

Avventura
463 Amsterdam Avenue
New York, New York 10024
212.769.2510

The Beach House
Cromwell Lane at Main Street
Tisbury, Massachusetts 02568
508.693.6091

Bellezza
129 Newbury Street
Boston, Massachusetts 02116
617.266.1183

Biordi Italian Imports
412 Columbus Avenue
San Francisco, California 94133
415.392.8096
Store and Catalogue

Ceramica
59 Thompson Street
New York, New York 10012
800.228.0858
Stores and Catalogue

Chequers
520 East Cooper
Aspen, Colorado 81611
970.925.7572

The Clay Angel
125 Lincoln Avenue
Santa Fe, New Mexico 87501
505.988.4800

Cottura
10250 Santa Monica Boulevard
Los Angeles, California 90067
310.277.3828
Stores and Catalogue

Kitchen Classics
Main Street
Bridgehampton, New York 11937
516.537.1111

La Tavola Imports
6208 Phinney Avenue North
Seattle, Washington 98103
800.210.8976

The Mediterranean Shop
780 Madison Avenue
New York, New York 10021
212.879.3120

O Suzanna
108 Main Street
Westhampton Beach, N.Y. 11978
516.288. 2202

Spruzzare
2602 Westheimer
Houston, Texas 77098
713.521.7918

The Stuart Collection
5 Post Road West
Westport, Connecticut 06880
203.221.7102

Toscana Ceramics
601 Townsend Street
San Francisco, California 94103
415.552.2118

Toscano
610 West 48th Street
Kansas City, Missouri 64112
816.756.0222

Tuscany
360 Greenwich Avenue
Greenwich, Connectiicut 06830
203.661.0444

Tutti Italia
700 N. Michigan Avenue
Chicago, Illinois 60611
312.951.0510
Store and Catalogue

IN CANADA

Casa
420 Howe Street
Vancouver, B.C. V6C 2X1
604.681.5884

Muti Ceramica Italiana
88 Yorkville Avenue
Toronto, Ontario M5R1B9
416.969.0253

Museums and Churches

THE UNITED STATES

California
The J. Paul Getty Museum

Florida
The John and Mabel Ringling
Museum of Art

Indiana
University Art Museum

New York
The Metropolitan Museum of Art

Washington, D.C.
The Sackler Collection
The Corcoran Museum of Art

EUROPE

England
Ashmolean Museum, *Oxford*
British Museum, *London*
City Museum, *Liverpool*
Courtauld Institute Galleries,
 London
Fitzwilliam Museum, *Cambridge*
Victoria and Albert Museum,
 London
Wallace Collection, *London*

France
Louvre, *Paris*
Musée Adrien Dubouchè, *Limoges*
Musée Alexis Forel, *Morges*
Musée de la Chartreuse, *Douai*
Musée de la Renaissance, *Ecouen*
Musée des Arts Decoratifs,
 Strasbourg
Musée des Beaux Arts, *Dijon*
Musée Lyonais des Arts
 Decoratifs, *Lyon*
Musée Nationale de la
 Ceramique, *Sévres*
Petit Palais, *Paris*

Germany
Kunstgewerbemuseum, *Berlin*
Kunstgewerbenuseum, *Cologne*

Museum für Kunst und
 Gewerbe, *Hamburg*

Hungary
Museum of Applied Arts,
 Budapest

Italy
Church of Madonna dei Bagni,
 Casalina (Deruta)
Church of San Pietro, *Perugia*
Church of Santa Maria Maggiore,
 Spello
Civiche Raccolte del Castello
 Sforzesco, *Milan*
Galleria Nazionale dell'Umbria,
 Perugia
Museo Civico, *Pesaro*
Museo d'Arte Antica, *Rome*
Museo del Vino, *Torgiano*
Museo delle Ceramiche, *Forli*
Museo Internazionale delle
 Ceramiche, *Faenza*
Museo Nazionale, *Firenze*
Museo Nazionale, *Ravenna*
Museo Regionale della Ceramica
 Umbria, *Deruta*
Museo Statale d'Arte Mediovale
 e Moderna, *Arezzo*

Poland
Museum Narodowe, *Kracow*

Portugal
Fudaçao Colouste Gulbenkian,
 Lisbon

Russia
Hermitage, *St. Petersberg*

The Netherlands
Gemeentemuseum, *The Hague*
Rijsmuseum, *Amsterdam*

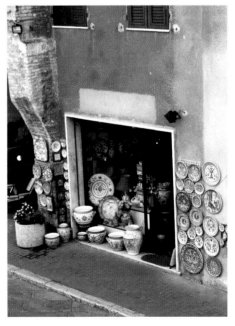

Bibliography

Page 161, top:
The Deruta Museum's seventeenth-century salt cellar bears the original inventory label from the 1920s.

Bojani, G., ed. *Ceramiche Umbre 1900–1940.* Perugia: Electa Editori Umbri, 1992.

———. ed. *Ceramica fra Marche e Umbria dal Medioevo a Rinascimento.* Faenza: Publialfa, 1992.

Bojani, G., and T. Seppilli, ed. *La tradizione ceramica in Umbria.* Perugia: Regione Umbria, 1995.

Busti, G. *Omaggio a Deruta.* Florence: Nuova Guaraldi, 1986.

Busti, G. and F. Cocchi. *Alpinolo Magnini e la ceramica Derutese del novecento.* Perugia: Tipografia Grifo, 1991.

———. *Terrecotte e laterizi.* Perugia: Electa Editori Umbri, 1996.

———. *Un fotografo ceramista Americo Lunghi.* Perugia: Tipografia Grifo, 1993.

———. *Ubaldo Grazia. L'Ingegno della copia.* Deruta: Tipografia Grifo, 1992.

———. *Angelo Micheletti.* Perugia: Guerra, 1992.

Page 161, bottom:
Shops in Deruta draw customers by hanging brightly-colored ware outside their doors.

Caiger-Smith, A. *Lustre Pottery.* London: Faber & Faber, 1985.

———. *Tin-Glaze Pottery.* London: Faber & Faber, 1973.

Cohen, D. H., and C. Hess. *Looking at European Ceramics: A Guide to Technical Terms.* Malibu, California: J. Paul Getty Museum, 1993.

Cole, B. *Italian Maiolica from Midwestern Collections.* Bloomington, Indiana: Indiana University Press, 1977.

De Mauri, L. *Le maioliche di Deruta.* Milan: Hoepli, 1924.

Drey, R. *Apothecary Jars.* London: Faber & Faber, 1978.

Fiocco, C., and G. Gherardi. *Museo del Vino di Torgiano, Ceramiche.* Perugia: Electa Editori Umbri, 1991.

Page 163: Deruta's classic table ware shows up in cafés and restaurants throughout Italy.

———. *La ceramica di Deruta dal XIII al XVIII sec.* (Deruta Pottery from the 13th to the 18th Century). Perugia: Volumnia Editrice, 1994.

Goldthwaite, R. "The Economic and Social World of Italian and Renaissance Maiolica." *Renaissance Quarterly* 42 (1989): 1–32.

Guaitani, G., ed. *Antiche maioliche di Deruta.* Florence: Nuova Guaraldi, 1980.

———. *Ceramiche Medievali dell'Umbria.* Florence: Nuova Guaraldi, 1981.

———. *Ceramiche umbre decorate a lustro.* Florence: Nuova Guaraldi, 1982.

Page 166: The ancient Porta Sant'Angelo is the main passage way for cars leaving and entering the old section of town.

———. *Gli ex-voto in maiolica della chiesa della Madonna dei Bagni a Casalina presso Deruta.* Florence: Nuova Guaraldi, 1983.

Hess, C. *The J. Paul Getty Museum, Italian Maiolica.* Malibu, California: J. Paul Getty Museum, 1988.

Mancini, F. F. *Deruta e il suo territorio.* Deruta: Pro Deruta, 1980.

Mostra della ceramica Italiana 1920–1940. Torino: Promark, 1982.

Piccolpasso, C. *The Three Books of the Potter's Art.* Trans. and intro. by R. Lightbrown and A. Caiger-Smith. London: Scholar Press, 1980.

Rackham, B. *Italian Maiolica.* London: Faber & Faber, 1963.

Ross, Ian Campbell. *Umbria: A Cultural History.* London: Viking, 1996.

Shinn, D. *Sixteenth Century Italian Maiolica.* Washington D.C.: The National Gallery of Art, 1982.

Watson, W. *Italian Renaissance Maiolica from the William A. Clark Collection.* Washington, D.C.: Corcoran Museum of Art, 1986.

Wilson, T. *Ceramic Art of the Italian Renaissance.* London: British Museum Publications, 1987.

Page 168: Each room in Grazia Deruta's factory still displays turn-of-the-century signs describing its use, in this case *tornianti,* where pots are turned on the wheel.

Acknowledgments

This book could not have been written without the dedicated research of scholars devoted to Deruta ceramics. Of fundamental importance were Carola Fiocco and Gabriella Gherardi's comprehensive studies, and Giulio Busti and Franco Cocchi's various and excellent publications. To these, and the many other scholars, we extend our admiration and gratitude.

Heartfelt thanks go to the cities of Perugia and Deruta, which generously gave their permission to photograph their ceramic collections.

Numerous people gave freely of their time and knowledge and we would particulary like to thank Giulio Busti; Mauro Mastice; Laura Pagnotta; Ubaldo Grazia; Franco Mari; Anna Sberna; Francesco Sberna; Remo and Carlo Berti; Father Antonio Santantoni and the Sisters of the Church of Madonna dei Bagni; Patrizio Chiucchiù; Antonio Margaritelli; Maria Tomassini; Marietta Cambareri; and Francesca Niccacci. A special thanks to Luigi Frassinetti of Tudergreen Nursery, and to Merete Stenbock and Charlene Engelhard for opening their homes to us.

Sincere thanks to the following firms in the United States that lent pieces for inclusion in this book: Gianfranco Savio at Biordi Art Imports, San Francisco; James Zimmerman at Cottura, Los Angeles; Tiffany's, Boston and New York.

We would like to express our gradtitude to all of those at Chronicle Books involved in this project: Jay Schaefer, Kate Chynoweth, Pamela Geismar, and Julia Flagg. For advice and assistance in the making of this book, we would like to thank Judith Dunham, Michael Carabetta, Debra Lande, Caroline Herter, Sara Slavin, Jennifer White, Rob McHugh, Herb Thornby, and Carla Morris.

This book owes much to the extraordinary talent of Susie Cushner and David Hamilton, who went above and beyond the call of duty to bring this story to life with their beautiful images. Their friendship, patience and creative collaboration has been greatly appreciated. *Grazie di cuore.*

- *Melanie Doherty and Elizabeth Helman Minchilli*

Credits: Front cover, Cottura, Los Angeles; back cover, endsheets, pages 1, 2, 5, 77, 78, 94, 98-111, 113-115, 117, 124-129, 145-147, 149, 151, 168, Grazia Deruta; 8, 11, Grazia Deruta/Cottura, Los Angeles; 144, 148, Grazia Deruta/Tiffany's; 12, 22, Church of San Francesco, Assisi; 14, 16, 18, 25, 28, 35, 36, 37, 40, 42, 46, 47, 49, 56, 57, 58, 60, 61, 69, 73, 74, 161, Museo Comunale delle Ceramiche, Deruta; 17, Vatican Museum, Scala/Art Resource, N.Y.; 19, 20, Museo del Vino del Fondazione Lungarotti, Torgiano, photographed by Leonetto Medici; 21, 29, 30, 48, 97, 136-139, Antonio Margaritelli; 31, "Basin with Geometric Patterns and Dragon" 1480-1500, Maiolica, In the Collection of The Corcoran Gallery of Art, Washington D.C., William A. Clark Collection; 43, Collegio del Cambio, Perugia, Alinari/Art Resource, N.Y.; 44 (plate) © photo RMN, Paris, photographed by Jean, Musee de la Renaissance, Ecouen, France; 44 (fresco) Church of St. Francis, Deruta; 45 (plate), 52, Museo della Ceramica, Faenza, photographed by Roberto Cornacchia; 45 (drawing), © The British Museum; 51, © photo RMN, Paris, Lourve, France; 53, Church of Santa Maria Maggiore, Spello, Scala/Art Resource, N.Y.; 54, Archivio di Stato, Perugia, photographed by Leonetto Medici; 62-67, Church of Madonna dei Bagni, Casalina, Deruta; 70-71, Fototeca Ufficio Beni AAAAS della Regione dell'Umbria, photographed by Sante Castignani; 44, 72, 75, 77, 78, photographs from Italo Margaritelli, Deruta; 112, 152-155, Patrizio Chiucchiú; 120, Fratelli Berti, Ripabianca; 121, Giulio Gialletti Ceramica; 122, 123, C.A.M.A., Deruta/Biordi Art Imports, San Francisco; 118, 130-135, Franco Mari; 140-142, Francesca Niccacci/Biordi Art Imports, San Francisco/Cottura, Los Angeles; 156-159, Ceramiche Sberna

Index

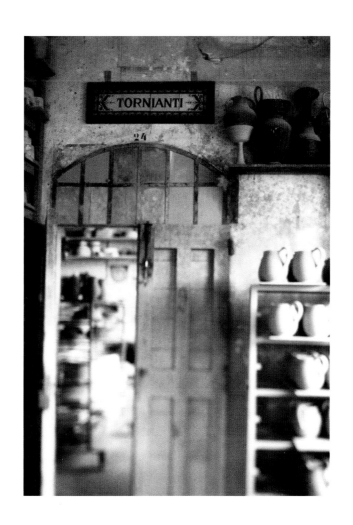